Jeremy GILBERT-ROLFE

Beauty **and the**
Contemporary Sublime

School of
VISUAL ARTS

ALLWORTH PRESS
NEW YORK

Published by **Allworth Press**
An imprint of Allworth Communications
10 East 23rd Street, New York, New York 10010

Cover **James Victore, Inc.**

Book design **Mary Belibasakis**

Page compositon **Sharp Des!gns, Inc.,** Lansing, MI

ISBN: 18-1838573-34-4

LIBRARY OF CONGRESS CATALOG-IN-PUBLICATION DATA
Gilbert-Rolfe, Jeremy.
 Beauty and the contemporary sublime / Jeremy Gilbert-Rolfe.
 p. cm. — (Aesthetics today)
 Includes bibliographical references and index.
 ISBN 1-581-15037-7 (paperback)
 1. Sublime, The. 2. Aesthetics, Modern. I. Title. II. Series.
BH301.S7 G55 1999
111'.85—dc21
99-043055

Printed in Canada

for Eugene Kaelin.

Table of Contents

Acknowledgments

It was Bill Beckley's enthusiasm for it and its topic—both ably represented in his introduction—that got this book published. The sense of pleasure mingled with urgency that Bill brings to the discussion of beauty and the sublime follows from his broad understanding of art and the art world, and I can only resort to an understatement and say that I appreciate having been fortunate enough to intersect with it. I am obliged as well to Tad Crawford for expressing pleasure rather than alarm on receiving a manuscript significantly longer than he had been led to expect. I should also like to thank Nicole Potter, Ted Gachot, and Jamie Kijowski for their invaluable contributions to the book's production, which included raising questions that improved it.

I am particularly grateful to Gabrielle Jennings, who in addition to letting me use a still from one of her videos has done everything from proof-reading the manuscript to taking photographs that illustrate it. Regarding illustrations, I should like to thank the artists who have let me reproduce their work; Lucina Gioia, of Krizia, Milan, who was extremely helpful in response to my request for fashion photography, and, in the same vein, Heather Marsh-Rumion of Corbis Images, Los Angeles; Christian Haub, for photographing a Stanford White building at the last minute; George Palmisano; and Mandy Hall of the National Gallery, London.

Of others involved in the evolution of this book, my thanks go first to Heidi Paris and Peter Gente, at Merve Verlag in Berlin, who published a shorter version of it—in German—in 1996. It is now more than twice as long as a result of questions its first version seemed to me to raise. In regard to material incorporated here but also published, since 1996, elsewhere, I should like to thank the editors of *Critical Inquiry,* in which V, "Blankness As a Signifier," first appeared, and David Moos, who edited an issue of *Art & Design* devoted to art and arti-ficial intelligence in which he was kind enough to include an essay that reappears, dispersed, in the following pages. Among those who provided me with public forums in which to develop the ideas put forward here, I should especially like to thank: Stephen Bann, Dalia Judovitz, Stephen Melville, David Scott, and John Welchman; Terry Smith, of the Power Institute, and Nicholas Baume, of the Museum of Contemporary Art, in Sydney; and the International Association for Word and Image Studies and the Modern Language Association. To these I must add the names of those friends who have helped throughout with informa-tion and opinion: Norman Bryson, Penny Florence, Dave Hickey, John Johnston, and Gilberto Perez. Finally, I should like to acknowledge the input I've received from my colleagues and students at Art Center and from my wife, Genevieve Gilbert-Rolfe, of whom it should also be said that without her forbearance in all matters having to do with my relationship to the everyday it is unlikely that I should get very much done at all.

Introduction

Sublimitas Mobilis

Everything goes past like a river and the changing taste and the various shapes of men make the whole game uncertain and delusive. Where do I find fixed points in nature, which cannot be moved by man, and where I can indicate the markers by the shore to which he ought to adhere?

—Immanuel Kant

Children say *beauty;* they seldom say *sublime.* As a boy, I felt something of the sort when I looked up at a stained-glass window that Tiffany had designed for the Reformed Church of Hamburg, Pennsylvania. More abstract than the other windows in the church, it was unlike anything else in town. A cross entwined with passion flowers hung above spires, which, through perspective, diminished in size and implied infinite space—space I could fall into. The spires rose high above two grapevines. In small town America, where a couple of beers defined you as alcoholic, these vines, perhaps, posed an additional threat.

In junior high school, when I first heard the word "sublime," I assumed it meant *really great.* Later, in college, I read Kant and learned it meant *absolutely great.* Lucky for me, because it was just in time to apply that definition to a night in the rain, when, at a muddy rock concert in 1969, my friend Mike and I walked off into the woods and stumbled onto a makeshift stage and a band called "The Grateful Dead."

Because of Kant's stress on the absolute, with his premise that all human beings share the same faculties—including taste linked with a common morality—the postmodern relativists of academe have tossed him out, kit and caboodle. At a lecture I gave in New York for an international conference of independent art and design schools, the audience demurred even at the mere mention of Kant. The German contingent was particularly acrimonious, to the point of throwing over-ripe lexical tomatoes.

I was sorry I didn't have Jeremy to back me up. Always the eloquent contrarian, he suggests here that, although the sublime may be an eighteenth-century concept, gravity is a seventeenth-century concept—and still relevant as we leap from cab to curb. In taking up subjects like beauty and the contemporary sublime, Jeremy is neither regressive nor reactionary. He torpedoes Marcel Duchamp, whose rich tradition of ready-mades, the shovels and urinals, led to the sleds, felt, and flashlights of Joseph Beuys, the fluorescent lights of Dan Flavin, the nutty submerged basketballs of Jeff Koons (and his vacuum cleaners illuminated by fluorescent lights) and the more predictable already-deads of Damien Hirst. I happen to love many of these objects, but artists have aestheticized ready-made objects for more than eighty years now. If someone drove a dump truck into Larry Gagosian's gallery on Wooster Street and closed the door, that truck would be art and perhaps not bad. But you would still need a

shovel to unload it. In bucking the Duchampian tradition, which is dependent on recontextualization, Jeremy plays with a different set of possibilities—the relationship of glamour to art, the meaning of surface, the reciprocity of painting and photography, and the techno-sublime. Jeremy's excursions into surfaces of the various media he compares—from Matisse's illusion of continuous movement, and Monet's marriage of stone and sky to video's plastic visage—are particular delights of this book.

Come to think of it, I have never really been able to figure out what Jeremy is, except unpredictable, humorous, and caustic, as well as politically unconstrained.

* * *

And then I returned to my hawthorns, and stood before them as one stands before those masterpieces of painting which one imagines one will be better able to take in when one has looked away for a moment, at something else.

—*Marcel Proust*

Natural History

The seminal texts on beauty and its relationship to the sublime are: Longinus's *On the Sublime* in the first century; Edmund Burke's *Philosophical Enquiry into the Origin of our Ideas on the Sublime and Beautiful* published in 1756 (and translated into German in 1773); Immanuel Kant's early *Observations on the Feeling of the Beautiful and Sublime* (1763) and his later *Critique of Judgement* (1790)—in particular, sections 23 to 29, "The Analytic of the Sublime;" and, more recently, Jean-François Lyotard's response to Kant in *Lessons on the Analytic of the Sublime.* These are not the only works on the subject, but I believe they have been the most influential to artists, from Thomas Cole, an English immigrant of the early nineteenth century, through Barnett Newman and Agnes Martin, in the nineteen fifties and sixties, to artists at the cusp of this new century.

But you don't have to go to the library or to Amazon.com to find attempts at the sublime. They are as close as the nearest cineplex. Recent disaster films, with their hurricanes and erupting volcanoes, aspire to what Burke and Kant defined as "terror sublime." Through the pleasure of terror coupled with the possibility of cuddling, inside the theater we feel the impact of that big ship sinking in the bottomless Atlantic of 1912—death by water both frozen and liquid. In the movie, the torrents of water flooding the corridors as the ship tilts and sinks, then the silent, floating, glassy-eyed bodies (overlaid with Irish music) aspire to a sublime described by Burke and Kant. In the film *American Beauty,* a contemporary twirl on *Lolita,* a middle-aged man falls in love with his daughter's

best friend, a teenage cheerleader, and goes on to find his death. His narration from the grave somehow usurps beauty from an upper-class suburban existence. The film journeys from appreciations of beauty, a paper bag floating in the wind, as well as the breasts of various love objects, both male and female, to the death of the narrator (but not the narration). The narrator tries like Aschenbach, in *Death in Venice*, to make himself beautiful so that he can attract the beauty he wants, and like Aschenbach, he dies because of beauty before surrendering to the sublime. It is not a coincidence that a panoramic shot of a vast sky, so often and traditionally a symbol of the sublime, is the last thing you see before the film cuts to black. It may be that these film makers have studied the sublime in a formal way or, perhaps, like Burke and Kant, have simply unlocked a reasonable course of events through the reality of human emotion.

If Burke was accused of trying to categorize the emotions, his attempt is fertile territory nowadays, a territory which Jeremy has critiqued and expanded condsiderably.Burke wrote of *terror* as "a sort of delightful horror, a sort of tranquility tinged with terror; which as it belongs to self preservation, is one of the strongest passions." For Burke, the beautiful is human in scale, the sublime out of scale and threatening.

Churches and cathedrals as well as museums have traditionally been the aesthetic epicenters of communities. I recently revisited both Bilbao and Barcelona, Spanish cities on different coasts where some of the twentieth century's greatest architecture was born. Gaudi began his still unfinished Sagrada Familia in Barcelona at the beginning of the twentieth century. Climbing a spire, my legs buckled from terror, fatigue, and awe. (It's impossible, sometimes, to separate phobia from aesthetic experience, and in climbing these towers one might confuse the fear of heights with the fear of God, a fear that may only be superseded by a fear of nothingness.)

On the northern coast of Spain, not far from the city of Guernica, Frank Gehry's Guggenheim Bilbao, equivalent in its organic complexity to the work of the great Catalonian architect, floats airily over train yards in the gut of the city. Gehry's brilliant use of contemporary materials, a house blown apart, is sublime light (in a Nietzscheian sense) to Gaudi's stone cathedral. Outside, guarding the main entrance of the museum, stands Jeff Koons's *Big Puppy*. Planted from head to toe with multi-colored flowers, the mutt is beauty's jest, in my opinion, to Gehry's sublime (I mean this as a compliment to both Gehry and Koons, and we mustn't forget what *dog* is spelled backwards). The vertiginous catwalks leading to the upper galleries may be a case where Hitchcock influenced an architect. In the crash of 1929, people committed suicide by jumping out of office buildings. In both Gehry's Guggenheim Bilbao and Wright's earlier Guggenheim in New York, it's an inside leap. That becomes part of the experience of seeing the work. At the time I visited, several Serras stood in one huge

room. Serra's work has a reputation for intimidation, a threat that is, on occasion, realized. The pleasure of *this* fear is coupled with the supposition that the sculpture (and the building) is sound.

Further lines from Kant, and gravity shed light:

> The sight of a mountain whose snow covered peaks rises above the clouds, the description of a raging storm, or Milton's portrayal of the infernal kingdom, arouse enjoyment but with horror; on the other hand, the sight of flower-strewn meadows, valleys with winding brooks and covered with grazing flocks, the description of the Elysium, or Homer's portrayal of the girdle of Venus, also occasion a pleasant sensation but one that is joyous and smiling. In order that the former impression could occur to us in due strength, we must have a *feeling of the sublime,* and in order to enjoy the latter well, a *feeling of the beautiful.* Tall oaks and lonely shadows in a sacred grove are sublime; flower beds; low hedges and trees trimmed in figures are beautiful. Night is sublime, day is beautiful.

They say that Kant seldom looked at art. The focus of his writing is nature, but he draws examples from literature and architecture—the pyramids, and St. Peter's Basilica in Rome. If the Irish writer Edmund Burke influenced Kant in his *Observations on the Feeling of the Beautiful and Sublime,* Burke based his *A Philosophical Enquiry* on Longinus's *Peri hypsous–On the Sublime.*

Longinus, writing in the first century, draws examples of the sublime from "grand conceptions and the inspiration of vehement emotion" and from art: proper construction of figures of thought and of speech, the use of metaphor, and "dignified and elevated word-arrangement." His hierarchy with respect to nature and the sublime derives from "whatever is great and divine in ourselves." So it is by some "natural" instinct that we admire,

> not the small streams, clear and useful as they are, but the Nile, the Danube, the Rhine, and above all the ocean. The little fire we kindle for ourselves keeps clear and steady, yet we do not therefore regard it with more amazement than the fires of heaven, which are often darkened, or think of it as more wonderful than the craters of Etna in eruption hurling up rocks or whole hills from their depths and sometimes shooting forth rivers of that earth born, spontaneous fire.

My son will grow up with a monitor as a child of Kant grew up with a pond. Jeremy suggests that in the contemporary environment "The limitless once found in nature gives way, in technology, to a limitlessness produced out of an idea which is not interested in being an idea of nature, but one which replaces the idea of nature."

In describing this transition, Jeremy says that one can't escape Kant but only "be irresponsible with what he says, which I have tried to be." This irrespon-

sibility involves both proximity to and distance from Kant. While dependent on Kantian categories, his argument insists on being at least agnostic about Kant's goals and assumptions. Or is it only about the ways in which they are said to be achieved?

<center>* * *</center>

The question that now arises is how, if we are living in a time without legend or mythos that can be called sublime, if we refuse to admit any exaltation in pure relations, if we refuse to live in the abstract, how can we be creating a sublime art?
<div align="right">—Barnett Newman</div>

Biography

Jeremy Gilbert-Rolfe is a writer and a painter. He was born in Tunbridge Wells, Kent in 1945, immigrated to the United States in 1968, studied in Florida for three years, and then moved to New York. Since 1981, he has lived in California, where he coordinates the master of fine arts program and M.A. program in criticism and theory at the Art Center in Pasadena. He has been married twice and has two sons: Cyrus, 32, and Cedric, 11.

He speaks Queen's English as if he had never left. His friend Dave Hickey, who wrote *The Invisible Dragon: Four Essays on Beauty and Air Guitar,* speaks with a Texas drawl. Together they have taken art criticism past the dull, pious, cynical, and opaque, and have democratized it. In writing of generosity, Cindy Crawford, Liberace, pleasure, Power Rangers, Hank Williams, and beauty versus an ever-shifting sublime, their criticism is as engaging as any art.

On the language of criticism, Jeremy has this to say:

I think all the time of how language has to be very complex in order that very simple things may be said. You have the whole thing in place, hundreds of thousands of words you're not going to use and a whole array of tenses and so forth in order to order a glass of water or something of that sort or order, which ordering may of course be done in an orderly way or not, to give another example of the sort of complexity which language takes for granted and out of which it is made. This means that simplicity is at best an effect entirely and exclusively of the complex.

On the other hand, I am interested in immediacy for the thing. I'm interested in the sense in which it's always *the immediate,* about which I have tried to raise some questions in the book. The corollary seems to be that immediate experience is felt by the body as one shock, unless the immediate experience is one of being presented with what is clearly an unfolding, i.e., with the process rather than a thing in space.

<div align="center">* * *</div>

If any shall thinke it too rude and unlearned for this curious age, let them know, that to paint out the gospell in plaine and flat English, amongst a company of plaine English-men (as we are) is the best and most profitablest teaching; and we will study plainnesse, not curiositie, neither in things humaine, nor heavenly.
—*Robert Cushman, from a sermon preached at Plymouth, December 9, 1621*

Puritans, Then and Now

In an English immigration earlier than Jeremy's, the Puritans settled near Plymouth Rock. (It was in December of 1620, not a very good time to arrive.) If I believe American history according to another English friend, Peter Hutchenson, they first landed in what would become his hometown, Province-town—now a thriving gay community. I mention this heritage because of Jeremy's formidable collection of essays, *Beyond Piety*, that critiques the remains of American Puritanism.

At a symposium at the School of Visual Arts last year, I asked Jeremy about the title of *Beyond Piety:* Was it the piety of the left or the right to which he referred? He said it was inevitably that of the left. While there were plenty of right-wing collectors, right-wing artists or critics were usually too intellectually disadvantaged to say anything that might excite comment, and in this the art world mirrored Keynes's division of the left and the right into the silly party and the stupid party.

The problem as *I* see it is this: If Jesse Helms pulls federal funding from your exhibition, it's in all the newspapers, people become curious, even obsessive, and you gain notoriety, as Mapplethorpe, Serrano, and Finley did. If a pious museum curator of the left finds your work objectionable, you don't get the show in the first place.

It is the affiliation of American Puritanism, with what has become of Marxism and the left, as well as the pushy devotions of the religious right, that makes these liaisons so *dangereuse*. If you speak from the right, you deny; and if you speak from the left, you indulge self-consciously, or for reasons of health.

In Victorian England, John Ruskin, speaking from what was then the left, put his mother's Scottish Puritanism to good use in his disciplined aesthetics. He linked beauty with goodness, but he forgot everything for Rose La Touche, a Victorian Lolita who was nine when her mother first brought her to Ruskin for drawing lessons. As for the American Shakers—who forbade intimacy even in marriage—they shook, made beautiful furniture, and influenced minimalists before they died out.

In the Mediterranean, they don't have Puritanism to grab hold of. A

couple of my friends in the southeast of France, one a novelist and philosopher, the other the editor of *Art Press*—are card-carrying Epicureans.

Warning: If in America we want to talk our way out of Puritanism, let's remember that eroticism is possible only through transgression.

Advertisement: The French recipe for good health published in the *Herald Tribune* today, Monday, June 10, 1999 (page ten) is: cereal, nuts, dark green leafy vegetables, orange juice, cheese, foie gras, bread (baguettes), and red wine (Les Clos de Paulilles).

* * *

Everything that is good is light, what is divine, runs on delicate feet.

—*Friedrich Nietzsche*

Glamour

Like Newman, Jeremy mistrusts the moral struggle involved in questions of beauty and the desire for sublimity. In "The Sublime is Now," Newman writes: "The invention of beauty by the Greeks, that is, their postulate of beauty as an ideal, has been the bugbear of European art and European aesthetic philosophies. Man's natural desire in the arts to express his relation to the Absolute became identified and confused with the absolutisms of perfect creations—with the fetish of quality . . ." Jeremy swaps morality for glamour. (Here in front of me as I write are Kant and Burke stacked on top of *Cosmopolitan* and *Vogue*.) Jeremy says that beauty is "inextricably entwined with glamour, a magic language of order without meaning, i.e., a grammar." He continues:

> The beautiful is powerless but always exceeds what frames it, and what frames it is discourse. It is unframable, however, to the extent that it is frivolous. That is why I am intent on discussing beauty as a matter not only of the attractive but precisely of the glamorous, and as such anything but passive . . .

His emphasis on the active recalls, for me, an earlier book: John Berger's *Ways of Seeing*, a seminal work of the early 1970s. I received a message from one wordless chapter of that book filled with paintings of naked women as well as Marxist restraint: Throughout the history of painting, artists portrayed beauty as passive; passivity is wrong, and so are painters and painting. (Tell that to Caravaggio's Narcissus, Cimabue's Christ, or anyone else's Christ—nailed to the cross and dripping with blood from the vertical slit of the spear.) That passivity, that bleeding Christ (Dionysus) on that rigged cross (Apollo), has held up quite well as an image for the past couple millennia. Now, as ever, beautiful girls and boys

have options: among them, to act with or without guilt, or to be passive with or without guilt. Neither activity or passivity has meaning without knowledge of the other, and the commingling of life and art, thematic in such novels as *Madame Bovary* and *Lolita* is much more complex than social realists suppose.

For Jeremy, what is more important is the relation of the intransitive and the transitive. He writes, "Beauty is seductive but goodness only productive, the production involved taking the form of a critique of the glamorous. If I may be seen in this to be saying that glamour is better for you than goodness, this, I think (like the relevance of irrelevance) is a paradox which follows from Kant's insistence that aesthetic pleasure involves experience free from concepts . . ."

* * *

> In all her pride the potent beauty knelt
> before the pitiable one, complacently
> savoring the wine of her triumph, reaching up
> as though to garner fond acknowledgment.
> —*Charles Baudelaire*

Gender

In literature and art, there is no regimented relationship between women and the *feminine,* and men and the *masculine.* If so, there could have never been a Sarassine, an Orlando, a *Crying Game*, or a Tadzio. Confusion between gender and sex exists today partly because the word *gender* replaced the word "sex." *Sex* lost the part of its meaning that differentiated the biological female from the male, and has been reduced (or elevated) to mean the act of sex. Often I am asked, "what *gender* is your child," as if he were a noun in a romance language.

Jeremy makes it quite clear that the sign's gender is quite another matter than biological gender, more so than Kant differentiated them. Kant proclaimed beauty feminine, and the sublime masculine. He flips between people and signs: "All the merits of a woman should unite solely to enhance the character of the beautiful, which is the proper reference point; and on the other hand, among the masculine qualities the sublime clearly stands out as the criterion of his kind."

Jeremy wants to keep people and signs apart, a distinction which he illustrates significantly by way of a film made for a very young audience: *The Mighty Morphin' Power Rangers.* He does so by following Kant's logic in a way that is irresponsible because of the importance it attaches to frivolity as a characteristic of the beautiful.

For Jeremy, the frivolous is what Foucault leaves out in locating everything within an epistémé of transitive power. Similarly, Jeremy sees difficulties in art history's having been founded on a theory—i.e., Winckelmann's—in which

severity's superiority to beauty folded the feminine into an exclusively male aesthetic derived from an exclusively male ethic. Finding these traditional formulations unsatisfactory, Jeremy has, as he puts it, tried to write a book in which beauty is not brought up so that it may be made to give way to a discussion of the sublime, but instead considered with a view to the ways in which it declines to do what both philosophy and commerce say it must. Frivolity is important to his argument because it can't be reduced to seriousness, while the sublime and the masculine always have been, and reason implicitly is.

While its inherent frivolity causes Jeremy to argue that beauty must be irreducibly feminine, it is the current condition of seriousness that leads him to propose that the contemporary sublime has to be androgynous. The masculine simply cannot contain enough to be regarded as the sole repository of reason—or, as Jeremy likes to say, since it allows for reason's underside to come into play—of discourse in general. Jeremy suggests that not only logic but culture as a whole—discourse at its most diverse—has come to reject the possibility that the exclusively or irreducibly male can serve as an image of anything very much outside the arenas of sports and the military. Outside these worlds of organized transitive force "the masculine has become absurd." He notes that one need only look at several male icons in popular music over the past thirty-five years—Mick Jagger, Iggy Pop, David Bowie, Boy George, Marilyn Manson, and so on—to see that androgyny has replaced masculinity. The strands of development which have caused us to doubt that the masculine is not the embodiment of reason, have their parallels in the implausibility, in the contemporary world of the exclusively male as an image. The androgynous look is at once transgressive, in that it pisses off those who are in denial about the collapse of the simple divisions Burke loved, but it is also actually a quite sensible—that is, reasonable or rational—use of cultural iconography. It acts out the way things actually are at the level of thinking in general. It is the public embodiment of how thinking is by no means biologically determined or specific.

* * *

And the sublime comes down
To the spirit itself,

The spirit and space,
The empty spirit
In vacant space.
What wine does one drink?
What bread does one eat?
—*Wallace Stevens*

Sublime as Continuum

For purposes of communication, language, both verbal and visual, divides continuums into units—units of recognizable sound (phonemes) and meaning (words); units of temperature (degrees); the spectrum into colors; time into days, hours, and minutes; and space into inches, feet, neighborhoods, cities, and countries.

It's difficult to paint without making divisions. Even if there's nothing else, the edge of the canvas falls to the wall. The vertical stripes that echo the painting's edge in Newman's *Vir Heroicus Sublimis* warn you of this fall. If you sit up close you can obliterate the edge of a movie, but then you are back to divisions—hands, fingers, stagecoaches, villains, scenes, shots, plots, and prickly things.

Pollock moved to New York from the West and brought space with him. Newman stayed in the City. Georgia O'Keeffe and Agnes Martin both left New York and traveled west. Dave Hickey writes from smack in the middle of Vegas—home of the mathematical sublime—surrounded by cactus.

Jeremy told me he came to America because of the space in Barnett Newman's paintings. He "accidentally" settled in California, moving from New York, where most of us displaced puritans still find refuge. I asked him how he felt his writing fit with his work as a painter. He responded:

> I'm not sure what I have to say about artists who write, they come in different flavours. I hate absolute self-confidence in critical writing and a lot of artists go a bit far in that direction. On the other hand, their strengths usually include their being aware of how artworks are made, indifference to which obviously impedes the argumentation of many non-artists who write about art. I began to write art criticism in part because it was there, and also, it must be confessed, out of dissatisfaction with what is being written. I think there is a clear difference between art and art criticism, and what I write about are questions or ideas which are best dealt with through prose. I wrote this book because I found myself led to the subject within my own work and related interests while becoming increasingly aware that beauty had been occluded by a lot of bullshit about social power.

Barnett Newman quipped that aesthetics is to art what ornithology is to birds. Arthur Danto provides a riposte: "Without a theory, black paint really would be black paint."

Maybe because of shell-shock, a generation of artists and writers after the Second World War, Newman among them, articulated beauty and their particular sublime. Since then, let's see,

TVjohnkennedymisterrogersmartinlutherkingexcitejohntravoltamichaeljordan
janisjoplinvietnambellaabsugandywarholR2D2chercellphonesumathurmanthe
fourseasonswoodyallendianajacknicklauscindycrawfordjacknicholsonjackie
kennedytheinternetmickjaggerkinghusseinpulpfictionsusansontagjerryseinfeld
watergatedonovanjohnashberyeasyriderLSDtheirrymuglermichelfoucaulttimothy
learythelmaandlouisejamesearljonesgracejoneswavesontheshorelineimacmalcolm
Xflight800frontalnuditykatemossthepilldavidlettermanemailblowuptomhanks
lightmyfiretinytimaidsthebyrdsdon'twalkawayrenétheweathermentomwaitsmarshal
machluanliberaceoklahomacitytheloungelizardsplato'sretreatjohnlennonyahoo!
thedeerhunteranniesprinkleslouisebourgeoischetbakeryvessaintlaurentroevswaden
aomicampbellbricemardenhubbletelescopebmwbobdylankeithharingangelad
workindollypartonaudimeninblackjerrygarciajeanpaulgaultier, as well as daughters,
sons, mothers, fathers, clients, lovers, and friends have passed by.

Jeremy takes up beauty and *our* sublime someplace where Barney left off.

BILL BECKLEY
Les Clos de Paulilles
July 4, 1999

* * *

This book evolved from an essay of the same title published in *Uncontrollable
Beauty* in 1998 (Allworth Press). The essay was first given as a lecture at the
Wexner Center, Ohio State University, in 1994. It is also based on a paper given
at the Interart Studies, New Perspectives conference held at Lund University in
Sweden the following year. An extended version of the original essay has been
published in German as *Das Shöne und Erhabene von heute*, before it was
expanded to its present length.

I.

There Is a Historical Context:
(Not) Only the Strong (Signs) Survive

While working on this book I was often told that beauty and the sublime (despite their prior histories) are for us eighteenth-century concepts defined by assumptions we no longer share. I am not convinced about the last part. Gravity is a seventeenth-century concept that continues to explain one's body's refusal to fly, and it seems to me that the visual and its description similarly remain usefully served by the qualitative terms I want to reconsider here. However, I am actually rather keenly interested in the differences between the eighteenth-century and contemporary world, and my review of the relationship between beauty and the sublime is predicated on my sense that one could not now find the sublime where it was to be found two hundred years ago.

The sublime and the beautiful coexist in a differential relationship. The one does what the other does not, but they also partake of one another, although not, as their interdependence would otherwise imply, symmetrically, because they are not traditionally seen as equal: One may have the sublimely beautiful, but I'm not sure that things can be beautifully sublime. There are four aspects of the relationship which are, as I see them, defined by assumptions with which one would now have some difficulty, but insofar as some people have always had difficulty with them this may be an insight intensified by the contemporary rather than produced by it. First of these is the one just mentioned, the presumption that the sublime is superior to beauty. The second has to do with beauty as a problem (either as a result of its alleged inferiority or as the rationale for the allegation), and the third with the related matter of beauty and gender and the problems caused by it when it does have a gender—I shall say it always does and it is always feminine. I have found these second and third aspects of the question largely interdependent, and it is in them that I find in its explicit form the matter raised implicitly by the first, that which has to do with the relationship of beauty to the good. The fourth has to do with another that has already been mentioned, the question of the contemporary location of the sublime. In introducing my topic, I shall briefly address its first and second aspects, and then turn to the fourth in order to anchor what I have to say in the present. Thereafter, I shall return to the third as the (im)practical expression of the second.

This is how Schiller described beauty's inferiority in 1795: "The beautiful is indeed an expression of freedom, but not that which elevates us above the power of nature and releases us from every physical influence; rather it is the expression which we enjoy as individuals within nature."[1] The definition of beauty, I think, remains unarguable. The assumptions around that to which it is compared seem less so. Whether from a position which is historically specific, or in response to questions arising from the original, i.e., eighteenth-century, argument I am not sure—I think a bit of both—I shall suggest here that beauty's

shortcoming, so described, causes or allows it to frustrate rather than serve that which is supposed to be superior to—even to the point of obviating—it, namely that "state of our minds . . . not necessarily determined by our sensations . . . [but by] a principle proper to ourselves that is independent of all sensuous affects."[2]

The principle proper to ourselves and independent of the sensuous is reason. However, sublimity's possible frustration by beauty suggests to me that, in attempting to describe the current condition or location of the sublime, one might—or must—inquire further into the independence of the principle on which Schiller says it depends, and in doing so ask to what kind of a self it might nowadays be said to be proper (which could include the question of where the sensuous might be found nowadays). Both beauty and the sublime, Schiller says, have to do with freedom, and in that respect, among others, both either play with or appeal to gravity's metaphorical connotations, in that the latter is linked irrevocably with seriousness while I shall associate the former with frivolity, which dislodges it from its traditionally assigned role as a preparatory phase of the serious. I shall say that the sublime is about freedom found within the archeology of knowledge, while beauty's independence is guaranteed only by associating it with frivolity, at which point one may assert: "Since its structure of deviation prohibits frivolity from being or having an origin, frivolity defies all archeology, condemns it, we could say, to frivolity."[3]

I want to place this observation alongside Kant's assertion that: "Whether a dress, a house, or a flower is beautiful is a matter upon which one declines to allow one's judgment to be swayed by any reasons or principles."[4]

These are the questions I am proposing to discuss here. The "beautiful" and the "sublime" are terms that both judge and describe and, as such, imply models. I have taken the proposition literally. I think the fashion model is where the beautiful is most clearly defined in our time, and it will be around the questions raised by her professionally frivolous image that much of my discussion of beauty will take place. It is there that one runs up most interestingly against the difficulties inherent in associating beauty with the good.

To do that I feel I must address the problematic offered by the model's model, Helen of Troy, to which long historical view I'll briefly turn below. The frivolous may have no origin, but beauty is largely known for problems of which it is said to be the origin, never as an idea but always as an image of itself. Kant makes a distinction with which I want to take some liberties: "Properly speaking, an *idea* signifies a concept of reason, and an *ideal* the representation of an individual existence as adequate to an idea. Hence this archetype of taste—which rests, indeed, upon reason's indeterminate idea of a maximum, but is not, however, capable of being represented by means of concepts, but only in an individual presentation—may more appropriately be called the idea of the beautiful."[5] I shall suggest that the beautiful is, in Helen and fashion photography, an image that always exceeds the adequacy of its ideation by suggesting an

ideal incompatible with reason, at least in its effects. Which is, I think, where the beautiful as an idea is most obviously seen to be inadequate to an ideal it seeks to name. Beauty as an image—and in that neither wholly idea or ideal, since an image would have to appeal to both—exceeds reason in the same way that Derrida attributes to the frivolous a freedom from definition in his book on Condillac from which I quoted above: The apparatus can't contain it, its meaning can't be *in* the dictionary.

However, I first turn, as announced, to the shorter view, and an anecdote which to me encapsulates the general condition of contemporary life and with it a post-Schillerian possibility of the sensuous left behind by what are at first sight two principles—technological on the one hand, critical on the other—which remember but do not require it, one the product of the sublime as the uncontrollable and the other of the sublime as control. It is at this everyday level that one finds, it seems to me, the elements of an idea proper to a contemporary subject, and with it the contemporary expression of the order beauty might threaten to disorder.

Sublimely Suburban

Orange County, California, is the home of Disneyland and a large section of the American armaments industry, nowadays euphemistically called the aerospace industry, and of lots of white-collar right-wing rednecks who work in both—and, therefore, of course, of an extremely liberal university, situated in an extremely liberal university town. On March 28, 1997, it bore witness to the closure of its last drive-in cinema, final victim of the television, which offers one a freedom of choice in exchange for not leaving the house with which cinema cannot compete. When it opened in 1955 the first film it had shown had been *Strategic Air Command*, a stolid piece of cold war blowhardery of which one could only say in the director's defense (assuming that he was only doing it for money) that it was bound to be boring because he could hardly have been expected to achieve much with a film set in the Air Force given that the damned war was, after all, cold and thus constrained by a plot according to which the most that one could do was to have a bit of close-proximity pouting with a Russian airplane over East Germany. All that is dreadful about it, however, including matters of ideology, clothing, and posture, finds its perfect but inverted reflection in the film with which the drive-in closed, *Beavis and Butthead Do America*. In the gestures with which it began and ended its life, then, the drive-in performed a farcical repetition of that passage from the heroic to the decadent that is so important to art history (and as such will come up here again) and, in that it may also be described as one from aggression to passive aggression, of the passage from recent to contemporary capitalism. Regarding art history one also notes that in both these respects the drive-in's career is paralleled by other kinds of cultural production.

The capitalism we now inhabit has lately come to describe itself as primarily a "service" economy as opposed to one based in production, which in practice masks a passive-aggressivity whose implicit goal is a world of techno-logical production post-human in its obviation of the human. I agree with Felix Guattari that: "One can 'find' capitalism in all places and times as soon as one considers it from the point of view of the exploitation of the proletarian classes . . . But the capitalisms of the last three centuries only really 'took off' from the moment that science, industrial and commercial technology and the socius irreversibly linked their common fate together."[6] He also seems to me to be probably right (if a bit apocalyptic) when he goes on to say that "A certain type of subjectivity, which I would call capitalistic, is overtaking the whole planet: an equalized subjectivity, with standardized fantasies and massive con-sumption of infantilizing reassurances. It causes every kind of passivity. . . Today it is massively secreted by the media, community centers, and alleged cultural institutions."[7]

It is in the constant stream of reassurances it puts forth that late capitalism's passive-aggressivity is seen most clearly, and where technology produces or colludes with the subject to produce an idea proper to capitalism during its passive-aggressive phase. Television, for example, epitomizes and embodies it, in that it has numerous channels providing access to (the same, multiplied) outside, and may be turned on and off at will—the opposite of the cinema, despite the drive-in's anticipating the car's contemporary function as an extension of the home. The exterior world, as historical, economic, and cultural context, may now be largely encountered as something like a supplementary epiphenomenon of the relationship between the subject and everything else proposed by television's relationship to its viewer, and, partly because of this, the private is now a more mobile state than the public ever was, and one in which the former need never entirely give way to the latter.

I mean by this that, in its ideal condition, contemporary capitalism requires of the subject only momentary flashes of engagement with public spaces that take place at clearly defined points of exchange. In Orange County, or nearly anywhere else in California, one drives between spectacles of standardized fantasy in the course of consuming infantile reassurances—from the home as spectacle, to the store's specularity, and back home again—in a mobile private space, as opposed to walking anywhere on any street as a member of a crowd. In the 1950s, a Janus-faced decade embracing McCarthy and Presley, America discovered the sports car and with it, and its skinlike closeness to the driver and passenger, the possibility of merging the car with the body.

Richard Martin discusses the meeting in America of the sports car with sports clothes—the latter, as he has shown us, the crucially American contribu-tion to twentieth-century fashion—in an image which combines speed with native talent, national technology, and nature, a new kind of life brought about

by a new kind of car, in an article on "Fashion and the Car in the 1950s," in which he quotes from the September 1954 issue of *Harper's Bazaar*:

> Two things starting here. Clothes for the open countryside that draw not only on a[n] authentic native talent for sports design—but on a new kind of life that's being lived, presently, out of town. And the first American sports cars: those small, spruce, low-sprung vehicles built-for-two whose primary motivation is speed; secondary, rakish appearance; tertiary, tall talk about gear ratios, getaway, direct drive and cornering.[8]

In passing, it seems worth mentioning that the boring rubbish invoked in the last part of the above would now occur around computers rather than cars, the mechanical no longer holding either challenge or fascination. Martin goes on to relate two-toned cars to two-toned clothes of all sorts, including furs, which thus reconcile the natural to the technological with that savagery that only the latter can command. An article in *Harper's Bazaar*'s "great rival, *Vogue*" published a few months later (February 5, 1955, *Strategic Air Command* will soon be on at the drive-in) suggests that "mobility and dress are interrelated . . . But what is it that we note of the cars and coats, even if the *Vogue* writer has chosen not to mention it? The two-toned cars and furs are directly analogous: The light and dark bi-colored contrasts of the cars—modish in the mid-1950s—is the direct point of stylish comparison with these extravagant fur coats . . . It is not clear which came first . . . but perhaps we are dealing with the kind of cultural moment and question to which the answer is that there is no answer necessary."[9]

I'm not sure what Martin means, but it seems to me that there could only be no answer necessary if the two were the same thing. Interestingly, Martin's article begins with a question posed by another writer, C. Edson Armi, about the same subject and how "[l]ike the postwar American car, the new fashion also fulfilled desires for lavishness, glamour, and a certain shapeliness."[10] Martin agrees with this assessment but recouches it in very different terms: "Armi . . . at least impressionistically . . . is certainly correct: The two-toned cars and separates dressing both attested to efficiency, speed, mobility, and the design ideals of the 1950s in America."[11] I don't know how deliberately he lined them up, but efficiency seems almost the opposite of lavishness, until one recalls the place in our lives of economies of redundancy such as, for example, the mass production of consumer goods and the scholarly archive. Glamour has an obvious association with speed in the twentieth century (i.e., once speed is of the essence, it's glamorous). Mobility is formlessness that can only be visually expressed as shapes or their convergence. (Note, by the way, the typical fifties nostalgia for the worst of the nineteenth century. "Shapeliness" is a word so rank with coyness as to have become extinct by the end of the sixties.) Both are right, then. The car's

lavish efficiency wraps the driver—situates her in an image of—glamorous speed, mobility expressed as an attractive shape.

"The new kind of life" that was, in the postwar era "being lived, presently, out of town" is still being lived in the same place, but it isn't new and the out of town is, presently, a town. Albeit an amorphous untown whose boundaries are known only to those who pay taxes there, its civic infrastructure known only through its roving metonymic presence in the form of police cars, the freeway, and its off-ramps—rather than buildings of any sort—with reference to which people give strangers directions. When walking, many prefer to wear a Walkman, which goes some way to extending the car's semiprivate space into the ambulatory. The cell phone keeps all conditions of separability between public and private, work and play, suspended. Accordingly, no one ever finally leaves the house, or fully resides there either. People make art about this, and not only in California. Even in New York, absolute condition of the crowd and the grid, one finds an artist who "addresses how we move through collective spaces such as streets, traffic, and parking lots . . . [going on to ask:] With the accelerated mobility of our culture, have our cars become our homes? [Kirsten] Mosher posits that our individual freedom to move is an ultimately more powerful force than our individual spaces."[12] It seems to me to be a freedom simulated within the home by the television, and the rest of life now a resimulation of that.

Perhaps one may say not that there is a comparative relationship of forces between them such as Mosher proposes, but rather that home now begins at the car door. The car is a semiprivate and mobile extension of the home. Perhaps this has something to do with why the sports car never caught on in America, where an expansive notion of living room requires cars to be as close as possible to the size of small houses. The cars that Martin and Armi were talking about were Corvettes, big fat things compared to the European cars whose market their manufacturers sought to renaturalize to the American way. In its recent regression to an image of comfortable infantilism and piggishness derived from the fifties and popularized by a right wing waging a cultural war on the sixties generation, America has returned to the bulbous shape of fifties cars but in the form of vile, vanlike soi-disant family sports utility vehicles whose very name says all there is to say about their relationship to either glamour or mobility: Their shape announces that all has given way to the sedentary. They are sports vehicles for sports fans. When attached to a right-wing concept, the family has to keep glamour at bay and regulate mobility. The first is achieved by associating the vehicle with the Puritanism of sports, the second by its being obese, embodying the sluggishness combined with aggression that represents trustworthiness to social reactionaries. The home itself is where the television and the Internet are, a private space for sitting and shopping to which electricity makes all that happens in the world immediately adjacent while safely distant.

This is the banal, historical context of capitalism as a techno-sublime

whose uncontrollability is seen in its conversion of the world into its own image—all the world available as long as one is sitting down; human movement minimized in the presence of its deferral into an electronic agility that short-circuits the social—and, importantly, its limitlessness. (In this sense, the historical context is found within a technological continuum, rather than vice versa.) Its uncontrollability is a recurrent theme here because it is always experienced from the vantage point of the experience of control. One turns the television on and off in order to have access at will to events over which one has no control. Quite a lot will be said here about how—in Schiller, Kant, etc.—the sublime finds its autonomy in its sense of itself as that which, because it can conceptualize the uncontrollability of nature, asserts its independence of it. The television pre-conceptualizes—literally preconceives, providing an image to which the real will retrospectively be seen (if seen at all off-screen) to aspire—the uncontrollability of techno-capitalism. I shall come to say that in such a situation it is not clear to me that the subject is best served by dwelling on an idea of its autonomy, perhaps because it has been driven into another relationship to what it thinks with by the technology of which television is a cornerstone or maybe core.

Turning from the (post?)sociological to the aesthetic, the Beavis and Butthead film is a vernacular cultural form made out of negative critique: "Doing" America suggests something other than "defending" it with nuclear weapons. Aggressivity is replaced by passive aggression, uniformed stupidity by uniform stupidity. But, as I said above, Beavis and Butthead represent a ubiquitous and deeply felt attitude to cultural production, which cuts across disciplines. Quite close to the site of the now defunct drive-in is Disneyland, paradigmatic expression of the exciting but harmless—despite being the realized dream of an anti-Semite inspired by a rat—and, therefore, containing nothing that could provoke critical sentiment or response. (Instead criticality slides off the rounded surfaces of everything it encounters, as ever inappropriate in the face of infantile pleasure when that is indeed the pleasure of children.) However, the Disney Corporation's headquarters building in Burbank—i.e., where the power resides—is a Michael Graves building whose façade resembles the Parthenon's but with the Seven Dwarves serving as caryatids, a gentler version of Beavis and Butt-head—postmodern architecture does Greece—in that it also produces meaning through negation. This is one level at which I want to talk, in what follows, about the limits of critique and, in doing so, to associate meaning-production through negation with the sublime. The proper idea is a critical idea. On the other side, if Beavis and Butthead negate a crude affirmation—and Graves one that was not crude but has been celebrated for its severity, hence its susceptibility to appropriation by the cute or infantile—a question remains as to what might negate or otherwise cut across the regime of the negative, which their negativity affirms, by offering a critique of critique that was itself not critical but nonetheless delimited or subverted or otherwise upset the critical. Apropos Nietzsche's

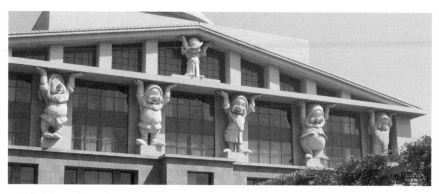

Michael Graves, Disney Corporate Headquarters, *Burbank, California, 1986. Photograph by Gabrielle Jennings.*

idea that philosophy should end in laughter, one may ask whether it is quite right that it should all be the same kind of laughter. I shall suggest that, whether rightly or not, meaning-production through negation finds itself frustrated—if not negated or critiqued—by what it can't enfold: another kind of laughter in which it finds not counterargument but irresistible indifference.

Michael Graves and Beavis and Butthead, whether with refinement or its opposite, demystify an idea of America that is ultimately an idea of or about Europe-America and the decline of the West's images of grandeur into signs of contradiction, and of its evolution into happy infantilism. La Jolla, California, just south of Orange County, has an art museum by Richard Venturi with dumpy little columns that perform the same symbolic democratization through regression performed by Graves's dwarves. What links all contemporary uses of demystification in the arts is the theme that the game is up. It is, though, an *ongoing* theme. Everything will survive as a critical image of itself. Like Helen of Troy, it will be as an image of itself that it will do most of its work. Except that, unlike Helen, it will be a critical image of itself, which is to say it will itself be critiqued by itself—laughter ultimately derived from a hermeneutically driven pathos, seeking its redemption in the cheerfully abject.

In its defense, one may (must) say of this demystification through (critical) laughter that it seems—and which also limits it—perfectly reasonable. To see it end in laughter is to be reminded that European philosophy, and retrospectively Europe as an idea of various sorts, began with people who held absurd ideas about intelligence in men and women inventing the syllogism while surrounded by slaves, this inherently implausible process continuing beyond the collapse of its initiators and their immediate successors through brutal Christianizations—Charlemagne and the Saxons setting the tone for the later version with a much bigger cast, the West versus the rest—performed in the name of the meek inheriting the earth while the kings got a civil service, along the way and in part therefore producing a new administering class that managed

to transpose religious fanaticism into nationalist fervor, and reaching a certain culmination in a colonial taxpayers' rebellion that invoked liberty and has turned into a state of permanent enslavement to the despotism of the market.

If the game is up, it is because the rest of the world got the joke, which it did as soon as it got over the shock of forced westernization. Forced to become Europe, it saw through it. Before that, the West must have seemed mysterious and inscrutable, a pink, seafaring swarm oddly preoccupied with mercantilism and monotheism: "But Christianity has never been an ideology; it's a very original, very specific organization of power that has assumed diverse forms since the Roman Empire and the Middle Ages, and which was able to invent the idea of international power. It's far more important than an ideology."[13] Capitalism is not an ideology in the same sense, and the ideologisms that supported the national state and dreams of strategic defense central to it become the objects of fun as they are exposed as secondary elements in a market economy that bank-rupts nations without the need for war or even hostility between political entities. Indeed, without the need for political entities at all—except to keep the deprived at bay, the idea of the polis preserved in the persistence of its original self-contradiction. In the sense that capitalism is not an ideology, the loss of empire is just as good a market opportunity as the possession of it—if one can turn it into a service of some kind. For example, let it be reborn as a joke about itself and people will line up to get in. I happen to think one could make the case that much of European philosophy saw the joke all along. But of Europe and what it became, the operative point is that its ending where it began is not apprehended as an ending at all but, rather, as a new beginning—resurrection and redemption through self-criticism being its nonideological theme—as a joke as much as in one.

I might even say a joke that produces an unconscious to which it has no clear relationship, but I am concerned here with what survives or persists despite this nonideological conversion without needing to be reborn, which is the beautiful: immune to self-criticism and, therefore, to redemption because it can only affirm itself. Its affirmativeness is what makes it so much fun without it having to make fun of anything else, but also what makes it immune to redemption through criticality. The Seven Dwarves simply replace the caryatids, while the Parthenon as such is symbolically brought down to earth. The beautiful has always been irredeemable. Detached from what it fascinates by what makes it fascinating, it persists in being resistant to (whatever) power which seeks to administer it, in terms that have remained essentially the same, if not from the start then from very early on. Schiller may claim that beauty falls short of the achievements of reason, but does not see that as a moral shortcoming. Plato did, disapproving of art because it is clever but not committed to the idea of the good, insisting that the pretty is in fact ugly in a politically correct sort of way that would not seem out of place in any contemporary art magazine: *I say the thing is*

ugly and shameful . . . because it shrewdly guesses at what is pleasant while omitting what is best."[14]

As Jacqueline Lichtenstein says of this passage and the argument of which it is a part: "An entire tradition—tenacious, iconoclastic, and mutable in its form though monotonous in its bias—takes this definition as the model for its moral and aesthetic puritanism and as the constant implicit reference in its attack, filled with hate, fear, and discomfiture, against the pleasures of appearance and the charms of the tangible realm."[15]

Helplessly Attractive

It is this longer view of the general situation that causes me to want to discuss beauty by first saying something about Helen of Troy. Lichtenstein's beautiful sentence demonstrating succinctly that beauty is that which the search for the good defined as intangible (but, we are supposed to believe, not just an image) cannot enfold—because it is a product of reason or, if not, can be reconciled with it without difficulty while beauty cannot—and therefore finds itself instead obliged to attack (for which there are also passive-aggressive equivalents).

It is because I want to maintain and explore a distinction between the beautiful and the good by discussing beauty in terms of attractiveness and glamour, that I want to say that beauty's model is the model, and the model's model Helen. Helen is germane to this discussion in several ways, beginning with the way she gets treated, and all coalescing around her relationship to roles she never requested in the first place.

At once a woman and the daughter of the chief god, she has little or nothing to do with the war that's fought over her, except that she is allegedly its cause. After the war, she's reconciled with Menelaus, but they have to live in seclusion because of all the bad feeling that's still around—irredeemable victim of her own attractiveness. Nor is that the end of it. One version of her demise has Menelaus killing her and then doing himself in, in final expiation for the shame she brought on him and his family. Another has him finally dropping dead of natural causes and her subsequently driven into exile and then hanged by his in-laws. Only when irreversibly *in*tangible is Helen finally given a break and allowed to live eternally on the island of Leuce with Achilles—who also has a reputation for being good-looking—rather than the boring Menelaus.

Helen exasperates. Her fate represents an attack on the senses by an idea to which they will not give way. I shall say later why beauty must be feminine (and the sublime androgynous), but here I am only concerned with what happens to it when it is. It is immediately given something to do for which it did not ask.

By Kant, for example: "[I]n forming an estimate . . . of animate objects of nature. . . Nature is no longer estimated as it appears like art, but rather in so far as it actually *is* art, though superhuman art; and the teleological judgment

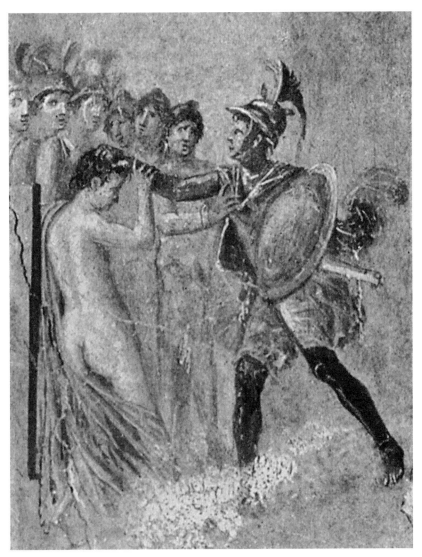

Helen is reunited with Menelaus *(detail)*. *Mural, House of Manander, Pompeii.*

serves as a basis and condition of the aesthetic, and one which the latter must regard. In such a case, where one says, for example, 'that is a beautiful woman' what one thinks is only this, that in her form nature excellently portrays the ends present in the female figure."[16] Adding ominously: "For one has to extend one's view beyond the mere form to a concept, to enable the object to be thought in such manner by means of an aesthetic judgment logically conditioned."[17]

Hubert Damisch quotes a section of this passage in his book *The Judgment of Paris*, noting that "In this instance, judgment is not exclusively a matter of taste but also doubles as a teleological judgment concerning her [i.e.,

Helen's] nature as a *thing* and not a simple object."[18] Kant has said that the beautiful stands apart from teleology, but not when it is a property of a woman.[19] Moreover, the basis of the teleology seems open to interpretation. In Norman Austin's *Helen of Troy and Her Shameless Phantom,* Sappho's Helen may well "excellently portray the ends present in the female figure" but not clearly in a way reconcilable with Kant's: "Helen appears in Sappho's 'Anaktoria' ode as Sappho's mythological *paradeigma,* the model she presents to support her argument that beauty is not an absolute value but a subjective judgment driven by desire."[20] Even more to the point: "Helen finds herself in Sappho's ode not because she was the paragon of beauty but because she was the most famous personage in myth who, in matters of the beautiful, exercised her individual judgment in complete disregard for the social consequences."[21] Philosophy wants to turn her into an idea, but Sappho sees her as resistance to ideas, which is to say, to reason.

Then there's the counter-version of the story, which Austin says was invented to spare Helen shame, in which she never went to Troy, but only as a spirit, the sign of the beautiful, gave the conflict volition and form.[22] Austin sees the Helen of Euripides' play about her to be a victim of this separation between herself and her image or spirit (*eidolon*), torn between her responsibilities as a person, where she feels guilt, and her responsibility as the daughter of one god and the protégée of another to behave like a god, which is to say, with indifference and irresponsibility.

It is as the irreducibly irresponsible that beauty resists or otherwise evades critique, because it is irreducible to it and may indeed precede it. The Trojan War follows from a contest in which Venus offers Helen as a bribe to Paris (who doesn't resist). Hubert Damisch has raised two questions about this, one easier to answer than the other. The question of why Paris needed to be bribed may be explained by the motive it provides for the war, which sets right not just the wrong represented by Helen's abduction, but a prior wrong in which a contest about beauty had been comprised by trickery. However, it is in any case not that, but the second question, which is of concern here. Why, Damisch asks, would the other two goddesses enter into a contest as to who was the most beautiful with the goddess of beauty herself?

It would seem to be a losing proposition, but Damisch hints that the judgment of Paris is a story about the precedence of Dionysianism over Apollonianism, about the body coming before the mind but having to be turned into an idea. For example, one in which cheating was acceptable if enlisted in a noble cause—the war, too, is won by deception: at the beginning, a corrupted judge; at the resolution, players who make the rules up as they go along. This suggests that Helen is linked to an Archaicism at odds with newer, more puritan, values, which must both lose its precedence and yet be maintained in some form compatible with the new order: "Hera, representing sovereignty, and Athena, representing military strength, join forces to combat the rich and voluptuous

Troy, which they accuse of having preferred, through the third person of Paris, the third function or party, that of riches and fecundity, represented by Aphrodite."[23] Having followed the model to India, Damisch concludes that "civilization or *Kultur* performed the important office of liberating beauty from its primordial tie to the reproductive function, resituating it on a more elevated level and eventually associating it with other, more cultivated ones—'sublimated' ones—in which the social dimension seems to have prevailed over the 'sexual root.'"[24] Sappho's Helen seems at odds with this ambition. She has survived it. As a mortal guarantee of victory in the contest, Helen also represents what will have to be displaced by war as the pursuit of justice, which is to say, by irreversible contestation in the service of an idea which has nothing to do with beauty—look at who the other two goddesses were. The war took place in order to make beauty irrelevant while blaming it for everything in sight. That done, the goddesses of war and justice could have a field day: Venus brings about her own defeat—i.e., the Apollonian succeeds Dionysianism—while remaining, of course, untouched by it thanks to the deferral of blame onto a human subject.

This is the sense in which the beautiful might seem to possess an economy of its own, as opposed to functioning as an ancillary component of a general economy. I shall say here that the sublime, in contrast to beauty, seems to have become a function of that general economy of signs out of which capitalism is made and which are made out of it, and that because of this, beauty has an ultimately adversarial relationship to it.

Both seek to exceed meaning, to overload it with some sort of presentation of meaning as more than itself, but where the beautiful is intransitive, and in that indifferent to negativity as an active force—indifferent, actually, to either activity or force, conceivably because it is what inspires them (Helen again, inactive catalyst for action)—the sublime must be transitive in some sense and is characteristically made out of reactivity of some kind. If in Kant the beautiful charms while the sublime moves—which to some might suggest that the one, at least in some circumstances, followed from the other—then it is also pertinent that he extended the concept "to include the feeling aroused by the failure of the imagination to comprehend the 'absolutely great,' whether in terms of measure (mathematical sublime) or might (dynamically sublime),"[25] underscoring, in his description of both its object and technique, the sublime's identification with reason and power. An identification that leads it to exceed reason while reaching toward that which eludes power. Beauty was never identified with reason, which it seems able to lead toward the unreasonable by something other than the power of rational persuasion—by something other than the official language of reason and power:

> Or consider Kant, so clear and persuasive on the main points; yet he has the
> weird idea that when I judge something beautiful, I am focusing not on the

thing but on what Kant sees as a command (something like the categorical imperative) that every human being must assent to my claim. Admittedly, it is true that if I think I am right, I will *expect* competent peers to concur in my judgement, but to *demand* that everyone agrees with me seems a most illiberal and anti-Enlightenment requirement. Here again, there may be a way of squaring Kant's doctrine with commitment to freedom of thought and expression, but what way has yet to be made out.[26]

Here, I am going to approach the question of what beauty might look like and do and where one might find a contemporary sublime by way of painting, photography, electronic technology, and the idea of the surface that connects them, through the fashion image as the currently authoritative version of beauty as frivolous (and from which it derives that authority). Insofar as this brings to mind Gadamer's book on the relevance of the beautiful, my position is that its relevance lies in its capacity to be irrelevant and yet remain indispensable.[27]

Indispensable, that is, to what would prefer to dispense with it but cannot—whether, as the following example shows, the institution in question be critical, capitalist, or communist—because of beauty's association with pleasure. In 1985 the Chinese government reluctantly agreed to allow the state swimming team to wear bikinis, a preposterous attempt to link the garment and its associations to asexual productivity but also just what capitalism does when it uses women in bikinis to sell cars.[28]

Likewise in critique the presumption seems to be that pleasure, being good, should be incorporated into something that is good for you. Stephen David Ross is well aware of the problem summed up by Lichtenstein and otherwise addressed by Gadamer but wants reconciliation, extrapolating from Kant that "Beauty is a symbol of a good beyond calculation, a good that interrupts the march of truth and the conflict of good and evil, a good whose memory makes it possible to pursue the good over evil, an exalted, sacred good."[29] But goodness which cuts across truth need not be beautiful, it seems to me, and the beautiful need not be it.[30] Helen's beauty doesn't offer goodness so much as pleasure, any goodness stuff being attributed to it without invitation. In her case, goodness only comes up as something she's made to care about, which is hardly to say it's a feature of her appearance. If, as Austin says, "Like the poles of a Heraclitean force field, in Greek thought the good and the beautiful were simultaneously in agreement and at war with each other,"[31] one begins to suspect that it was only as ideas that the first part was true. The most widely disseminated image of Helen's meeting with Menelaus after the war shows him grabbing her by the hair, a scene of violence by a man against a woman permissible because everyone knew that Cassandra would immediately step in before things went too far. This suggests compromise rather than agreement on irresponsibility as a virtue.

The Helen that survives as a body and an image in contemporary fashion is Sappho's embodiment of irresponsible indifference rather than Kant's symbol of ends proper to some reasonably deduced use for the feminine. It is a body that lives as an image and is derived from an image-world: "For Versace, the image, not the street, is the arbiter of fashion values, in its complex range of photography, video, runway shots, and advertising."[32] As an (or the) image of irresponsible attraction, the history of the female body in fashion since the mid-nineteenth century is directly comparable to that of the art object, with the difference that the one has led to a glorification of frivolity and the other to the institution of an inflexible seriousness. With the exception of the 1950s, which amounted to a wholesale return to the values of the late nineteenth century, fashion has proceeded smoothly from the Victorian presentation of the body through layering to one of presenting the body not so much through revealing as through intensifying it: certainly a general principle of display as uncovering has replaced one of covering as display. The crucial agent of acceleration was the First World War, during which women had to be permitted to wear shorter skirts, and which set in motion a process which resulted in thigh-length skirts for flappers barely twenty-five years after Queen Victoria's death. The passage is one from an image of the statuesque, stately if not static, to one of thin mobility.[33] During the same period, cosmetics have replaced the idea of layering as enhancement through obliteration—powder—with that of intensification as clarification.[34] As the powdered face gives way to the moisturized one, matte to gloss, a complexion obscured by white opacity to one enhanced by a flesh-colored glaze, the image of the feminine is increasingly (and nowadays conclusively) adjusted to the condition of color photography. Where once it could be analogized to painting, an art of layering, it now reaches out to the photograph, an object of minimal substantiality in which one cannot readily separate the surface from the support, and where the image is not apprehended as a construction but, rather, as one which comes into being all at once instead of being assembled stroke by stroke.

1. Friedrich von Schiller, "On the Sublime,"*Naive and Sentimental Poetry and On the Sublime*, trans., introduction, and notes Julias A. Elias (New York: Frederick Ungar Publishing Co., 1980), 198.

2. Ibid.

3. Jacques Derrida, *The Archeology of the Frivolous*, trans. and introduction John P. Leavey Jr. (Lincoln, NE: University of Nebraska Press, 1987), 118–119.

4. Immanuel Kant, *The Critique of Judgement*, trans. with analytical indexes James Creed Meredith (Oxford: Oxford University Press, 1952), 56.

5. Kant, op. cit., 76.

6. Felix Guattari, "Systems, Structures and Capitalistic Processes," *Soft Subversions*, ed. Sylvere Lotringer, trans. David L. Sweet and Chet Weiner (New York: Semiotext(e), 1996), 250.

7. Guattari, "Four Truths about Psychiatry," op. cit., 266.

8. Richard Martin, "Fashion and the Car in the 1950s," *Journal of American Culture* (Fall 1997, XX, 3), 56.

9. Ibid.

10. Martin, op. cit., 51.

11. Martin, op. cit., 56.

12. Press release for "Cruise Control," an exhibition at Cristinrose Gallery, New York (January 16–February 20, 1999).

13. Gilles Deleuze, in Felix Guattari, "Capitalism: A Very Special Delirium," *Chaosophy*, ed. Sylvere Lotringer, trans. David L. Sweet et. al. (New York: Semiotext(e), 1995), 57.

14. Jacqueline Lichtenstein, "Plato's Cosmetics," *Uncontrollable Beauty*, eds. Bill Beckley and David Shapiro (New York: Allworth Press, 1998), 86. The quote is from Plato's *Gorgias*, the italics added by Lichenstein.

15. Ibid.

16. Kant, op. cit., 173.

17. Ibid.

18. Hubert Damisch, *The Judgment of Paris*, trans. John Goodman (Chicago: University of Chicago Press, 1996), 57.

19. See also Stephen David Ross, *The Gift of Beauty* (Albany, N.Y.: SUNY Press, 1996), 144–145: "This is a point of supreme betrayal of the good in Kant . . . For we know that freedom, God, and immortality... belong to restricted economy only as wild intermediary movements of general economy. Kant releases freedom and the angels to fly to God, but God belongs to law. Intermediary movements are irresistible in Kant. Intermediary movements must be curbed if we are not to fall into the abyss." Ross's book is subtitled *The Good as Art*.

20. Norman Austin, *Helen of Troy and Her Shameless Phantom*, (Ithaca, N.Y.: Cornell University Press, 1994), 52.

21. Austin, op. cit., 57–58.

22. Most of Austin's book is taken up with the later version. See especially chapter 6, "Euripides' *Helen*, the Final Revision," op. cit., 137–203.

23. Damisch, op. cit., 118.

24. Damisch, op. cit., 123.

25. Howard Caygill, *A Kant Dictionary* (Oxford: Blackwell Publishers Ltd., 1995), 379.

26. Mary Mothersill, "Beauty," *A Companion to Aesthetics*, ed. David E. Cooper (Oxford: Basil Blackwell Ltd., 1992), 47.

27. Hans-Georg Gadamer, *The Relevance of the Beautiful and Other Essays*, ed. and introduction Robert Bernasconi, trans. Nicholas Walter (Cambridge: Cambridge University Press, 1986).

28. One more example of the perfect symmetry of right and left in regard to sex, pleasure, and power. See Jeremy Gilbert-Rolfe, "The Beach Party and the Parties of Power; Summer's Content, Winter's Discontent," *Beyond Piety: Critical Essays on the Visual Arts, 1986–1993* (New York: Cambridge University Press, 1995), 271–278.

29. Ross, op. cit., 13.

30. What Mother Theresa did was surely good, despite her work not actually being of any medical help to the afflicted whom she served, and regardless of whether there actually is a God, but to describe it as

beautiful is tortuously metaphorical—and would not be adequate to the enormity of the sacrifice involved, at least in my opinion.

31. Austin, op. cit., 62.

32. Richard Martin, "A Note: Gianni Versace's Little Black Dress," *Fashion Theory*, II, 1 (1998), 96.

33. This and the perfect symmetry of right and left on the topic first led me to write about beauty and its place in contemporary life. See Gilbert-Rolfe (with Stephanie Hermsdorf) "A Thigh-Length History of the Fashion Photograph—An Abbreviated Theory of the Body," op. cit., 255–270.

34. For some discussion of the semiotics of advertisements for contemporary cosmetics see also Gilbert-Rolfe, "Moist Attraction: Observations on an Advertisement Which Appeared in *Vogue* (U.S.), May 1992", op. cit., 293–301.

II.

The Attack:
Painting and the Invention of Photography (Forget Duchamp)

Photography has always held contradictory promises for painting: What some perceived as a technology that released painting from certain obligations so that it might do things it had not done before, was welcomed by others as a historical instrument which implied and would facilitate painting's demise—the sins of the older form disappearing along with its sociocultural indispensability like the personal debts of guillotined aristocrats. Art history shows both relationships to be flourishing: While some artists have seen photography as a weapon against painting, others have found it irresistibly attractive, although I think not fatally.

Deployed most often as a weapon in ideological discourse, the photographic finds release from its assigned role as footnote to historicist teleology in the fashion image, where photography's relationship to instrumentalism is modeled by the models it exhibits. Painting, the body, and a technology summ(on)ed up by the photographic, converge once one describes them as surfaces. I shall return to photography's attraction for painting after developing the idea of the attractive itself, as a secular version of the beautiful, through further discussion of beauty and the sublime themselves. While deferring my discussion of its attractiveness, however, I want to say something about the photographic as weapon now, because it is in the photographic that elements enter the discussion of the sublime which don't seem to have been there before, and these, derivatives of the technology that photography symptomizes, are first encountered as instruments of theoretical attack or displacement by technological alienation.

Continuous Surface

Beyond offering painting release from responsibility, technologically speaking—in the sense of technology as an extension of science and, as such, as producing a kind of measurable and verifiable knowledge—the invention of photography brought forth important clarifications of, and revelations about, vision, most especially for the impressionists and their followers. Frequently described as historically irrelevant for that reason, these had and have no direct relationship to the series of calls for the total abolition of painting as such, which have accompanied the history of photography.

Before the invention of photography it would have been no more imaginable to call for the abolition of painting *per se et in toto* than to seek to do away with writing. During the twentieth century, however, the call has gone out several times: from Duchamp, who advocated the abolition of the retinal in the interests of a very old-fashioned distinction between form and content; from Russia, on the grounds that easel painting and the concept of originality associ-

ated with it—which was not, interestingly, regarded as such an encumbrance when it came to, say, music and poetry—were hopelessly bourgeois; and from the pop and conceptualist (two sides of the same coin) artists of the more recent past in the name of both a Duchampian attack on the retinal and the grounds of the form's *embourgeoisement*. All these, of course, constituting highly original attacks on the notion of originality, and all arguments made possible by the existence of photography, which has been seen to call into question, especially by virtue of its identity as a machine, the undeniably humanist implications of painting's being handmade, regardless of whether the language that it seeks to make out of its mode of production be one that means to find within itself the terms of an (originally classical) order—discernable sense—or one that sees itself as the raw material for an (originally romantic) construction of a subject—discernable non-sense.

A couple of reservations about historicism might be introduced here. Given its influence in contemporary discourse, it seems worth noting that Walter Benjamin's essay about commercial lithography, *The Work of Art in the Age of Mechanical Reproduction*, seems, in its preoccupation with replication's capacity to undermine the status of the unique original, to miss the point of the photographic altogether.[1] In photography, as opposed to, for example, lithography, the original need not be unique to begin with. It is not in its similarity to printing that the reproduced image may call into question the value or other qualities attributed to an image by virtue of its originality, it's in photography's origin in replication and reproducibility. It's not that the image can be infinitely reproduced (which in practice it can't), it's that anyone can take the same picture: Given the same sunlight, infinite numbers of tourists can take the same photograph of the same monument. This is, rather than the death of the author, the infinite replication of the author function. Like Heidegger, Benjamin seems always to postulate the technologies of late capitalism as extensions of earlier ones rather than as decisive breaks with them, so that Paris becomes the capital of the nineteenth century by never quite entering the twentieth.

The second reservation would also have to do with Benjamin's possibly unintended influence. William Arctanger O'Brian has said (regarding Novalis) that:

> Since Walter Benjamin's 1920 dissertation, "The Concept of Art Criticism among the German Romantics" (*Der Bergriff der Kunstkritik in der deutschen Romantik*), it has been an interpretive commonplace to see German Romanticism as having received its theoretical impetus from early philosophical Idealism. Unfortunately, Benjamin's inheritors have too often framed their analyses of Kant and Fische's importance to Romanticism in terms of influence, and have generally overlooked the extent to which Romanticism problematizes Idealism—most specifically, its representational understanding of language and

its unswerving belief in the Subject. Romanticism . . . not only set philosophical idealism into prose and verse; it also criticized, and, in crucial respects, rejected Idealism.[2]

Similar reservations might be made about the discourses surrounding the relationship between painting, which seeks to make itself out of discernable non-sense and the ideational structures to which its adversaries might seek to reduce it. It could be that painting has been dismissed for its responsibility to ideas to which it has only ever been irresponsible. Unlike Helen, there is no reason to suppose that painting is immortal, and if it has survived the attacks launched against it, then it hasn't survived them unscathed but has instead changed—although not only in self-defense. However, its survival has, in practice, been guaranteed by its being guilty of the charges leveled against it, since these demonstrate what is peculiarly useful about it as a specific type or form of cultural production.

For example, painting may indeed be quintessentially retinal, in that it may succeed in being a visual art only to the extent that it is. From such a point of view one may say that when it's not retinal it's not painting, except that it uses the latter's materials and conventions to some discernable end in which they themselves may or may not be critically implicated. Since it's hard to think of anything else that could be said to be, or to be apprehended as an aspiration to an idea of, purely retinal (which is not to say that painting ever is), Duchamp's dismissal of painting seems instead to make a case for it. Ornament and decoration could never be purely retinal, having as they do to go immediately to some principle of reassurance, i.e., some idea, the opposite of the retinal by Duchamp's own account. Only art could possibly do it, and why would one not want the purely retinal if one could have it? What possible reason could there be for denying oneself this opportunity or resource? The answer is that it is a distraction from something else, which is thought to be better for us, more teleologically responsible, as it were. Painting is dogged by the same arguments that surround beauty, and I shall return to them.

Another exhibit in the case made for painting by its detractors is one made not by Duchamp himself so much as by an argument into which his and Benjamin's and, latterly, Foucault's have retroactively been enlisted, which is that painting may be seen to be irrevocably bourgeois insofar as its own history is entangled in the history of that class. So too, however, is the history of all the other arts as well. One of the things we like about them is that they tell us about the bourgeois subject, i.e., ourselves. The problem with painting goes beyond that, however, and is found in the idea of possession it enshrines by not being a public art, not in the sense that one looks at paintings individually (one listens to music in solitude too, even when in a crowd) but in that only one person can own one at a time. This guarantees painting's survival as long as the bourgeois survive;

they like to own things that are unique or, as an idiom which takes on a meaning other than its traditional one in the contemporary context has it, one of a kind. But all visual art insists on this condition, especially photography, which restricts itself to limited editions in order to protect itself. Even here, then, at the level of market dissemination, painting as the bourgeois cultural object epitomized provides a model of engagement with bourgeois consciousness that persists in providing a touchstone or point of reference to all the practices which are not painting, which are, as it happens, largely defined by and as what they are not (and in being thus are themselves bourgeois, and perhaps, in their negativity and reactivism, more obviously so than painting).

Painting's ability to survive and persist, encumbered by history but not in that necessarily defined by historicist argument, detraction, and even repression, does seem to me to be a function of its redundancy, of all that its abolition by photography left it free to do: to realize, for example, the promise of its modern origins in impressionism, which sought to realize the possibility of a world seen without first being drawn.

Norman Bryson has shown how, in the history of painting, presenting the body in a way that could enable it to signify erotically (where the erotics were not sadistic) required that it not be trapped in perspective, i.e., in drawing:

> Imagine a body, of whatever desirability, located in the tangibility and recession of perspective, with perspective lines running through flooring, windows, tables, chairs, anchoring the body in its own space outside the picture-plane; however erotic, the anchoring functions as erotic obstacle, for the image cannot easily be dislodged from its surrounding world and accepted by the viewer as though made solely for his possession. Such a body is engaged, busy, unavailable. Spatial dislocation in Boucher is the exact mark of sexual availability and in suppressing coherent space through the use of amorphous substances—cloud, water, tinted steam—which cannot be precisely located in space, the body is presented in the minimal form that the erotic gaze most desires: as, simply, posture.[3]

In potentially liberating or distancing painting from drawing—in denying drawing its traditional priority—impressionism proposed a purely retinal painting (the profound radicalism of which was precisely what Duchamp failed to understand) in which the world could be imagined in the same way that it's seen, as arriving all at once, before it's organized (schematized or drawn) rather than afterwards; that is, signification would now be a question of what happened before or without, rather than after, drawing.

Painting, whether Malevich's or Matisse's, Newman's or Pollock's, has continued to make it its business to present what has not been seen, rather than what hasn't been thought, as a visual event. Insofar as it has been programmatic,

it's always had a program that exceeds itself. Impressionism, which Newman identified as the first movement committed to the idea of nonoriginality—the impressionists' anonymous dab as opposed to the romantics' autographically gestural brushstroke—culminated in surplus subdivision (pointillism, the form as the infinite subdivision of its surface into constituent colors rather than parts) or impossible supplementation (Cézanne's doomed attempt to reconcile impressionism's subversion of the classical priority of drawing over color with exactly that which it sought to subvert—a truly mad and final ambition, Heideggerian in its scope, precision, and unrealizability, as Merleau-Ponty showed).

The denial of the priority of drawing was a denial of the priority of form, Cézanne a master because he was a master of self-contradiction. Duchamp failed to understand that an art of presentation would necessarily eschew representation, would be involved instead in something other than anchoring the image in a conception of form—meaning—that preceded it (in contemporary terms, Duchamp was metaphysical where impressionism was not), but right to see that what he called the retinal was threatening to him because it was thought detached from that responsibility which comes with drawing, the "graphic," a word that brings drawing and writing together, signaling that they're both inscriptions which describe and propose, both bound to the discursive. So that when, in English at least, one talks about a "graphic description," one means one that is descriptively excessive, so laden with detail and substance and sharply inscribed as to be more real than the real—or at least *as* real as the real, if we grant that nowadays nothing has fully entered the real until it's been described and inscribed, its own corporeality in actuality a protoreal awaiting fulfillment in mediation. (The real's realization fulfilled in its significance, i.e., its status as a sign.)

Photography, considered as the industrial realization of the possibilities of drawing, was from the start the culmination of the history of art as the history of the visually legible. What this means is, in practice, not that there's no need for painting after photography, but that there's no need for drawing. It ends painting as a dualism, or, rather, since that cannot be realized—all that is finite has been drawn, every painting has a stretcher or the absence of one—it reverses the traditional relationship of drawing to color in painting. Where color once added charm to drawing (as both Kant and Poussin say), drawing now supplements the colored surface. The history of the visually present but not necessarily legible can now begin. It was of course there all along, but knowing no development, has no history.

In this reversal, one sees something else. It is not photography's final realization of the demands of the graphic that makes it attractive to painting; it is its surface. Out of photography as the graphic there emerges, I think, a contemporary sublime made out of photography's intractable scrutiny, its foundation in empirical reason and its realization in and as technology; but on its surface, in

the photograph as light or lightness, the photo rather than the graph, one finds a question about beauty.

That is a question about beauty's completeness, and the attraction that photography holds for painting, and I shall expand upon it in the chapters that follow and with a special emphasis in chapter 4. First though, having now introduced still photography and its place in this discussion, I must make some introductory remarks about two other material constituents of contemporary life on which this idea of completeness and my overall argument depend: video (photography as electronic movement) and plastic.

Electric Dematerialization

Martin Heidegger, who has been mentioned twice already, hated technology, which he identified with America and with converting the world into a picture of itself and, in doing so, leading thinking astray, because:

> "We get the picture" concerning something does not mean only that what is . . . is represented to us, in general, but that what is stands before us—in all that belongs to it and all that stands together in it—as a system . . . Hence world picture . . . does not mean a picture of the world but the world conceived and grasped as a picture. What is, in its entirety, is now taken in such a way that it first is in being and only is in being to the extent that it is set up by man, who represents and sets forth.[4]

Heidegger's postwar writing on the subject has set the terms for a great deal of subsequent discussion of technology and cultural life because his prognosis that a technological image of the world would come to conceal the world from itself seems to me to have become true. But it is not clear to me that this is a bad thing, as he thought it must be. It could just be a change, bound up in a joke about the idea of authenticity and origin so central to his thinking. Heidegger liked to recall the pre-Socratics—although he didn't like to call them that[5]—who theorized atoms but accepted that the world was given rather than insisting upon a first cause, and who, although less interested in origin than subsequent thinkers, were nonetheless—or consequentially—for him the originators of philosophy, which is to say, of discursiveness and the power of the word:

> To go by the poetic experience and the most ancient tradition of thinking, the word gives Being. Our thinking, then, would have to seek the word, the giver which itself is never given, in this "there is that which gives" . . .
> . . . The whole spook about the "givenness" of things, which many people justly fear, is blown away. But what is memorable remains, indeed it only now comes to radiant light.[6]

My use of Heidegger here follows from his insistence on the priority of the word, of hermeneutics, which leads him to the observation which is the source of his influence—that to explain technology one must look outside its own terms. However, I am interested in the contemporary as that which escapes the word in several senses, of which one has to do with that which did not originate in the word, another with that in which the word is used by technology. For all his talk about nature, by the time he comes to talk about the threat of technology as Americanism, i.e., as capitalism, Heidegger is situated entirely within the technology of writing, where, at his hands, the eighteenth-century subject has now become a hermeneutic self, seeing the world only as message. He got technology right because he saw it exactly as a threat to the supremacy of writing as a technology, which is to say, to the model of thinking which writing proposes.

Intuition is unfashionable at the moment but it seems relevant here. Kant altered the role of intuition by giving it a priority that made it at once judgmental and at the same time the condition for a further judgment. Where Descartes, Locke, and Leibniz had shuffled it around in various ways that permitted it to be the link between sense impressions and reason, Kant made intuition occur coincidentally with—or both before and after—sense impressions, so that one's impression of the world was also an intuition of a degree of pleasure or pain, a judgment about whether one liked it. From there, thinking could become a judgment of one's judgment which reexamined the intuition discursively, confirming it or modifying it as the case may be. No one, I think, has any doubt that it's through such a process that paintings get made—of course that itself has been used to argue that paintings should in fact no longer be made at all—but it raises a question about artificial intelligence: a spooky equivalent for being, given by technology and composed entirely of a memory in which no item is more memorable than another, its opening to the world a glowing screen.

Presumably, artificial intelligence is pure in its intellectuality in that it needs no sense of pleasure or pain to guide it, originating as it does in being written. This would mean that when it responds, it responds instantaneously to sense data, which are for it already and exclusively discursive. It is in this light that, in the following paragraphs, I want to introduce some relationships which might be seen between painting and the products of that history of technology which has the possibility of an artificial intelligence as its implicit goal, and with which the photographic image is closely associated.

I am interested in how things look and what that implies. It seems clear to me that where painting has in the past been comparable to other media and objects, its relationship to the video screen alters the terms of such a comparison. In that this is a question of intensity as a characteristic of phenomena, it demonstrates how Heidegger's nightmare has come true in terms that are quite consistent with his own. The video image is one of intensification—it makes the world more than it is, more colorful, more defined—which at the same time robs things

Gabrielle Jennings, Video Still, To Whom It May Concern. *©1994 Gabrielle Jennings. Courtesy of the artist.*

of their substance. Heidegger, I think it safe to say, would not have liked it very much for that reason.

Heidegger talks about strawberries growing on a hill in the passage from which the above quote is extracted—wild ones, presumably, as opposed to the kind that grow in greenhouses or at least with plenty of straw and attention to keep the frost off—but I prefer to recall raspberries, which also grow wild on hillsides, because their form contains the principle of liquidity.

Compare that to a cabbage's. A cabbage can be deep green and is itself fleshy, substantial, replete with structure as form, delicate at its extremities and firm at its core. A raspberry, on a gray day—on a hill, say—is a very intense spot of color. As a thing, it's very fragile, light—its taste is as intense as its color.

A painting could, in Heidegger's terms, treat either object as an essay in substance as essence, where the recognition of the one initiated a return to the other. It would be in the substantiality of painting that the essence of the object would be reconvened as manipulated substance. It seems to me that this would not be true of the video image. The screen is a hard plastic surface with no discernable part to play in one's relationship to the ephemeral image it contains, substance subsumed into transmission. Video's surface, made of plastic illuminated and animated by electricity, provides no way through which the image may return to the world, and it is because of this, the sense in which video is

everything painting is not, that it holds such a fascination for it. In substituting transmission for substance, video announces, or institutes, its identity as an other, as belonging to a world of meaning (communicated intent) whose terms derive from elsewhere, and lead elsewhere. What it offers painting is another surface to which to refer: in this case, one that is brighter than any that preceded it, unimaginably thin—describable only as an exterior when viewed as an object, a surface without depth—and continuous by definition. It is everything that painting is not: an uninterrupted surface born of pure reason. An irradiating plastic light, spooky in its continuity and speed, given by and embodying technology. What (provided one isn't Heidegger) could be more seductive?

This is the sense in which I want to think of the history of technology as the history of surfaces and colors—and of the bodies which they demand, but I shall deal with those later. The surfaces and colors to which video appeals, and the material in which it lives, are plastic.

One may compare plastic, the culminatory techno-surface, to skin, in that both are continuous, which is to say that objects made out of plastic simulate the condition of the body in its original, pretechnological, condition. There had been a plastic surface before, the surface of painting, but that had been a plasticity made out of openings, interruption, and conjuncture. A plasticity of morselation, made out of adding up and layering and even reconsidering. Plastic's most obvious point of comparison to painting is its status as the first continuous surface which, in not being an accumulation or combination—not built or woven or otherwise assembled—is a thing, rather than an image, with the properties of the photograph. In fact, the latter's history is linked to plastic's. As is (I think) well known, the development of widely marketable film required a flexible support for the image, which was first made out of a natural silicate found in Central America but became economically viable on a mass scale only when an alternative, synthetic, early plastic "silicate" could be produced. Photography as we have it was made possible by chemists finding a plastic that can synthesize a skin originally available only in an organic, natural, form. One may add to that the evenness and clarity of plastic, also properties generally found desirable in flesh. These are the material conditions of plastic that make possible the brightness associated above with video.

If contemporary technology implies extension toward the retrospectively implicit goal of achieving a condition in which it can do without the human, as I shall suggest it does, then it is in the light of that ambition that it may be seen to constantly invent artificial surfaces and bodies that, like the artificial intelligences it produces, first appear as simulations of those that already exist.

Plastic began by simulating wood—early Bakelite, the dashboards of cars in the forties and fifties—but soon took over the world with its own colors, the pastel shades of the sixties, the lipstick and shoe colors of the more recent past. Barthes, writing before color video or intense plastic colors, saw that plastic

would achieve that takeover by being "wholly swallowed up in the fact of being used; a single one replaces them all: the whole world *can* be plasticized, and even life itself since, we are told, they are beginning to make plastic aortas."[7] Barthes saw the beginning of the present. The whole world has now been plasticized.

This changes the way one sees it. I'd offer, by way of setting the scene, the Kent and East Sussex Railway in southeast England as an anecdotal example of the way plastic and the computer recontextualize everything that preceded them. Built at the turn of the century by a former colonel of engineers who was the son of an art critic, the Kent and East Sussex Railway was a folly from the start. Running between two small towns, Paddock Wood and Robertsbridge, it was supposed to provide transportation for agricultural products and hop pickers—an annual migration of casual labor from London—so it was a folly that originally came complete with peasants. It was a failure from the start because of being undercapitalized, and perhaps undermined by the fact that the two main lines that it linked had and still have a perfectly satisfactory junction at the nearby town of Tonbridge. Now, lovingly restored, the bit of it that's left blends into a picturesque nature exactly as Schiller describes Gothic ruins blending in with nature as they lose contact with history. The ruin, having become discontinuous with daily life, becomes timeless. In this case, it's a working ruin that does work as decoration. The Kent and East Sussex Railway creates a scene that has no contact with the post-human, memorializing instead a world when technology was still only adjacent to nature. From inside an automobile one looks out from the techno-sublimity of plastic and the electronic toward a sublimity now forever framed, and in that desublimated, I suppose, toward a recalled world in which the industrial was still a visible process. Where a train is a series of delayed responses, processes set in motion and then consummated, inside a car things are instantaneous. Sitting in a car one can only be struck by the extent to which the preelectric may exist within the electric as its antecedent, but the relationship is irreversible: There's no way back to the one through the other. The car itself is linked to the train, of course, by their mutual production of carbon monoxide—one of the histories of technology is the history of poison.

(Close by one might find Heidegger's nightmare as a rural scene: A farmer has a plastic heart, his sheep are cloned, his wife just returned from plastic surgery and liposuction; they will watch the operations on video together, electronically and effortlessly displacing themselves in time and space so that he may share her retransformation as object and subject.)

Plastic objects generally have to be shiny, hence shoes and lip gloss as referents: Think about what picking up a shiny black telephone and speaking into it most obviously resembles. Indeed, Gabrielle Jennings tells me that the 1960s television show *Get Smart* featured a telephone shaped like a shoe. The length of one's head and that of one's foot are the same; one's hand is as long as one's face; telephones are, like shoes, detachable adjuncts—i.e., telephones are

Fandra Chang, Untitled (Square Canvas) *(detail), 1996. Ink on canvas, anodized aluminum and plastic.*
Collection: Michael Healy, California. Courtesy of the artist.

Claude Monet, Rouen Cathedral; The Portal, *1894.*

colored like shoes not like hands or faces or feet. Plastic, unlike oil paint, comes in two conditions: things which are touched and held, like telephones and keyboards, and that which—like paintings—exists only to be seen, the screen. In this sense video is continuous with a world of objects, as paint is not. It is bright like a light because it is a light, and it's plastic like nearly everything else in sight.

The arrival of plastic's own brightness was slightly ahead of that of color video—also pastel during the sixties, now similarly capable of greater intensity. Both replace the brightness of the world with a greater brightness, and in both cases this is a brightness that is primarily understood as technological. That is to say, while admiring the way in which a medieval (European or Islamic) miniature also replaces the world with a greater brightness may begin with an appreciation of the qualities of gouache and colored ink, it is likely to lead to a theological-philosophical appreciation of what that greater brightness is (supposed to be) about, whereas plastic or video propose themselves as conditions in which the technological level is not transcended, leads nowhere, but is already theological-philosophical.

Moreover, rather than propose another condition, it subsumes within itself those with which it might be compared. Where in a medieval illumination figures might be larger or smaller in accordance with their possession of divine grace, and brighter than those in the real world by virtue of the elimination of shadows in the interest of a theologically derived requirement for completeness, the color of the telephone is familiar but only from within the world of plastic, while the video image replaces its referent by being more like it than the thing itself. If one may say that no one looks as good in real life as she does on the screen, then one may at the same time note that in the Middle Ages a comparable sentiment could have meant something quite different. What's more, while they may be compared with others, plastic objects are, as often as not, things that didn't exist before plastic itself, like telephones or computers or electric coffee grinders. As objects, their pre-plastic history is antecedent, lost in that of the objects they replaced: the note delivered by a servant who would wait for a reply (or the cryptic and ambiguous telegram); the elaborate Victorian contraption using punched cards; the simple mechanical device fetishized by Duchamp, artist of symbolist nostalgia.

John Gage has pointed out that nineteenth-century naturalism, emerging out of that of the preceding half-century, amounted to a significant change in painting in that it required that the identifiable properties of the medium and facture be repressed in the pursuit of a reconvention of the experience of nature.[8] It was now important that paint seem to take on the characteristics of what it represented in a way, or with a thoroughness, that it previously hadn't, and this representation was to be founded not—as was, for example, the desire for mimesis of earlier painters in Venice or Holland—in convincingly representing materials (lace or flesh or silk or fur) but atmospheres, climactic conditions, states

of vibrancy or decay. The modern call for a "truth to materials," then, is reactive. Before naturalism, there never was an artificiality so great as to replace the truth of the material. Gage describes the history of color usage in the West and begins with theories that relate the palette to the colors iron turns when it's heated up, so that black is at one end and white at the other with red in the middle and with attitudes to color's application that forbade mixing colors and, instead, relied on cross-hatching, so that mixed colors were seen as combinations of essences rather than as degradations of essence (called in philosophy, as once were all combinations and derivatives of essences, "accidents"). Theological-philosophical from the start, such approaches never knew anything but a preoccupation with the truth of materials. Just before the arrival of naturalism—roughly contemporaneous, as we now realize, with the beginning of nature's disappearance into its own preservation, whereby it would be saved from extinction by becoming a cultural appendage, surviving as a park maintained by the state or, should it be veldt or jungle, by tourism or the Body Shop—there was a fashion for paintings with cracked varnish called "crackle." Again, the possibility of at least playing with a kind of truth, the look of the historical, the poetics, as it were, of an image historicized in its content and also its constitution (of a past activated by and preserved in an image which contains an idea of its pastness). What was played with, for the last time for a while, was the truth of materials. When it reemerged it would be a secular and dehistoricized truth, the thick light of impressionism.

Because if Gage is right about naturalism requiring that the medium disappear in favor of what it depicts, one may say that John Constable and others ushered in a change in the notion of the world and what mediates it. My concern here is with seeing naturalism as the origin of the antecedents of color video, which I'll propose as the light of a plastic world.

The antecedents I have in mind are impressionist painting and color photography, and in that both seem to frustrate the kind of reading that Heidegger performs in *The Origin of the Work of Art*, they may be seen as intermediate stages between naturalism's identification of its medium with sensation in the presence of nature and video's electronic intensification of data as sensation.

Taking a Greek temple as an example, Heidegger draws conclusions from the fact that it is made out of the rock on which it stands. The temple itself is at once Temple and substance, World and Earth, the transformational passage between the two, the capacity of the one to maintain that of which it is a transformation, is what Heidegger thinks one's looking at.[9] To experience the work is to experience the gap between the two as the realization of the essence of the one by the other, where the act of realizing is also what keeps them apart. Certainly one could look at many paintings in such a way. Medieval miniatures come to mind once again, made as these were out of art materials whose origins were known and recognizable while directed toward an essentialism. Or Vermeer, constantly adjusting painting technique to the material to be represented, so that

the painting is an elaborate identification of perception with method—the thingness of the thing, particularly when considered as a surface, calling forth a particular deployment of paint.[10]

But that's not, one gathers, how one is meant to look at John Constable, and it seems impossible to do with impressionism in the sense that the materials the impressionists worked with have an origin deep within the bowels not only of the earth but of technology. Earth colors, the colors of crushed sea animals, and the metallic colors that are the basis of painting's brilliance, were supplemented for the impressionists by industrial colors of no recognizable origin in either the natural world or the Iron Age (an age which, in its simplicity, might have been technologically acceptable to Heidegger). The impressionists, doctrinally committed to reconstituting the brightness of daylight, were obliged to the inventiveness of the German petrochemical industry, which gave them alizarin crimson, viridian, and other colors necessary to the task of simulating the natural that are in themselves unnatural in every obvious sense except that they do indeed exist in nature. Or do they? Consider this: One painter paints a red butterfly in the eighteenth century; a second paints another at the end of the nineteenth. A connoisseur, Heideggerian in bent, looks at both. In the one, the colors mixed to make the butterfly's red lead off toward minerals manipulated by elementary physics and crushed shellfish, in the other toward the Ruhr and industrial chemistry. In the latter case, the butterfly's red is no longer seen by a perception developed in response to simple technology but to a more complex one in which material origin is, as a matter of course, inconceivable except as a formula facilitated by a machine. The origins of perception are less clearly in the earth as a visible earth, perception as recognition (as Heidegger wants it to be) has nothing to recognize. In these terms it can only recognize—Heidegger's nightmare—an ungrounded ground, colors that are truthful but have no re-cognizable origin as matter. One could relate this to Galileo having to prove Aristotle wrong. Aristotle insists that what is visible to the naked eye is superior as information to that gained through the use of an instrument; Galileo had to prove that the telescope was right and the eye wrong, that the moon may look smooth but, in fact, is cratered. Impressionism is the art of a culture that's long since conceded that a truth comes from the instrument that need no longer be confirmed by the senses themselves. The material origin of color as paint played no part in the choices an impressionist painter made, the passage from what a color is as a part of the world to what it can do in approximating a perceptual condition was complete.

There is a further sense in which I want to propose impressionism as an antecedent for video color that underscores this. Patti Podesta has pointed out to me that one can't have muddy color in video. There's no black in impressionism and no mud in video. Where everyone from Plato to Goethe had wanted to see color as an accidental consequence of black and white, the impressionists sought

the reverse. The shoes of which Heidegger makes so much (who cares whose they were, obviously he's right) would never have been returned to the blackness of the signified if they'd been painted by Monet rather than van Gogh—there's a lot of other things they wouldn't have been either—but would instead have found themselves deoriginated in the light which fell upon them, in all that they were not: white, infinitely subdivided. By the same token, from wherever video looks at the world and the earth it has largely replaced, it finds an origin for the image in a schematized division of white light. Like the colors of medieval painting, video has no need of the impure. Unlike medieval painting, and because of its foundation in a naturalist aesthetic, video has plenty of pictures of mud and the muddy: Like impressionism, it presents that which cannot be found in its own constituents.

I offer the following precession, which depends for its formulation on Gage's account of naturalism as the tendency that precluded truth to materials. One could do it either with Heidegger's temple or with the painting he makes up out of several van Goghs that he seems to have confused with one another. The precession is from a grounded sign, a sign concerned to recall its origin and to signify through that recollection, to a sign grounded in its own ungroundedness: from Heidegger's work of art, through impressionism, and thence to video color.

Consider three things: Heidegger's temple, Monet's paintings of Rouen Cathedral, any video image of an old building made out of stone. The temple is made out of the materials on which it stands, enabling it to be both stone and an image made out of stone which partakes of the—pretechnological but containing the essence of the threat of technology, one would have thought—properties of stone. The Monet, on the other hand, is a thick painting in which the air, the sky above, and the atmosphere all around, robs the stone facade of its preeminent materiality: It is no more or less substantial than all that it is not, including emptiness and insubstantiality itself. And the video image? It has no weight at all. The building and the screen are joined by light. Neither is present to the other through thickness of any kind, but are rather continuous with one another through a light that shines from within. Video realizes the ambition of impressionism in that it replaces substance with light in a way unavailable to painting. Not only can it not be muddy, it's also not a kind of mud. It does not share a ground, cannot return to it, with its referent. It has, perhaps one could say, no recognizable relationship to the essences it seeks to recall. Neither as a material object that signifies, in its own materiality, a continuity with that to which it refers—unlike the temple, and also unlike Monet, where painting dematerializes the cathedral through an emphatic materiality of its own—nor through visible transformation, which is to say, through duration made visible. The Heideggerian nightmare is twofold here. All things have become equally insubstantial, mediated by a medium that has no correlation with things as substances—it is not stone transformed; it is not a process in the sense that painting is visibly that, a

passage with an end which has concealed but reflects its beginning—and it is also instantaneous and automatic. It is materially discontinuous, as a fabricated object or sign, with the world whose image it presents (or produces), and it makes time invisible. Things cannot exist without time, but in video—unlike temple construction or impressionist painting—time is photographic: technological time, duration conceived as an instant duration, therefore, as invisible to the naked eye as is the origin of alizarin crimson.

Color photography, unlike paintings and temples, is seamless like the body and the plastic object and a consequence of the same industrial technology that gave the impressionists alizarin, and, like vision—or the mind's idea of vision—present all at once to the camera as an impression and emerging all at once, as a simultaneity rather than an accumulation, in the developing fluid. The video image takes the photographic to a logical conclusion, adding movement, which once again reads as though it were seamless because video runs at thirty frames per second ("real-time," but one wonders when this reality became the real) as opposed to film's twenty-four. The color photograph has an emulsified surface so thin you can't see it as a thing, and a paper support inseparable from it. Video has no surface except its support, electricity within a plastic surface. Painting's fascination with photography has always taken two directions: toward the photographic's capacity for clarity and toward its ability to record the opposite—dispersal, vaporousness, atmosphere. Uta Barth's photographs suggest painting in the sense that they could remind one of Gerhard Richter's fuzzy photo paintings, which is to say, of paintings of photographs. In this, they demonstrate that the nagging challenge that photography offers painting is not about verisimilitude but, rather, continuity. What does a Richter do? Of course it does a lot of other things too (three of which I shall discuss in chapter 4), but it also reminds one of the impossibility of simultaneity in painting, particularly when it addresses the instantaneous. The heterogeneity of painting's surface forecloses its access to the continuum of the instant, which comes naturally to the homogenous surface of the photograph—a surface, moreover, which is unlike painting in that, as Barth's photographs show, for one part to be in focus is for another to not be. Nothing of the sort is true for painting, whose heterogeneity guarantees that it will be a mass of foci all uncomfortably related to each other. One further point about photography: In suggesting that the contemporary object aspires to the condition of plastic even when it is of necessity made of something else, I'd also suggest that normative color is nowadays photographic color and that nowhere is this more true than in the area of tonality (colorlessness). The gray test card, the pure condition of color photography, surely provides a zero condition for color comparable to the zero condition for the object offered by plastic's extruded or molded continuity.

The point I want to make here is that for photo gray to have achieved that status, photography would have had to displace painting as a normative

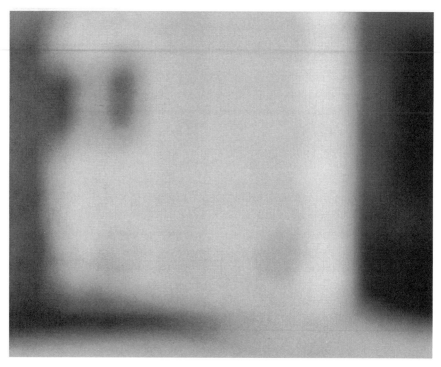

Uta Barth, Field 2, 1995. *Color photos on panel, 23 × 28.75". Courtesy of the artist.*

referent, and has. It is photo gray that we recognize rather than (in painting there's always a choice of two; it's binary, like the computer) Davy's Grey or Payne's Grey.[11] Likewise, I suggest, with color itself. It is also relevant here that the equivalent in video is "white balance." Which is to say, oxymoronically, balance found elsewhere than at the midpoint between light and dark. Drawing is about gray, grisaille the basis of academic painting, which is to say painting founded in drawing with color as a local addition; video, like impressionism, is founded in white.

Painting, I should say especially nonrepresentational painting, can nowadays only refer to the colors of plastic/color photography/video (all the same thing), either affirmatively or by ignoring them: Their presence is implicit. Having replaced the colors of nature, they are the naturalized intensities that now constitute the colors of everyday life: what one sees in the shops, as often as not the colors of the shop itself, the basis of the colors that are used in cosmetics, the colors of the video screen. This question returns one to the liquidity of raspberries, while also suggesting that from a certain point of view Heidegger's nightmare may be Deleuze's quite nice day.

Deleuze, as have others, sees naturalism as leading toward liquidity. Here is a sentence from *Cinema 1:*

Indeed, already in Maupassant, naturalism is nothing but a façade: things are seen as if through a window-pane or on the stage of a theatre, preventing duration from forming a coarse substance in the process of degradation; and when the pane thaws, it gives way to running water, which cannot be further reconciled with originary worlds, their impulses, their fragments and their outlines.[12]

Like raspberries, paintings are things. They may or may not be images in the sense of having a referent—a landscape or a fuzzy interior—but, as things that are meant to be seen, they function *as* images. It's in these terms that I want to compare a work by Fandra Chang, a painting that is not exactly a painting, to the surface of video. I shall, similarly, come to say later on that one cannot properly discuss the large paintings of Pollock and Newman without reference to the space of cinema—of, actually, Cinemascope. Hard, continuous, and brighter than daylight, the surface of video converges with painting's in Chang's work and becomes a referent or even an origin for it, in that deoriginating or re-territorializing it.

I think that what Chang presents is disembodiment as a process that intensifies what was never embodied. The work involves multiplication through the recombination of derivatives, that, in being combined, deoriginate that from which they derive. What leads one to video here, however, is an idea less of flow than of intensities, which is to say of transmission rather than embodiment. If the model for pictorial order was once the abstract idea of quantitative expressions of the possession of grace, and subsequently that of a mind that converted sense data into reason (the Enlightenment mind preserved in the possibility of artificial intelligence), and after that to a sensibility that knew itself through reconsideration (addition, and erasure as addition), then that to which Chang's pictorial order appeals would have to be the video screen: once again as an equivalent rather than a negation, and once again maintaining that equivalence through doing what video can't do—by preserving material differences where video begins with their elimination. As an array of intensities, Chang's works reembody nothing so much as they present something that is not a body.

Heidegger says that the word gives being, and he wants it to be audible giving, he wants the word to be present as a kind of material. Elsewhere, but at around the same time and in the course of another despairing attack on the contemporary, he talks about needing to hear the sound of the original Greek word as the Greeks heard it, which I can only think of as a theologically inspired impossibility that is nonetheless obviously profound in its implications. I should adapt what Heidegger says about the word to say that in Chang one is presented with painting as a thing which is also a practice, and where it has to be recognized as such before anything will happen *in* it—before any painting can make painting give anything. What is given in Chang is painting ungrounded,

Fandra Chang, Untitled (Square Canvas), *1996. Ink on canvas, anodized aluminum, and plastic.*
Collection: Michael Healy, California. Courtesy of the artist.

painting as at once discontinuity and its opposite, hypercontinuity, joined inextricably as event.[13]

In making these works, Chang begins with a small stretcher, from the art store, which she then paints one color. Then she rolls ink onto it through a screen, which makes an impression that reveals the stretcher. Then she takes the stretcher to a lab and has it photographed in a negative and positive image. One of these images is then printed on a sheet of Plexiglas (what the English call Perspex), which is then placed over a piece of metal or paper on which either the negative or positive image—sometimes the same as the one on the Plexiglas, other times not—has also been printed. By the time the process is complete, black dots which had begun by referring to the raised bits of the canvas's weave have come to look like digital dots, and the soft and interrupted surface of canvas has been replaced by hard and unbroken plastic. What's on the surface of the plastic points to an interior that has no more to do with where the work began than it does, a mutual deferral to what one's actually looking at and simultaneously to what's not there.

A passage from a book by Richard Dienst that discusses television, and therefore the video image, in terms of Heidegger and Deleuze, underlines the kind of equivalence for the latter that I find in Chang: "With video, the mechanical movements that break up the instantaneous and charge up the continuous are in fact inseparable . . . What some descriptions of television register as fragmentation, reification, and formal heterogeneity can be more fully grasped as diffracted slices of still time, and what strikes us as television's compression of distance and presence is perhaps best understood as its capacity for automatic time."[14] With Chang, one would only, but significantly, need a definition of the mechanical that included the intuitive and of the automatic that could encompass the accidental.

Which seems to me to be another instance of how Heidegger's nightmare might well be Deleuze's quite nice day, because where, for Heidegger, the human gets lost in technological extension (its intensification as function), which leads away from itself, with Deleuze something else can always be added on and

even has to be. In Deleuze, the mind as transmitter and receiver finds not itself, but *a* self—the one it seems to need at that moment, in the outside that meets its own outside. Furthermore, what it attaches itself to, finds itself through or within or in convergence with, is a principle received (perceived, recognized) as a type of force. Little Hans sees that a cart horse has more in common with an ox than a racehorse, and in that thinks of being as action and in action rather than in identity as genealogy. Projection and reception replace the question of origin, returning will literally get you nowhere.

I am told that many in the field have thrown up their hands at the idea of artificial intelligence because it is remorselessly pre-Kantian, which is expressed as an inability on the part of computers to manage pattern recognition, and prefer instead to talk about "intelligence enhancement." The intelligence is human and the computer is added on.[15] Adding on, I notice, is a function of the advertisement, particularly of its use of the model, and in a way that is in a sense directly comparable to the use of deferral and association in Chang and, conceivably, to the categorical language of Little Hans. In the course of a twenty-second segment taken from a television advertisement for a cosmetic, every shot of the product is followed by one of Cindy Crawford touching something to her skin, these bracketing a sequence in which she moves from dancing with someone to cuddling a baby, a dog, some old guy, and then back to her partner. You can never tell what's going to work in either art or advertising, but here one may say that one has an example of both working in comparable ways. But I would suggest that such images are in effect, as images, beyond or something other than images of flow.

When naturalism's facade turns to running water, as Deleuze has it, flow, as he says, replaces the outline and the fragment, situating all in an unsituated movement of deorigination. I have suggested elsewhere that Deleuze's importance for nonrepresentational painting lies in one's finding in his treatment of water something like a systematic treatment of the not-constructed, the flow as an entity, and liquidity as a condition of contemporary mobility will come up here again in that and other contexts.[16] But flow is still understandable by humans as an animal sensation; one can be caught up in it and even imagine resisting it. Beneath and behind it lies electricity, endless and imperceptible impulse, holding everything together and holding everything apart. This is understandable only by humans as intelligences, as a fact outside and within the body but inaccessible to it—and also as the way video works. Once white was the white of the page (Manet/Mallarmé, the page pregnant with meaning) and then of the wall (Ryman, undifferentiated white framing white as differentiation), but now perhaps painting, which always found itself somewhere else as the world found itself in painting, finds white leading it toward that which it can't be, the principle of the same as a function of the imperceptible, force without material substantiality, the thin and brilliant light of video.

And what does painting learn from video (and from plastic and from color photography)? If from whiteness as pregnant meaning it learnt how to survive the fall of naturalism through the potential of the object, and from white as the undifferentiated terms of whiteness as interruption and, therefore, differentiation through attaching it to a substance (paint) which was continuous with a practice (painting), from video it learns the secret of the electronic: that there are no gaps, that presence and deferral are indistinguishable in a sheet of clear Plexiglas, that there is movement in interruption. Like impressionism, video is never still. In that inability to be still while always being shallow and brighter than the world, painting finds itself—which is what it found in the page and the wall—always and as ever an artificial intelligence focused on a blur, the meeting point between the surface and the depth it must both imply and fail to be.

It seems to me that video's inability to be still underlies the questions I am seeking to raise here about what we're looking at and with, when we look at either painting or the surfaces that fill or make up the world outside of the art world, conditioning what I shall now say about beauty and the sublime. Following which, I shall eventually return to the blankness that typifies those surfaces, in which beauty and the sublime converge and share at the end of the twentieth century.

1. Walter Benjamin, "The Work of Art in the Age of Mechanical Reproduction," *Illuminations*, ed. and introduction Hannah Arendt, trans. Harry Zohn (New York: Schocken Books, 1969), 217–251.

2. William Arctanger O'Brian, *Novalis, Signs of Revolution* (Durham, N.C.: Duke University Press, 1995), 5.

3. Norman Bryson, *Word and Image, French Painting of the Ancien Regime* (Cambridge: Cambridge University Press, 1981), 95.

4. Martin Heidegger, "The Age of the World Picture," *The Question Concerning Technology and Other Essays*, trans. and introduction William Lovett (New York: Harper & Row, 1977),129.

5. See below, p. 183.

6. Martin Heidegger, "The Nature of Language," *On the Way to Language*, trans. Peter D. Hertz (San Francisco: Harper & Row, 1971), 88.

7. Roland Barthes, "Plastic," *Mythologies*, selected and trans. Annette Lavers (New York: Hill and Wang, 1972), 99.

8. John Gage, *Color and Culture, Practice and Meaning from Antiquity to Abstraction* (Boston: Little, Brown & Co., 1993), 105–111. *See also* Chapters 9 and 11.

9. See E. F. Kaelin, *On Texts and Textuality: A Philosophy of Literature as Fine Art* (Amsterdam: Rodopi), forthcoming 1999.

10. Bryson, op. cit., 24–25.

11. As also: lemon or cadmium yellow; cerulean or ultramarine blue; viridian or emerald green; scarlet or crimson.

12. Gilles Deleuze, *Cinema 1, the Movement Image*, trans. Hugh Tomlinson and Barbara Habberjam (Minneapolis: University of Minnesota Press, 1986), 133.

13. There may be another sense in which Chang's work may be seen to be ungrounded which has to do with her relationship to the Euro-American painting tradition. The question of Asian art as having more to do with passages between than essences as cores or interiors could well be raised in regard to what she does *to* that tradition. Needless to say one will get nowhere by supposing that her work may be directly compared to that of others just because they too are of Asian descent, as in one fanciful comparison between her (a Taiwanese) and a Vietnamese filmmaker who is also a woman. That is about as useful as lumping Matisse and Dziga Vertov together on the grounds that they were both European artists and male. A serious investigation of her's and others' works as multicultural in the kind of deorigination they produce would however be exciting.

14. Richard Dienst, *Still Life in Real Time, Theory after Television* (Durham, N.C.: Duke University Press, 1994), 160.

15. I am indebted for this information to my colleague Peter Lunenfeld, of the graduate faculty in the Program in Communication & New Media Design, Art Center, Pasadena.

16. See Gilbert-Rolfe, "Nonrepresentation in 1988: Meaning-Production Beyond the Scope of the Pious," op cit., p.51.

III.

Beauty and the Contemporary Sublime

In the art world, the idea of the beautiful often threatens to make an appearance or comeback but, in practice, tends always to be deferred. When not deferred it's devalued, so that references to the "merely" beautiful are common but invocations of beauty unaccompanied by that adjective scarce, to the extent that some might see a Freudian dimension in this deferring and diminishing of what's nominally at the center of the discourse.

Damisch quotes Freud on beauty's elusive yet ostensive value: "Beauty has no obvious use; nor is there any clear cultural necessity for it. Yet civilization could not do without it."[1]

Civilization is one thing, the art world another, and by and large *it* does do without it, most recently being, instead, devoutly preoccupied with the— ideological, historical, and sexual (that is, political)—cultural ambitions reflected and expressed in the conversion of Benjamin, Duchamp, and Foucault into a unified instrument of redemption (and administration). However, if the contemporary art world is uncomfortable with beauty—a discomfort that seems to me to derive from beauty's irreducibility to, and consequent irresponsibility toward, other forms of discourse—it finds comfort in the sublime for the opposite reason.

In this somewhat crucial respect, the art world mirrors the larger one rather than providing an alternative to it. We have come—a nineteenth- rather than eighteenth-century assumption—to expect it to be, seeming to have internalized within its own production the relationship between art and the rest of society or culture, which the latter attribute to it; i.e., art represents, but is subordinate to, ideas to which, being corporeal, it must give way. One may further say that the contemporary art world is by and large an economy (with more than one currency) that pretends to be Nietzschean, and thus to escape the eighteenth-century subject's sins of arrogance—for example, originality and disinterest—but is, in fact, Hegelian. The discourse in charge of contemporary art world discourses is a new—original but not disinterested—application of Hegel, which has substituted for the art object and the aesthetic a cultural object meant and judged as an articulation, through a rhetoric obligatorily that of demystification or appropriation, of a historical, or nowadays, anthropological (i.e., Hegel inverted and apologetic) idea, as image, of the spirit of the age. Kant talks about there being "no science of the beautiful, but only a Critique,"[2] but it is not clear that he envisaged this becoming the beautiful only as the critiqued— nor that it should, unless, as is the case, it is seen as the source or embodiment of a problem, rather than an answer to one.

The art world's discomfort with beauty as opposed to history may, in part, reflect the latter's always wanting to be a science. I have seldom if ever read

an art critic or historian and seen a work described as "merely critical." In that contemporary art often suggests a milieu in which beauty has been buried by critique, Kant's role in it is to be a ghost constantly summoned up in order to be symbolically driven forth, much as Derrida describes Marx as being necessary to those who make careers out of insisting on his irrelevance.[3] And it is Derrida who, in that discussion, provides the appropriate cautionary note. I have little to say here about commodification as a capitalist subversion of all that is worthwhile, but I have described the art world as an economy in which Nietzchean ideas—for example, a popular notion of the end of history that releases us from it by apologizing for it—are used to sell Hegelian commodities. In this economy, artworks are valued not because they look good, but because they attempt to demystify the good-looking by showing it to be entangled with corrupt thought—which is to say, for their critical significance, in terms which repeat, without acknowledgment and with a view to abolishing the aesthetic rather than realizing it—Hegel's reconciliation of Kantian judgment with Absolute Spirit's (also known as Hegel's) historical teleology.[4] In practice, this means that one artwork, now as ever before, costs more than another because it may be said to better articulate the spirit of the age, which is, in the present case, one that believes itself to be beyond ideas like that of the spirit of the age because its Hegelianism is masked by the Nietzschean genealogies of the discourses used to explain works symbolically and contextually, but the discriminations made between, and therefore within, them are, as ever, Kantian. Derrida puts it this way: "[i]f a work of art can become a commodity, and if this process seems fated to occur, it is also because the commodity began by putting to work, in one way or another, the principle of an art."[5]

The principle of an art is put to work by what it is not. That application of (eighteenth-century formulations of) art, which was also an assault upon it (and them), fueled and was a fundamental of the desire of much of modernism to bring art closer to life, including the invisible life of the unconscious. In the earlier twentieth century, the art principle was kept intact so that it could be rethought as a principle in need of being purified, applied, or turned into an instrument of transgression against an earlier version of itself: Mondrian preserved a Kantian idea of aesthetic independence within what is nonetheless a Hegelian explanation of why painting should move toward pure plasticity; Brecht(ianism) took an already Hegelianized Kantianism to its logical conclusions; while surrealism recalled Kant (preserved the aesthetic as memory) so that he could be savaged by Freud (who could not have done without him). Insofar as it reflects an intensified state of late-surrealist and post-Brechtian deaestheticization, the current situation takes them further. As in Hegel's enlistment of Kant's (possibly compromised) disinterestedness into the march of history (both in the sense of a forward movement *en masse* and with a goal and, spatially, in that of the secondary meaning of the noun, where "the marches"

refs to the border) but also as in that in which Schiller already—i.e., prior to the age's acquiring a spirit of its own—had beauty giving way to reason, surrealism and Brecht's realism put the art principle to work by preserving it intact in order that it might be repeatedly subsumed into another. In the art world of the later rather than earlier twentieth century, reason puts the art principal to work by forgetting it excepting to the extent that it recalls it through its demystification. Early modernism began with art. Postmodernism has replaced the ends of art with the end of art, art after art is art which does without art, its origin to be found in that which it no longer deems necessary. One could not deny that this sounds like a serious problem, or at least a problem for seriousness.

I live in the art world—where images have the status of things, whereas elsewhere things exist only as images—and could imagine occupying no other condition of mobility, and it was against the background of the general transformation of art into applied anthropology of an increasingly respectable sort, which one may date from the mid-seventies and the reinvention of Duchamp in order to topple Clement Greenberg and disestablish his followers, that I first found myself wanting to see the relationship between beauty and the sublime as one between that which is attractive but irresponsible and that which, however negative its formulation may be, is always apprehended as the voice of responsibility because it's always attached to a serious idea.

As I said in the beginning, one suspects that one's context has drawn one's attention to a condition that is historically particular but may have been there all along. In a situation where art is remembered by being forgotten, in the interests of the history and culture whose original sins it is said to embody, the frivolous could be seen to succeed an irresponsibility that had been, as it were, "merely" transgressive. In that the frivolous is the irresponsible as that which never was responsible for anything, except through the gratuitous attribution to it of tasks it did not originate, it is an irresponsibility much closer to Helen's indifference than to modernism's transgressiveness.

The Differential

This would complicate the sense in which the sublime has a differential relationship to beauty, which makes them complements but not opposites. Derrida describes Kant as unable to keep the ideas apart, because in defining the beautiful as that which is complete and may in that be framed, he seems to separate it from the sublime, which is for him by definition formless and unframable, but this raises the question of what forms and frames the formless and unframable so that one may see them.

Derrida's description of the differential relationship between beauty and the sublime shows it to be a question of what renders the invisible visible, of the sublime's dependence on the senses from which philosophy otherwise seeks to set

it apart, and, concurrently, of reason's need to frame itself, to recognize, and define itself in contradistinction to, its own limits, which, in that gesture of recognition, enfold within themselves—appropriate—some of the properties of that which contains them. Significantly, Derrida finds the idea of the frame best expressed not in *The Critique of Judgment* but in Kant's *Religion within the Limits of Reason Alone*, where it is the sublime's need for framing that is at issue: "Because reason is 'conscious of its impotence to satisfy its moral need' it has recourse to the *parergon*, to grace, to mystery, to miracles . . . This additive, to be sure, is threatening. It involves a risk and exacts a price . . ."[6] As with the implicit relevance of the irrelevant, I take this to mean that frivolity, irresponsibility, and irrelevance are values which extend but do not necessarily invert what Kant calls a "moral need," instead—but only from its perspective—confirming reason's obligation to find, explore, and incorporate what is exterior to it by its own account.

Later Derrida describes the risk and price of grace, mystery, and miracles as additives, which are that the values of production and calculation are dissolved by beauty's independence, becoming, once undone (perhaps like eunuchs in their combining impotence with forcefulness) ancillary indices of it: "The analytic of the beautiful . . . ceaselessly undoes the labor of the frame to the extent that, while letting itself be squared up by the analytic of concepts and the doctrine of judgement, it describes the absence of concept in the activity of taste."[7] Beauty lets itself be "squared up" by that of which it simultaneously announces its independence, in that threatening to rob the sublime of its priority, of preventing it, in the very act of framing itself so as to be present, from being present at all.

Moreover, the formless and limitless sublime can itself be opposed to a sublime made out of specificity and hardness (and mathematics), which like Kant's finds its first theoretical formulation in Longinus, and which Kant's contemporary Winckelmann saw as preceding the beautiful while at the same time defined by its resistance to it (and which becomes for the latter the art historical version of the circularity Derrida identifies in Kant). So one may say that the tradition of the sublime as seriousness comes in two versions that are inversions of each other.

Paul Guyer, in a work that returns one to the connection between beauty, the sublime, and freedom in Kant (and Schiller), describes the relationship between the two brands of sublimity as follows:

> Kant's distinction between the mathematical and dynamical sublime might seem to reflect a fundamental distinction between theoretical and practical reason, each form of the sublime revealing one form of reason. In fact . . . it seems more accurate to interpret the two forms of the sublime as progressively

revealing two *aspects* of the single, and ultimately practical, faculty of reason. The mathematical sublime reveals the *infinitude* of its scope or power of comprehension, and the dynamical sublime then adds a representation of the *independence* or autonomy of reason from the influence of the natural world.[8]

But this independence is, surely, a reconvening in other terms of that of which it is said to be independent, i.e., of what is apparent in the natural as opposed to the mathematical world, namely grace, mystery, and miracles:

> The real threat from external nature would not be our physical destruction but rather nature's effect, whether by threat or gratification, on the inclinations within us, which could lead to the heteronomous rather than autonomous determination of the will. It is in freedom from this that the "sublimity of our vocation even over nature itself" lies—the sublime is nothing other than the experience of our own autonomy (*CJ* 5, 28:261–2)—and for this reason sublimity must be contrasted to nature rather than ascribed to it.[9]

I take this to mean that the mathematical risks being undone by that nonmathematical side of itself to which Guyer has it giving way once it has set the stage for it by "squaring up" infinity—announcing its control of the infinite through its division or formation into a grid.

Thus, in the genealogy of technology, from the Cartesian grid, to Leibniz and continuity made out of points, to the television and the computer, reconvening within and through the mathematical a force like life's but independent of it—but more about that later. I mention it here because it raises the matter of mimesis and reconstitution, without which the visual arts cannot function—another explanation of their irreducible criticality—regardless of their relationship to it in any moment or work. Guyer demonstrates that the work of art is, for Kant, not autonomous because it is not disinterested, being an intended object, and that likewise beauty is only free in nature.[10] Somewhat paradoxically, he shows that while "Kant . . . seems to assume that a work of art can have some claim to sublimity, at least by representing the naturally sublime. Nevertheless, works of art have no part in Kant's image of the sublime."[11] The apparent paradox being that he seems to be saying that Kant's image of the sublime is an image without the art principle, an unimaginable image in other words, or one inseparable from, and only encountered as, that of which it is an image. It is an image of an autonomy which may be undone through susceptibility to "either threats or gratification" by a heteronomy from which it both stands apart and derives its terms—and in this the threat nature poses to reason seems comparable to that offered to being by technology in Heidegger's account. Without the art principle, which causes it to assert the absence of the principles on which it itself

depends—reason seduced away from its true path—it also becomes an invisible autonomy: It can't be seen but has to be willed, in opposition to the heteronomy that threatens or tempts it; and it can't be separated from the latter, an image without the art principle being either an idea or the thing itself—in other words, an image which is a nonimage, since images lie between these two but cannot be either, being themselves ideas and things which take the place of those to which they refer. This is why I think it significant that Derrida found the argument's crux in a book by Kant about religion rather than art.

For many of us it comes as a surprise to learn that Kant excluded the sublime from the morphology of the work of art. One reason for this is that no one else ever has, often, if not usually, while perversely attributing its inclusion specifically to Kant. A habitual misapplication of a term he reformed so as to preclude just such a misunderstanding, possibly reinforced by our using it to describe works of art while seldom if ever—because we are rarely there, and when we are photographic vision intrudes—making judgments about and in nature's presence; i.e., we only use it where he said it wasn't, we never have it where he said it only was. Moreover, such a misattribution of sublimity to the work of art itself is indispensable to art history, the contemporary art world's historicism as counterhistoricism replicating in this the sublime's traditional application in historical judgments about works of art. This is the case whether the historical is conceived as a teleology derived from or comparable to that which Kant perceived in nature, as might be said of Winckelmann's treatment, in his founding theory of art history, of the parabola from birth to productivity and decline traced by individual styles, or as a teleology reflecting a more progressive will, as in Hegel's application of Kant's idea that the ends of nature are man to an idea of art's history as a natural practice renaturalized by culture so as to culminate in dialectical, i.e., historical, consciousness.

Winckelmann brings sex back into the picture, or as I should say in his case, sculpture. His use of the terms "beautiful" and "sublime" is not necessarily Kant's, but it is interesting to compare the two. Kant never makes the claims for severity that Winckelmann does, and despite giving beautiful women responsibilities they did not request and which he does not name, is much less categorical about gender than his contemporary. Winckelmann is, however, himself significantly less arbitrary in this regard than others who have formed our habits in the history of visual art.

I'm indebted in what I have to say about Winckelmann to Alex Potts's book about him, in which he proposes that Winckelmann offers a dialectical alternative to Burke's crudely oppositional theory of the sublime. Where Burke proposes that the sublime is straightforwardly masculine and beauty unambiguously feminine, Winckelmann advances a theory of exclusively male beauty—that is, which excludes the actually female—which obviates Burke's by recognizing that, in order to attract, the sublime would have to have some of the

properties described by Burke as feminine: "A . . . male body that . . . was nothing other than . . . [a]n aggressive display of . . . brute physical violence would all too easily appear ludicrous or repulsive rather than impressive and compelling."[12]

Potts explains Winckelmann's position as follows:

> Can the body that gives the most intense pleasure also be the one that most powerfully evokes a free expansive subjectivity produced by political freedom? . . . Winckelmann's position is yes and no.
>
> The gendering operating in . . . Winckelmann's . . . time made the male body the only possible focus for such an unstable and highly charged conjunction. This is a simple factor of the casual exclusion of the feminine from most radical eighteenth-century discourse about the free subject. Moreover, the ideal female body in art conventionally had a relatively simple function as a signifier of sensuous beauty, as the object of desire, uncomplicated by associations with more austere ideas of freedom and heroism. It was only in the representation of an ideally beautiful male body that tensions between the body as the locus of pleasure and desire, and an ethical investment of the body as the sign of an ideal subjectivity, the ideal subjectivity of the virtuous and free republican subject, could be played out.[13]

In other words, Potts shows that beauty and the sublime were, in eighteenth-century cultural debate and the use it made of art objects, closely related to a debate about power (or empowerment) and the invention of a self-determining (i.e., republican) subject. It is, then, from the start a theory about how power, conceived as the property or concern of a subject defined as male, uses beauty to its own ends (while simultaneously claiming it originates within itself). One notes that Potts himself links the word "simple" first to the feminine's casual exclusion and then to sensuous beauty, while reserving "austere" for its customary place next to the free and the heroic. In this reconvention of the Schillerian bias with which I began, Potts's commentary seems at times to recall the rhetorical predispositions of the subject that is its topic.

For my part, I want to suggest a model in which the sublime is androgynous and beauty irreducibly feminine, although in a way also unlike Burke's, not least insofar as the difference for me is not that between the active and the passive but between the transitive and the intransitive. But perhaps more obviously and immediately, this is the point at which to take note that the masculine has become absurd. Popular culture makes the point for me that intellectual history makes for Potts. From Mick Jagger to whomever is hot right now, the dominant male icons in popular music for the past thirty-five years have been androgynous, while on the other side of gender representation in the marketplace of the marketable, the image deployed by Madonna is continuous with, or exemplifies, the unandrogynous femininity of the fashion photograph,

which may play with androgyny but, when it does, plays with it from outside it, recognizing it as a (now permanently) suspended condition lying between it and what is at once its opposite and complement in this sense. The exclusively masculine figure useful to Potts's eighteenth-century intellectuals is now a subject found, either iconically or practically, only in the archaic functions of sports or the military—while remaining as central to political life now as it was then, hence the subversion offered by popular culture however compromised it may otherwise be, and underscoring the unreality of contemporary political and social life. No one takes masculinity seriously anymore except those who have an administrative relationship to seriousness; otherwise it's a spectator sport that simplifies ideology while getting people to pay to ingest it. Fittingly enough, the best application of Burke in recent years must be Dave Hickey's now famous discussion of Robert Mapplethorpe, in which that male subject finds itself as an object by turning the masculine's self-identification with power on itself.[14]

In a curious way, the androgynous sublime fulfills the promise of the exclusively masculine sublime outlined by Potts: It would have to become androgynous in order to perform the task Potts's Winckelmann assigns to it, i.e., in order to take everything in, including its own critique. In parallel with its place in the evolution of the iconographic representation of the subject, the inclusiveness of the androgynous relates to why one would also suggest that the sublime is elsewhere nowadays a technological sublime—Heidegger's nightmare, and/or/as Orange County—in that technology's relationship to power similarly seeks to be inclusive in regard to all possibilities of gender and conjunction: All that there is to use in the world is used (to extend the world's "usability," i.e., its conversion into a technological equivalent for itself which will become the world as it is given, the masculine as the origin of the feminine, technology as the origin of nature).

The eighteenth century that Potts describes could only use the beautiful as a component of a preoccupation which continues to be characteristic of cultural life. Julia Kristeva once asked whether resistance to modern literature wasn't evidence of an obsession with meaning, and one might ask the same question about contemporary and modern art's resistance to beauty.[15] This is also the sense in which I am suggesting here that beauty is found in that which does not exhibit the characteristics traditionally associated with the masculine, but is instead typically located within fragility and the delicate, and that it is in this that it places a limit on the language of force to the extent that it resists being subsumed by what frames it. This resistance being only an effect created by its indifference to what is brought to it. The beautiful is powerless but always exceeds what frames it, and what always frames it is discourse.

It is unframable, however, to the extent that it is frivolous. That is why I am intent on discussing beauty as a matter not only of the attractive but precisely of the glamorous, and as such anything but passive, but inherently intransitive

rather than transitive in having no necessary object for its subject nor being in any sense engaged in reactivity nor externally determined. By thinking of the beautiful as glamorous I seek to make it into a secular concept which, in its substitution of frivolity for faith (in doubt), could offer an escape from secularization instituted as an ideal, enabling one instead to see "the pleasures of appearance and the charms of the tangible realm" in some condition of independence from the puritanical tradition of monotonous bias and discomfiture described by Lichtenstein. Beauty is seductive but goodness only productive, the production involved taking the form of a critique of the glamorous. If I may be seen in this to be saying that glamour is better for you than goodness, this is I think (like the relevance of irrelevance) a paradox which follows from Kant's insistence that aesthetic pleasure involves an experience of freedom from concepts,[16] while the proposition that glamour does something to goodness seems confirmed in the confusion, or discomfort, caused to that idea of freedom by the teleological attributions of the idea of woman when Kant found beauty there.

Art History

For Winckelmann, the beautiful is at once the property of a particular style, and, elsewhere and in general, a property or quality which is itself not a product of stylistic development.[17] Both ideas are useful here.

To take the last point first, he argues that while the arts develop in the sense of becoming more sophisticated or articulate, the beauty of early Syracusan coins surpasses those of later periods. So the beautiful may already be there, but one may lose it or have never had it.

At the same time, the beautiful as a style is something that comes after something else. Winckelmann sees the apex of Greek art as in fact occupied by two styles that occur in rapid succession—so that the apex itself would have to be a zone of division, an imperceptible break. He calls one the high style and the other the beautiful style. Where the high style is characterized by a lack of refinement, the beautiful style is refined.[18] Where the high is hard, the beautiful flows.[19] Winckelmann thought that the beautiful style was what the Greeks did once they had surrendered their autonomy to Phillip of Macedonia, which may or may not add to one's sense of the one as a style which is about authoritativeness and the other as one which is prepared to be seductive as well as instructive.

Winckelmann saw the high style as a struggle against the beautiful, that is, as an art made out of not falling into temptation, while he also saw the Laocoön, an example of the beautiful style, as "less purely ideal" than the art of the high style because of its beauty. So the high is characterized by its capacity for restraint, and the beautiful denied access to the purely ideal not on account of its own impurity but because it won't restrain itself and become something else. It cannot be purely ideal because it's purely beautiful. This differential relation-

Barnett Newman, Vir Heroicus Sublimis, *1950–1951. Oil on canvas, 7' 11³/₈" × 17' 9¹/₄" (242.2 × 513.6 cm). The Museum of Modern Art, New York. Gift of Mr. and Mrs. Ben Heller. Photograph: ©1999 The Museum of Modern Art, New York. ©1999 Barnett Newman Foundation/Artists Rights Society (ARS), New York.*

ship between the high and the beautiful styles is then another version of that which exists between beauty and the sublime in Kant's formulation, but it reverses the order. In Kant, the sublime follows from the beautiful and is what the latter is not; in Winckelmann, beauty follows the sublime and amounts to a loss of sublimity.[20]

So beauty finds itself surrounded: on the one side an idea of restraint, which comes before the beautiful but is at the same time made out of refraining from becoming it while still knowing what it is, and on the other, an idea of the not-beautiful made out of limitlessness. Furthermore, what surrounds beauty also reflects it. Kant divides beauty into two sorts: beauty not judged according to a predetermined order, which I interpret to mean not according to a principle of production and beauty judged according to a predetermined concept, as in, "the beauty of man presupposes a concept of . . . its perfection, and is therefore merely appendant beauty."[21] The first kind of beauty sounds like the sublime as formlessness; the second (in which "merely" again holds beauty in its place) is certainly reminiscent of the high rather than the beautiful style. So there are two kinds of beauty, and in certain respects they're rather like the two kinds of sublimity, except that the sublime is not beautiful: beauty that behaves like that which doesn't care about the beautiful, and beauty only realizable in that which restrains it and attaches it to a worthwhile idea. One notes that having to be attached to something would mean that beauty was not itself that thing, while the sublime is worthwhile and the worthwhile sublime.

Longinus, whom, as Lyotard notes in an essay on Barnett Newman and the sublime, both Kant and Burke read closely, lists among his examples of the sublime the surprise provided by an erudite and sophisticated speaker using an

"extreme simplicity of turn of phrase, at the precise point where the high character of the speaker makes one expect greater solemnity. It sometimes even takes the form of absolute silence."[22] This extreme simplicity continues to play a part in the Kantian sublime, where, as the material of art it can be rough and coarse insofar as it can signify the natural, but no longer as a lack which has rhetorical force so much as a condition in itself, and therefore not really as roughness or incompleteness, because one is no longer seeing the rough as something which could be potentially smooth or the incomplete as something which awaits completion.

I want to discuss Newman briefly here and, in doing so, to suggest that he formulated a version of a post-modern Kantian sublime that is no longer available at the end of the century as it was in the middle of it, when he made it up. It's no longer available because it's a sublime which still finds itself in nature, but it provides the terms for what seeks to find a way out of it.

I think Newman's paintings are clearly involved with the idea of limitlessness. They are certainly rough in this or that sense and present color without form, pointing in that to the possibility of formlessness, an emptiness which is at the same time full. Typically they do so through the indeterminacy—which Lyotard sees as Newman's theme—offered by red, which unlike yellow doesn't advance, unlike blue doesn't recede, but instead hovers in the middle ground. The model might be Matisse's *Red Studio*, where red holds together foreground and background, and where the clock at the back reveals, in its unpainted face, the ground of the painting as a whole. In making the origin, the ground of the painting, also its culmination, what's at the center of the furthest recess made by the pictorial space, Matisse is quite Heideggerian in the way he makes the painting be a matter of the return of the origin at the end and as an end. This is not quite what happens in Newman, where there's no trace of the ground.

Newman painted his first, as they are called, zip painting, and most but I think not all the subsequent ones, by putting tape down over a color and leaving it there until the painting as a whole was finished, removing it at the end. So the last mark marks the act of removal which reveals the first, leaving traces of the buildup on the tape which had covered the original color, and which now give an irregular edge to the stripe or zip. Therein, along with his generally very cavalier attitude to painting technique, lies the role of roughness and simplicity in Newman's sublime.

Richard Shiff described Newman putting down first color and then tape as an act of subdivision, which at the same time engages the temporal by, as it were, dividing one duration by that which it replaced.[23] One could add to that the complication that comes from the different way one sees even the same thing if it's on the left or on the right. In any case, the stripe or zip is the provision of a third area between two others that are identical to one another and in a sense follow from the one from which they mutually differ. And though they look and

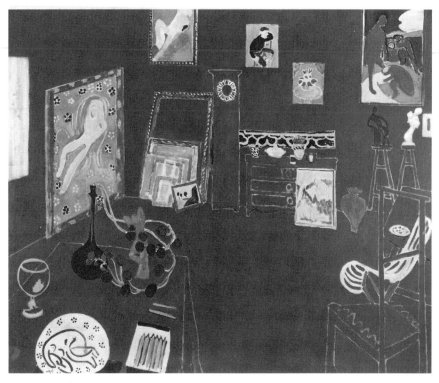

Henri Matisse, The Red Studio, *Issy-les-Moulineaux, 1911. Oil on canvas, 71¼" × 7' 2¼" (181 × 219.1 cm). The Museum of Modern Art, New York. Mrs. Simon Guggenheim Fund. Photograph: ©1999 The Museum of Modern Art, New York. ©1999 Succession H. Matisse, Paris/Artists Rights Society (ARS), New York.*

are the same, the one thing we know for sure is that they don't run behind the stripe, because the stripe or zip is a sign of origin re-presented after a period in which it's been hidden, revealed at the end as an initiation. Lyotard goes on to say of Longinus's evocation of extreme simplicity that: "I don't mind if this simplicity, this silence, is taken to be yet another rhetorical figure. But it must be granted that it constitutes the most indeterminate of figures. . . Must we admit that there are techniques for hiding figures, that there are figures for the erasure of figures?"[24]

That question reverberates through much of the present discussion, leading back to the substitution of the technological sublime for nature and the reversal of the presumptive relationship between the two. In Newman erasure is presented in two conditions, one of the irreversible development of the main field of the painting, the other its suspension and reversal in the stripe left by the masking tape's removal.

Lyotard also relates Newman's sublime to the temporal, itself an idea inherent in themes like limitlessness—which can't be spatialized, and as such is

an invisibility apparent to vision but unrealizable by it—and it is in these terms that one could say that in Matisse the painting begins with its ground but in Newman it begins with the stripe, which is what survives of a color first painted over the whole of the surface.[25] The origin to which one is returned is not the ground of action but an originary act meant to subsume that which preceded it, its ground. The sublimity of the act lies in its roughness and indeterminacy—the latter underscored in those paintings where Newman places the tape over wet paint—and thus it is that Newman can be discussed at length, and has, without mention of beauty.

On the other hand *Onement* is symmetrical, a property usually associated with beauty, and *Vir Heroicus Sublimis* organized according to the golden section, the high style epitomized. So what is framing what? Certainly limitlessness is being presented in some way. As a red painting *Vir Heroicus Sublimis* hovers like Matisse's *Red Studio*. But being a nonrepresentational painting, and therefore ungrounded in representation—which is to say, the recognizable—it contains no extremities of near or far, so that indeterminacy means the loss of hierarchy, and movement must become something other than the possibility of movement between things. In both Matisse and Newman, red envelops as well as joins, but in Newman, the act of linking is the same thing as the act of holding apart, in a context where, unlike Matisse's, there never were any solids or voids, because the stripes or zips function spatially, as fields of color. Their initial appearance as things suspended in or superimposed on the red is problematized by their dissolving into spaces, which is to say voids, when one actually looks *at* them.

In order to be sublime in the way that he said they were, Newman's paintings had to be large, which could link him with the specifically American sublime theorized by Harold Bloom. This sublime would seem to be caught up in Protestantism's close relationship with the Old Testament, with a purposive creation, with law as logic, with the plain and simple of Jonathan Edwards. A severe and hard sublime predicated on questions of origin and boundlessness. Others have seen the New York painters of the 1950s, Newman among them, as an American version of the German romantic sublime, an art concerned with the overwhelming and with the idea of destiny as an idea of acting out, a sublime severe but atmospheric and engulfing rather than hard and resistant.

In addition to these, the size and format of Newman's paintings could also invite comparison with a third sublime, not unrelated to Bloom's, which is the banal sublime of the propagandist painters of what was in the nineteenth century called America's "manifest destiny." Large canvases containing honest settlers dwarfed by the vistas they are about to conquer, with in at least one painting an angel in the sky goading them on, the awesomeness of the landscape mirrored in the awe with which the soon-to-be-displaced indigenous population regards them. Such paintings employ a wide-screen format (the proportions of

marine paintings applied to the Wild West) as does *Vir Heroicus Sublimis,* and while I am not suggesting that Newman's work is continuous with that tradition (any more than I could subscribe to the thesis that Rothko's paintings are Friedrich's without the trees and figures), I want to see Newman as related to it through a kind of negation. Newman was interested in the art of Native Americans, a fascination he shared with Pollock (who, unlike Newman, was from the West) and in thinking of the role of limitlessness and indeterminacy in his work, I think of Newman's interest in a Native American dance in which the dancer places a pole in the ground and dances in response to it: an idea of mobility which can vary, be potentially limitless, on all sides while retaining a constant center. As I think of this, I think also of Newman's expressed desire, eventually fulfilled I think, to go to the tundra, where one can turn around through 360 degrees and the horizon will remain constant and level. Again, limitlessness with a fixed center and also the idea of flattening, i.e., of unimpeded extension and, by implication, of uninterrupted movement.

One could say, then, that the theme of limitlessness offered in an earlier American sublime persists in Newman in some other way. What locates that sublime in Newman, anchors it, is a principle of origin and return. He finds a model for it, as nineteenth-century American art did not, in Native American culture as well as elsewhere, and in the American landscape at its most remote and most fragile. One of the elsewheres where he found the model was, as is well known, and has been discussed at some length by Tom Hess and others, the Cabala. There Newman found, for example, the theme of the absent as a sign of immanent presence, in the idea that before making the world God had to make the space it would occupy. A theme not unconnected to ideas like manifest destiny or, in another sense, to the ideals of Puritans like Jonathan Edwards.

Newman's sublime, then, is one of limitlessness visualized within the terms of an activity which leaves no trace of what was there before it but returns to what began it. Or very little trace. This sounds quite American, and I think one can find in it the reasons why later painting would want to build on it without being able to preserve its assumptions. But nowadays the image of the tundra, which, as an idea of emptiness and freedom to move, inspired Newman, might be seen to have been replaced with the knowledge that invisibility itself, the air, is filled with electronic signals. An, as it were, geographical image of limitlessness has given way to a technological one. Immediacy—what Lyotard calls the enigma of the *Is it happening?*—is in a sense a technological convention, second nature to the computer and the phone company, leaving the work of art to expand that immediacy into a gap of which one may be conscious.[26]

A contemporary sublime might, then, have to engage an environment in which multiplicitous signification, that proliferation of systems which is the technological condition of late capitalism, is not only the norm but the model, and where the issues are not the incomplete and the rough but the intersection of

differences and repetition as difference—where, as Deleuze has pointed out, repetition precedes and makes possible the original. What makes it a repetition is also what prevents it from being one, it is in fact not that which it repeats.[27]

And I think one might ask whether this would not be a good place to stop talking about consciousness as organized around or through oneness (or "onement") and ask instead whether it should be seen as a realization of a state like that warned against by Kant when he says that heteronomy threatens or tempts the subject's autonomy. In that it originates in knowledge and production rather than nature, the contemporary sublime seems less readily describable through the model of an autonomous subject—techno-capitalism's success being a function of its not being clearly one thing—than of one that could find itself in "the most indeterminate of figures" by being a mobile collection of centers without a single determining form. Immediacy, as a condition of everyday life, would require it, as would the logic which suggests that while one may have a single theory that explains nature (that attributes an end to it), knowledge is heteronomous as nature is not, in that it originates in competing and contradictory discourses. Immediacy is a state in which the message is already at its destination, or where one could not separate the start from the finish. A state of permanent immediacy is one in which the message is always already there—thus, at the banal level, its perfect expression by the television, a set of continua that includes what has happened a minute ago, or is happening right now—but not here, thank God—but which also cannot end. Here autonomy is a reactive con-firmation of absence, hence its perfect relation-ship to the banal, but it also illustrates the need for absence on the part of the autonomous subject in its more elevated forms. The extreme mobility of the contemporary sublime erodes autonomy because it calls for movement through the heteronomous which is itself heteronomous, provisional singularity taking the place of the irreducible, movement being the basis of the indeterminacy of what is erased and represented within it.

Lyotard says that in criticizing Burke's

over-"surrealist" description of the sublime work . . . Newman judged surrealism to be over-reliant on a pre-romantic or romantic approach to indeterminacy. Thus, when he seeks sublimating in the here and now he breaks with the eloquence of romantic art but does not reject its fundamental task, that of bearing pictorial or otherwise expressive witness to the inexpressible . . . [which] . . . does not reside in an over there, in another time, but in this: in that (something) happens. In the determination of pictorial art, the indeterminate, the "it happens" is the paint, the picture. The paint, the picture as occurrence or event, is not expressible, and it is to this that it has to bear witness.[28]

Newman was in little doubt that the inexpressible was an idea, tradi-tionally conceived. That is to say it was one thing—or, as Lyotard puts it, an

"it"—that was to happen in the paint and picture, or that these were to happen as, when each or either were encountered as an (inexpressible, which is to say, unsayable) "occurrence or event." In contrast to this presumptive unity of the indeterminate, I think that in later painting this "it" has to become a "them" or, rather, seeks to. The inexpressible takes another turn or form, and it is an idea of autonomy that becomes indeterminate, or, more precisely, could be seen to have the option of seeking to become more indeterminate. I believe I can illustrate this through a generational comparison.

The relationship between Newman and Clement Greenberg was not straightforward, and the position of the one should not be mistaken for the other's. But they share broad generational presumptions that will allow me to attach Lyotard's observations about paint in Newman to Shiff's discussion (elsewhere than in the essay referred to above) of Greenberg's ideas about purity of means and therefore ends.

It is worth quoting at length, because it goes to the question of nature, when considered, as it were retrospectively, as limitation:

> Recall again that Greenberg spoke not of realizing purity, but of desire for purity . . . the ubiquitous desire he attributed to American culture. Like Benjamin (but unlike Schapiro), Greenberg did not believe that art would change society . . . he also believed that "literary men have a tendency to confuse aesthetic with social values."
>
> Perhaps the hard choice the literati faced was to be either confused or disillusioned. . . With a similar ambiguity, it might be argued that for Greenberg materialistic positivism was modernist art's advantage—it got the viewer's attention. Yet because positivism generated a "pure" art of abstraction, it also entailed a disadvantage—the face that a more complex, naturalistic art would have been preferable. Nature remained the living, breathing essence of art: "The best modern painting, though it is mostly abstract painting, remains naturalistic in its core, despite all appearances to the contrary. It refers to the structure of the given world both outside and inside human beings."[29]

Shiff concludes his remarks about Greenberg (who himself painted landscapes) with an anecdotal description of him championing the figurative work of Horacio Torres in the 1970s, with the invocation—whether Adorno-esque or Heideggerian, or both—of a wrong turn having been taken that came with that: "With both evident sincerity and a bit of maliciousness, Greenberg would point to the nude, telling visitors that *this* was what art should be like. Or rather, had the world of the modernists been a better one, *this* was what its art would have been."[30]

Such pessimism and its consequences have no place in Newman's career, but the idea that nature remained the living, breathing essence of art does. Shiff's

reading of Greenberg suggests, to me, that the latter's idea of purity preserved nature through what was at once negation and affirmation. Its concentration on means as the location of meaning pointed toward a complexity that could not be expressed through representation, i.e., it suggests a theory of painting in which mimesis of actual appearance is replaced by an attempt to induce some of the properties found in an experience of the sublime in nature. That seems consistent with Newman. Newman eschews illustrating nature in order to reconstitute its indeterminacy through the relationship between a field and the gaps in it, which subdivide it as they float in it and mark what it all once was. It is pictorial simultaneity that is first rendered indeterminate through one's recognition of different times in it. Thus, in Newman, the sublime is suggested (if one concurs in Kant's prohibition against its being there in fact) through a systematic in which "the inadequacy of the images is a negative sign of the immense power of ideas."[31]

Shiff leads the reader from Pollock to Jasper Johns in order to show that Johns realizes Greenberg's argument for the surface of painting as the place where an aspiration to purity occurs, but at the same time reverses Greenberg by emphasizing aspects of painting he discounted. Johns's success is to be found in his use of those of its physical iconographical aspects which identify painting as a cultural object of a certain sort, i.e., as a kind of labor and a language, but which Greenberg wanted to see subsumed into spatiality—i.e., into (perceptions of) movement, relationship, surface as crust giving way to the space it reveals or conjures up, tactility considered as a quality accessible only to the eye rather than as a quantity associated with an object. Shiff does not actually say that Johns's *Target* is more like a body than a space, I think because he wants it to be a semiotic of embodiment that is as much a reconvention of the body's terms as a body itself, and is as such neither exclusively iconic nor indexical. Accordingly, he says that while much depends on everything in *Target* being made to support its iconicity, this last is to be seen (or, as icon, read) as offering a tripartite model of perception communicated through "*materiality* (body) . . . *surface* (face) and *image* (look, appearance,)." This is a model of perception assembled out of the conventions associated with presentation as representation (Greenberg reversed), but Shiff then moves from the presentation of representation to presentation without iconography: "Because of the way the paint adheres to the canvas, gravity seems to pull against it like gravity pulling against skin supported by a human body. Johns's object *looks* as if it responds to physical stresses and strains just as we *feel*, in a kinesthetic and rather tactile way, that we do."[32]

It is, Shiff says, because the image's final destination as well as its beginning may be found in an encounter with the painting's surface like that of one with a living being that "With a certain irony, Johns' *Target* satisfies the criterion Greenberg once articulated: 'The best modern painting . . . refers to the structure of the given world both inside and outside human beings.' In and out,

back and forth, adrift between the sign and sign itself, the 'best modern painting' becomes breath."[33]

What Shiff has said here is that Greenberg's naturalism—which has its parallel in Newman's image of the tundra—is continued in other terms by Johns. I should say that the gesturalism of abstract expressionism is regulated by Johns, but the almost imperceptible play with density as intensity found in Newman's surface has no equivalent in Johns's painting because of the latter's fundamental commitment to drawing as opposed to color, so that the surface of his is always exclusively a space of production. That aside, Johns can realize Greenberg because they share a model of the body as an inside and outside, realized through a surface which renders painting's surface indeterminate ("adrift") in order that it might become breath—not an idea, then, but the presence of the living. It is happening, and it's organic. Or it's not organic, it's a figure (of erasure, thus the simple surface which replaces representation). If the latter, it begins by rendering erasure indeterminate. It is not erasure; it's a surface, an addition. All of Western painting erases as it adds. What's underneath can be quite unlike what's on top, unlike in, say, Chinese painting, which is hung up on a model of friction and passage rather than solids and voids, insides and outsides. You can x-ray a Western painting and find something no one knew was there. But the surface doesn't erase anything excepting in the presentation of something that is more than erasure (even if it is erasure, as in certain techniques). In that breathing cannot be erasure nor negation (excepting to the extent that it negates a negative, i.e., death), Shiff's account makes it clear that Pollock's and Johns's painting, however simple in Longinus's sense of the straightforward as a rhetorical effect, presents something by being present (e.g., rather than being present as the announcement of an absence). It is affirmative even in its use of negation (of the implication in what makes possible of, also, what is not possible).

I think, fifty years after Newman and forty after Johns, one question about painting that might be seen to follow from Shiff's observations could be about the indeterminacy of the idea of autonomy. Can painting now refer "to the structure of the given world" in terms continuous with the idea of it found in Newman, Greenberg, and Johns, or does the given world call for another idea (or sense, or feeling) about its structure?

Positively Heteronomous

I obviously think so, and perhaps equally obviously suspect that the most useful way of approaching the question would be through Deleuze's notion of the machinic assemblage, at once organic and machinelike, one side of the equation related to the other through a process of de- and reterritorialization (the teeth and mouth are a machinic assemblage designed for the territory of eating, which process becomes deterritorialized into sound, thence reterritorialized, by and as,

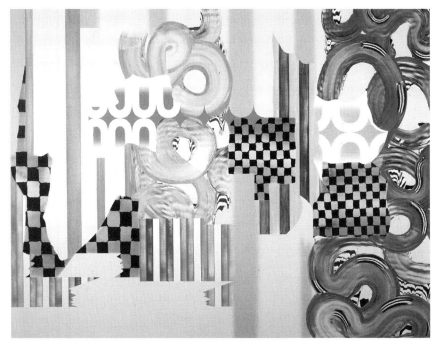

meaning—once again the sensuous giving way to signifying).[34] I should even say that, once proposed, it is already there in Newman: Paint is designed for the territory of the spatial (and is a surface). The spatial gives way to the temporality of the layering through which the surface is present. The painting, as I've described it here, is a convergence of times, particularly first and last, origin and end in simultaneous concert, an idea about time and unity (which are not surfaces but ideas). But in Newman this did not have to lead to an indeterminacy that brought autonomy into the convergence with its heteronomous nemesis. It seems to me that in the contemporary situation it does, and this is because of painting's (and everything else's) differently orientated, more saturated, relationship to an everyday in which nature has been largely replaced.

When I turn to a contemporary example to conclude the generational comparison I'm advancing here, I find that in practical terms some things have not changed very much and others may have changed without meaning to (a general principle as active in art as elsewhere).

My example is drawn from an interview with the nonrepresentational painter Shirley Kaneda conducted by David Carrier, an aesthetician who pays close attention to contemporary painting, in 1998. Carrier asked a number of questions, of which I want to discuss two. One is about beauty, the other about technology.

Beauty is barely present in Lyotard's discussion of Newman (appearing with its customary "merely" on one of the few occasions when it does show up, but essential in that it provides the calm required for contemplation), has no part to play in Shiff's that I can see, and as far as I know was never mentioned in any context by the artist himself. Its presence in Kaneda's interview is, then, a difference in itself from that of the manly atmosphere of yesteryear. Beauty is, however, summoned in order to be waved away according to tradition, although its summoning and dismissal is not, for once, exorcism. Kaneda is an Asian-American, so Carrier thoughtfully, or cautiously, asks his question about beauty in terms that do not oblige her to give in to what might be a quality identified with a subject specifically German in conception and genealogy.

Carrier asks:

> Much recent discussion has focused on that much beleaguered concept, "beauty," or its multicultural equivalent, "pleasure." What would you say about these concerns in relation to your work?[35]

Kaneda recalls several Germans, one directly, plus Baudelaire. First she says something compatible with the Schiller extract with which this book began: "The important issue for me is aesthetic experience as it is tied to the sensuous. And beauty is part of that experience . . ."[36] Describing beauty as at once a riddle and an evolving concept, which sounds exactly right, she then announces an Adornoesque program for the beautiful in her work: "I happen to agree with Adorno that pleasure imparts good feelings and that it is these that make us human."[37] Kaneda ends her answer with a sentence, Kantian in affirmation of taste as a legitimate concept, Baudelairean in its equally strong desire to undermine, the two being brought together in a very Frankfurt Institute desire to regulate: "What I am interested in is the notion of taste and our ability to regulate or subvert it."[38]

Now we know where we are in relation to a certain evolving concept. Beauty has been Hegelianized, thus able to evolve while on occasion serving in the ranks of that which subverts and/or regulates it. It could be thought of as serving in those ranks most of the time (a theoretical possibility instantly dispelled by a glance at Kaneda's work, at least for her own practice) or, alternatively (and a more credible description of her work, perhaps), more often evolving despite, whether in resistance to or just in parallel with, its subversion or regulation.

All in all though, Kaneda's brief discussion of beauty is as traditional as her discussion of technology is not. Having elicited, in response to a question about unity and how traditional notions of composition become problematic for painting because they lead to monochrome, a response from Kaneda in which she quotes Adorno's requirement that unity include "'much that resisted

integration,'"[39] Carrier turns to biography, where he gets from her a fine child-hood distinction between the "psychedelic" colors of Korean clothes as opposed to Japanese kimonos—"they seem more contemporary"[40]—and then to a question about technology:

> Does your color and structuring of space owe something (even in reaction) to TV, movies, and the computer? Any painter would envy the kind of absorption we feel before the television screen, caught before floating images which show reality, but because they are themselves attached to no surface, are easy to associate with fantasy. Any analogies between your layering and computer images?[41]

This question contains two questions of general interest here that have already come up and will continue to recur. Carrier's first sentence suggests but does not define the possibility of an obligation, on the part of painting to respond to electronic media, specifically, to the look of what's on the screen. He will have been aware that the phrase "even in reaction" could be read two ways. That obligation would be in response to a screen which I have said dematerializes and which he says facilitates or encourages fantasy—as opposed to a sense of the real—because of the lack of (perceptible material) continuity between it and the depictions and narratives which appear on it. In my opinion it is very astute of Carrier to single out for the painter's envy the "kind of absorption we feel before the television screen," because that reminds us that it is an idea of subjectivity that would be at issue here. Similarly, his notion that in painting there is a connection between the surface and what is represented refers to a connection which could only take place within the subject. There's as much nonrelationship as relationship between a mark and what it represents. In pointillism, for example, there is as far as possible no relationship. The relationship to which Carrier refers is one posited by the painting being handmade where the video screen and its contents are not. It is, then, a hermeneutic as much as a visual distinction. The relationship is between perceived continuities of production and the alternative. The painting is like Heidegger's chalice, raw material transformed by human attention but still visible and present as a material, and everything in it is known to be either a trace of the hand or recognized as a process that defers to the presence of the hand even while deferring it, as Pollock's drips trace or present gesture deferred by temporal delay, as Poussin's drawings make the hand defer to an idea, in which it reappears as the grounds for both a space and its connoisseurship, or as spray paint in art is read as a negation of gesture, which very condition keeps it firmly at the center of attention. No one ever talks about painters who've eliminated gesture except in terms of gesture and its elimination.

Kaneda answers Carrier's question about reaction and envy with a statement about her work that is ambiguous:

It would be impossible to say that there is no influence of television or computers in terms of how we visualize some abstract images now. There is always a parallel if one wants to make works that are indicative of the visual culture we live in . . . [But] [u]ltimately the painting's space is complex and does not have to adhere to any logic . . . If a comparison is to be made . . . I would like the paintings to function like a hypertext, in that each image of the painting, with its own specific qualities of surface, structure or color, links it to other areas in which each acts as a commentary on the other . . . This notion of linkage between similar and diverse bits of information seem to be the real content of the digital as a universal medium.[42]

 I have left out the bits where Kaneda makes it clear that electronic media are hampered by being irreducibly "mimetic," because her being a nonrepresentational painter more or less dictates that. What interests me is the tension between her description of painting as complex and not obliged, ultimately, to adhere to any logic—i.e., it can claim an unsupported, frivolous, freedom—and of the notion of linkage as the "real content" of the digital. One cannot imagine earlier abstract painting claiming to be freed from logic by its complexity, excepting as a kind of text in which more than one logic converged—although even there one would expect that unity to which Carrier referred—or as release from logic in the alogicality of expressionist or other theories of the gesture as communicating feeling without the need for concept and therefore logic, or in surrealist counterlogic. No one has had difficulty finding logics to which Pollock and Newman's and Johns's paintings may be seen to adhere—including, as has been noted, Newman himself, who while critical of Burke derived his idea of the sublime from Burke's version[43]—whether or not such attribution takes place with reference to a once general adherence (subsequently recanted or not) to Greenberg's version of Kant reformed by Hegel. So this sounds like a difference between now and the forties and fifties. Painting now, whether or not understood to be obliged to respond to the electronic, feels no obligation to logic.

 The question is not whether or not it behaves logically. At various levels it would have to: It's an intended object, and decisions have been made whose logic may now be traced and reconstituted by the viewer, for example. The point is, rather, that Kaneda says that it doesn't have to adhere to any particular logic, while earlier artists and critics would seem to have insisted it did. It had to follow the logic of the body conceived as a property of nature, at once continuous with and distanced from the "skin of the world," which continuity Shiff reinterprets as that of an inside linked (invisibly) to an outside by breath—the dialectic of the one and the many as an economics of intake and output. (For some, both Merleau-Ponty's famous term and Shiff's use of the idea of breath will contain echoes of the Annunciation, of impregnation through—God's—breath and light.) Kaneda, in asserting for painting an independence from any particular

logic, could be implying that it is as independent of the logic of the body as of that of the computer. To be independent in that sense would not be to posit a reactive a- or counterlogic—i.e., logic sustained by an exclusion or inversion themselves sustainable only through invoking what they are not—but it would be to posit another possibility for the body. It would suggest a body with options, thinking the world at one moment through the irreducible grounds of experience founded in a tactile continuity which was also the basis of perpetual analogy, at another through another model, which didn't need to breathe. That could be the model proposed by Kaneda when she finds technology to be united by an idea of linkage, which is to say that while painting is not committed to a logic, technology clearly is, and it is the logic not of an entity but of an infinite series of connections between similar and divergent bits of information. For Kaneda, then, but perhaps not for Pollock or Johns, were painting to address technology ("even in reaction," and leaving aside the question of whether in fact it could avoid doing so), it would be addressing that logic from a position of independence rather than, necessarily—although it would remain an option—from the perspective of an idea of meaning-production tied to the logic of the body.[44]

Such an aspiration as I am extrapolating from Kaneda's remarks could only be that. It could no more be realized than could Greenberg's purity, and for the same reason. The body does not think outside itself except to the extent that it knows itself able to be thought. I raise the question of independence here because it leads directly to questions about thinking's dependence on both nature and the organic and the alternative model(s) offered by technology. Within Kaneda's remarks one finds a question about technology which raises another question about the indeterminate, or another use for it, having to do with the limits of the idea. Lyotard relates the indeterminate to both the faculty of understanding and that of reason:

> [B]ecause the feeling of the beautiful results from a form, which is a limitation, its affinity lies with understanding. The affinity of sublime feeling, which is or can be provided by the without-form, lies with reason. There is indeed a similarity between both cases in that the presentation of the given should be able to be thought by a concept but, in both cases, is not. That is why the concept of understanding, like that of reason, remains "indeterminate."[45]

In Kaneda, we have painting as a form which can use, i.e., understand, ideas ("logics") at will and a technology which is irreducibly a logic (of "linkage") which is indeterminate in being potentially ungraspable but is wholly the product of reason. For her, painting itself has no logical obligations while being obliged to be a form and therefore to present itself through a logic. We could look in her paintings, for example, for a logic of surfaces, which did not have an inside or an outside. There is by her account as much reason to expect that as any other.

This could, I think, diminish painting's obligation to be exclusively the skin of an organism. The surface could become interpenetrated or intermingled with the idea of the screen, for example. It always has been. The surface that disappeared so one could fantasize is a staple of academic painting. But Kaneda brings this possibility into view in the absence of a final, regulatory, autonomous subject. Explaining that the world can't be unlimited because space and time can't be apprehended if "totality is infinite" and can't be limited because that would suppose empty space and time beyond the finite world "and no sensible intuition can provide objects that correspond to this supposition," Lyotard observes that even though Kant concludes "from this aporia that the question cannot be resolved in a determined way, that is, by understanding. . . Nonetheless, the very concept of the limit persists, even when it can only be speculative. The limit is the object of an Idea of reason, a 'being of reason.'"[46]

By his own account, painting was for Newman in the idea, indeterminate in its inexpressible control of the concept of the unbounded (which would also mean that he knew what he was doing when he was being spontaneous, including when that meant that he knew he didn't know what he was doing in so many words), found in the limit of the surface, which understood it in terms of the indeterminacy of beginning and end simultaneously present. But there need be no such completeness in Kaneda's theory of painting. Indeterminacy could take a different form inasmuch as the understanding, which was ultimately irreducible to any logic, need not find its origin either in the ideas of unity thought to be natural to it nor in the logics of linkage to which it might appeal. Or possibly it would find itself in both, thus rendering both indeterminate and at the same time a singular assemblage. If the latter, it would no longer posit a "being of reason" who reasoned with terms derived from nature alone.

It might instead relocate that being. I have said elsewhere, following Kristeva, that painting was always invaginative before it was phallic, a space before it was a figure, whether or not the figure then becomes a reason for the space and thereby its retrospective origin.[47] Newman's paintings, mostly made of space, stripes which are in fact gaps, force which is not a form within force which is not a form, then, could be seen in such a light. The image of a stick with endless space around it, already erased by one's sense of how the stripe is a revealed part of a buried surface, would then give way to one of voids within voids—which I have said is what happens when one looks at, as opposed to past or around, them. It seems to me there could at that point be no connection between the image and the surface other than that they canceled one another out by being immanent in each other in an indeterminate way.

Kaneda's idea of an idea of linkage present in technology and faced by a painting with no loyalties to any logic offers something else: painting that can take everything in, i.e., while still positing for itself an other. The technological

lies within and without it as a ("universal") idea of linkage. The subject produced by painting is presumptively indeterminate in its situation between the skin that breathes and another kind of life. I note that the "feminine sublime" has been said to be characterized by its making explicit "the subject's encounter with and response to an alterity that exceeds, limits, and defines her."[48] There may, then, be other causes than technology for Kaneda offering a theory of painting in which the limit gets moved. What I have been describing as a generational difference inspired by a change in the technical environment could also be a product of political change. Nonetheless it is in this instance technology which is standing alongside the body in Kaneda's theory of painting and its possible relationship to a content defined as a universal, but other, system of linkages.

This is not a pictorial effect, it seems to me, so much as it is something like a (counter)teleological presumption, which gives rise to pictorial effects. One can see in Mondrian's late New York paintings an unpresentable theory of modern life presented as painting, abstraction as a story about how strange it is that the underlying rhythms of the geometricized, industrial, world, should be those of jazz, a non-Western music of nonindustrial origin, which understood the mechanical as classical music never had. Likewise one sees Cinemascope in Newman and Pollock, and in both the idea of the film frame rather than the picture frame, that is to say, the frame as the whole image rather than what surrounds it and, as in film and impressionism, a wholeness not compositional but constituted temporally, out of an image or idea of the immediate.[49] Here I have restricted my remarks to what Kaneda says rather than what she does because the difference between her and Newman or Johns is, I think, less one of what the surface is like than of the intentions she has for it.

This is the sense in which, where Newman sought to visualize the invisible concept of spatial limitlessness in order to articulate a temporality conceived as a dialectic, the sublime as the fixed point and all other points, nonrepresentational painting might now find itself concerned with a sublime founded not in a relationship between beginning and end and origin and potentiality but, instead, imagined as an indefinitely decentered context of deferral, an androgynous sublime that collapses orders of priority—figure and field, surface and support, color and drawing—into one another to propose a temporality other than that of nature, a temporality of simultaneity and sameness, in the sense of painting as a body, a completeness, which is less continuum than a combination of continua. The limitlessness which was, for Newman's generation, represented by an image of expansiveness is perhaps nowadays a limitlessness conceived as a process (a temporality) deoriginated by its technological access to immediacy, and for the same reason without a destiny which could be located anywhere but in the present. What I have tried to show here in regard to possible recent changes in the art historical environment, themselves contingent on broader environmental changes in the culture at large, is that

where Newman could feel that painting could sum everything up in an aesthetic which did not need to acknowledge the technological as another form of life, and could therefore see the subject and the world as united by the same life force, Kaneda doesn't seem to need to do that.

But this may not be best described as a question of the recognition of an alterity, even if that is what is at first suggested by Kaneda declaring the sensuous as the basis of her aesthetic while noting the presence of a system of linkages that had not been there before but is now universal. In practice, I don't think art such as Kaneda's presents technology as an other, excepting to the degree that it is an, or one, other other, i.e., an idea of alterity in which technology is recognized as other in the sense of alien cannot be sustained. Indeed, it seems to me that the alienation phase came and went very quickly in contemporary painting. If one compares the poured Rhoplex paintings Ed Moses made in 1974 with those made by Linda Besemer in 1998 out of acrylic (both painters using the material as a self-supporting surface), one sees that the Bessemer has no need to see plastic in terms of something else, while Moses turned it into something that looks a bit like a Native American blanket. If the sublime (subject) were a question of alterities, it would be one in which, nowadays, the human and the technological were in an other than oppositional relationship. This could be seen as a schizo-relationship between two systems of delimitation (infinite nature and infinite technology) and limitation (nature made all the more finite by technology, technology finite because produced), which overlap but cannot be said to have the same ends. Or perhaps it could be imagined as a relationship which denies them a fundamental difference because its predicates lie elsewhere than in such a difference: "Heidegger . . . judged the opposition between the 'in me' and the 'outside of me' in the problematics of the so-called external world, to be inane."[50]

If so, it would accompany and overlay, or run beneath or through, whatever sexual language was reserved for the remnants of the human, or natural, subject. Sexually, but at the same time only reactively or critically—where the sexual is a politics before its an economy—one could posit the androgynous sublime as an axis, reimagined by an originally modernist self-consciousness, with an inversion of Burke at either end. On the masculinist end, Mapplethorpe's counter-Burkean version of the sublime as one of the same against the same, male power literally disappearing up a male and therefore its own arsehole. At the other, a feminist sublime counter-Burkean in its at least neutralizing the force of the one with another kind of energy, often described as more dispersed, certainly not centered around any pole or derived from it. But underlying that, making free use of linkage of any and every kind, and therefore paralleling the new found androgyny of the sublime as a field of sexual difference—the sublime politicized in terms implicit not only in Burke's simplification, or aggrandizing, but also in Kant's difficulty with beautiful women—there could be, perhaps, a

parallel (alterior) matter of forces and systems of ("universal") linkage, pulses finding themselves in other pulses, frictionless action without solids and voids, and as much like electricity as breath.

Glamour

There could then be an androgynous sublime made up of negative critique built out of responses to a sexual structuralism expressed most memorably by Burke, in which the sensuous is the basis for a sublime (political) reason: Nature leads to politics in the same gesture in which it frames the human. That is the basis for most debate around the sublime in the contemporary art world, and for the good reason that the art world is largely concerned with the conversion (or repression) of the sensuous into the political. Lurking around it is the androgynous sublime of technology, in which linkages are not grounded in criticality but equivalence, and which frames the human with the post-human. Of course, breathing too is irreducible to sexual identity.

I shall henceforth want to proceed, however, with the notion that the idea of indeterminacy necessary to the sublime subject has shifted to an indeterminacy in which reason hovers (or is not one thing) between a discourse originating in the body, i.e., in nature, which may in consequence be seen as an economics or politics of power, and an eerily more powerful power which originates in reason but is irreducible to its natural terms. The limitlessness once found in nature gives way, in technology, to a limitlessness produced out of an idea which is not interested in being an idea of nature, but one which replaces the idea of nature. Nature sublimated in a sublime that comes after it and in, or with, which it is now obliged to live. It's already there in Turner. The steam engine is not only in opposition to nature—a force within and despite the wind, fire and boiling water creating pressure which propels steel through the rain—but already, to the industrial subject, part of the landscape. The landscape potentially now has in it forces comparable in power with nature, but products of reason rather than forces that just are and, therefore, having no respondent (as the wind has breathing) in the senses but only in the mind. I should say the subject is already speeding toward heteronomy when it sees a continuity or equivalence, makes linkages, between forces—realized by Turner in paint, as Cézanne would make equivalent a mountain and the sky—which will erode the sublime's (pure reason's) autonomy as subjectivity comes to be parasitic on a force, which parallels nature but from which, since it originates in reason, this time it cannot make a clean break. Coal, however, came out of the ground. The working class and their oppression in the service of progress may be little in evidence in Turner's depiction (making possible a whole historicism of the excluded and its role in the nineteenth-century idea of nature, sort of like the Native Americans' absence from vistas of promise and destiny), but fire and steel are tangible. The

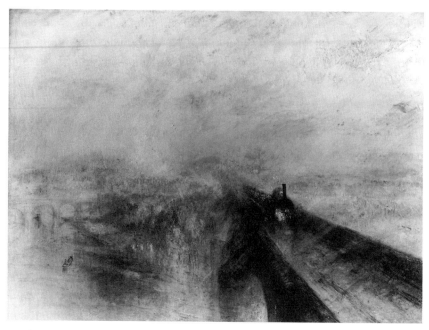

Joseph Mallord William Turner, Rain, Steam, and Speed . . . The Great Western Railway, *before 1844.*
Courtesy: National Gallery, London.

glowing screen is not. It is another idea of indeterminate limitlessness altogether, and about a present rather than a potentiality.

Beauty, meanwhile, remains off to one side, its frivolous unfoundedness giving it the strength to eternally resist deorigination because it itself has no starting point excepting those located through its effects. Derrida comes very close to equating the sublime with language because it is at once limited and limitless, and this underlies my insistence on beauty's necessary frivolity. If it remains beleaguered, it is so because it hampers the serious. As Schiller's formulation makes clear, once established as a motive for thought, about a thought which has no clear relationship to it, i.e., freedom, one needs to get it out of the way by replacing attraction with reason. But I think this is the sense in which beauty, if beleaguered or surrounded, confirms its identity in its indifference to such hostile investment.

Like Lyotard and others mentioned here, Michael Fried and Steven Bann have also pursued the distinction—also eighteenth-century in its origin—between an art in which one looks at something and an art about that act of looking, i.e., an art in which one could look at oneself looking. The first sounds like being attracted, the second like wondering what it means to be attracted. In Fried's study of Diderot and Greuze he makes it plain that the art which achieves the last condition most fully is that which treats the beholder as if he (now an indeterminate s/he) weren't there, self-consciousness achieved in the presence of

a rhetoric of indifference and completeness: the self finding itself in relation to a self-absorbed work, that is, one that does not require completion as does the "theatrical" work. The existence of the distinction announces the presence of the self-conscious viewer.[51] Bann, comparably, says that "Diderot is implying what might be called a morality of representation, whose principles are summed up in his antithesis between 'seeing' and 'being shown.'"[52]

This could also be the difference between the irreducibly visible and that which had to be visualized. I can see for myself but it's uncontrollable, whereas that which is shown has been visualized (as some unity made out of the aspect of what is shown that is revealed in the showing, showing is always partial). Likewise, act, process, and time are visible only as traces of what is essentially invisible, while beauty, in contradistinction, would have to be visible from the first. It was never other than visible and in that never needed to be brought into view. Except, of course, when it had been suppressed. One way of doing is to insist that it existed as an idea before it had any physical form, and of which it is said to be an imperfect (which keeps it safely "mere") instance whenever encountered in an object.

The morality of representation requires that the visual be restricted to the task of controlled revelation and exclude the uncontainably visual and with it the beautiful as frivolous. Beauty's uselessness lies in its being that which can't be reduced to its critique, i.e., to the sublime that is realized through critique and in the object of self-consciousness, in the self, which finds itself in wondering about what it means to be or have a self.

If beauty exceeds critical adequacy, is counterproductive where the sublime is critically productive, in the same way that seeing exceeds being shown, then the Laocoön problem is not the problem of slackening, of a loss of seriousness and sublime ambition, it's that beauty, because it is not critical nor a product of criticism, can only undermine that regime of good sense that is criticism's search for meaning. Beauty, in being frivolous, and in that trivial and irrelevant, is always subversive because it's always a distraction from the worthwhile, which lets us know it's worthwhile by not being beautiful.

As such, beauty stands in opposition to the idea of productive thought and perhaps to the idea of production itself. This may be why advertising, techno-capitalism's human face, is so dependent on beauty. As noted above in regard to the Chinese government and the bikini, it has to associate products with that which they implicitly cannot be and which is implicitly indifferent to them. Here one finds a very straightforward example of beauty's having to be feminine if it is to be irresponsible, if only by default. That the male can't detach itself from the principle of production is demonstrated by the fact that the male models used in advertising have to, at some level, look like they'd be at home in an office while female ones don't have to look as though they have any engagement in commerce whatsoever.[53]

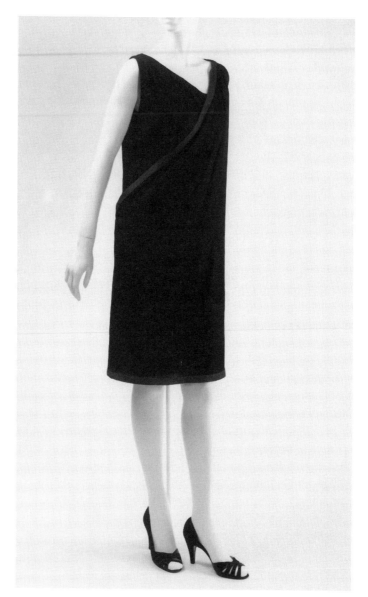

Gianni Versace, Day Dress, *1983. Black linen. Collection: The Metropolitan Museum of Art, New York, Gift of Carol R. Reiss, 1994. (1994.472.3ab)*

Beauty places a limit on the principle of production because—unlike subjectivity, which has a history of irreversible alterations in its appearance, becoming officially speculative and therefore formless (indeterminate) during the Age of Reason—it changes but is always the same. In its completeness it is not open to innovation, whereas philosophy and its adjacent disciplines reimagine the subject regularly.

Burke, who claimed that angularity causes discomfort in the viewer, would have been quite put out by some of the twentieth century's choices of body type, but on the other hand the persistence of certain archetypal norms is confirmed when one recalls that an early attempt at systematizing feminine beauty, Firenzuola's *Della Bellezza delle Donne,* which was published in the sixteenth century, says that the two most desirable hair colors for women are blonde that verges on light brown, and, as second choice, light brown.[54] Feminine beauty as it's conceived by the fashion industry, for example, changes body type every fifteen years or so but is always a matter of symmetry (whether playing with discomfort or comfort at the time). When it's asymmetrical, that's because that's the game that the fashion industry's body type of choice is playing with symmetry at that moment. (Dress design is sculpture's opposite in that it works with a form that is always symmetrical, but moves.) As such, complete and thus a singularity, it seems that beauty must be feminine because there's nothing else for it to be. It's not androgynous because it's irreducible and complete, and it can't be male because it's not encumbered by anxieties about power.

If one is to talk about the aestheticizing of the female body, then, one is I think talking about the place of the female body in an aesthetic where the beautiful is irreducibly feminine. That there is no clear relationship between women as such and the feminine as a principle or an image is I think demonstrated by the following example.

I have a child and therefore see a lot of children's films. In the film *The Mighty Morphin' Power Rangers,* a multicultural and sexually mixed group of pubescents finds itself on a distant planet where a very attractive young woman, slightly older than they and wearing an ecologically sound leatherette bikini, guides them to a point beyond which, despite the fate of the entire universe being at stake, she cannot go because if she did she would lose her eternal youth. Without a murmur of dissent, the Power Rangers go on alone, and I think one sees here a disassociation between women as such and feminine beauty (underscored by a woman in a bikini being powerful when an image of attractiveness and vulnerable when just a woman in a state of undress), which in a story that identifies the Power Ranger girls with the androgynous function of the group illustrates the independence of beauty with regard to the general economy of signs out of which capitalism is made. The film inverts what is usually an image of frivolous irresponsibility and identifies it with reason—whose mantle is soon passed back to the androgynous group—in a way which adds charm to the story, in that it both separates the image from the practical while involving it in it, and in that articulates both the teenage male fantasy and its worst fear—which could be Burke's too—namely the possibility that the fantasy might be as smart as she is cute. It is hard to recall such blasphemy occurring in an adult movie, where to be smart you have to look like the girl next door; beauty being more often either an accompaniment to the good (which is tough and male) or a temptation

ancillary to its adversary. Comparably, Burke sees the feminine as reflection, but what if it were instead power (a.k.a. reason) which didn't have to be expressed as hard and severe? It could stop being a rock and become a fluid, at which point I suppose one would have a feminine sublime that did not have to find itself in alterity. It wouldn't just have to always be wearing away a rock.

Here, however, I am interested in the feminine as the form taken by the beautiful. *The Mighty Morphin' Power Rangers* puts forward a vernacular image of the beautiful where it is once again found in properties or qualities such as lightness and flow, i.e., constituents of traditional definitions of feminine beauty and perhaps therein confirmations of beauty's being feminine, since it is these qualities that reason seeks first to co-opt and then obviate—Mapplethorpe seeking to frame the latter by the former in the traditional way. This is the sense in which beauty's proscription by dominant art practices raises questions that lead directly to the challenge to art's seriousness proffered by the frivolity of the fashion photograph. In the fashion photograph, because of beauty's frivolity, the powers of co-optation are visibly rendered weak. The image requires no clarification through supplementation or diminution, and is as such ungovernable.

Compare that to a problem traditionally associated with images of men that are meant to celebrate the male. Norman Bryson has asked why, in an art form so preoccupied with proportion, the male genitalia in Greek sculpture should be so small. His answer is that their reduction obviates distracting comparison: "The gap between actuality and the imago is dealt with by reversing it so that the idealized genitalia do not compete with the real thing; or, more precisely, they are made to compete—gap and disparity are presented—so that the spectator wins."[55]

In the next paragraph, in regard to a photograph of Arnold Schwarzenegger, Bryson talks about a comparably necessary sublimation of the genitalia in the bodybuilding aesthetic: "[T]o expose fully the bodybuilder's genitals is to leave behind the visual arena in which the activity is supposed to take place for an altogether different visual genre."[56]

Where the masculine seems unable to separate itself from the language of power, which obliges it to suspend sexuality in the service of an ideal—hardness and restraint as ideological imperatives—the feminine, fluid and unrestrained, could provide the possibility of a secularized beauty which we know as the glamorous and which in effect suspends the idealisms of power—through the substitution of the thrill for the thought, arousal for contemplation—by virtue of its implicit powerlessness. The limit it places on theories of production is the same as the one that the intransitive places on the transitive, which is that the former is what the latter cannot become, in that beauty, frivolous and not worthwhile, always has to be framed by something less than itself in the sense of being less complete, something which is always both supplement and in need of supplementation, something made out of the language of lack or absence or the

need for completion—in short, the discursive. If one were to describe Mapple-thorpe as the masculine counter-sublime, i.e., as a critique of the already critical, its continuity with the old masculinism would be found in its presentation of itself in and as action with an object, itself supplement to prior action and in need of a supplementary context to explain it.

The sense in which beauty requires no explanation is the sense in which its completeness leaves nothing for the work of art to do except to frame it, which once meant to give it a purpose but, such a purpose having become discredited, has more recently meant that it is prone to do it in a way that makes it disappear, as art could be said generally to have done from the gray and brown roughness of Courbet onwards. Roughness perhaps assuring one of the presence of the sublime at its most masculine, while grayness, as Goethe pointed out, "is all theory," which beauty is not.[57]

Goethe seems to have meant what he said. John Gage has shown that Goethe's popularity with intellectuals was a result of his clinging to a belief derived by Plato and Aristotle from Empedocles and Democritus, which, while wrong, philosophers had always preferred because it left reason in charge of everything else by making color an accompaniment and in some instances an epiphenomenal effect of black and white: "Aristotle stated that 'the intermediate colors arise from the mixture of light and dark.' He also identified five unmixed intermediate colors: crimson, violet, leek-green, deep blue and either gray (which he conjectured might be a variety of black) or yellow (which might be classed with white, 'as rich with sweet.'"[58] (Elsewhere, correctly associating color with energy and therefore heat, Aristotle would illustrate the idea that color derived from black and white through the example of heated iron, which turns from black, when cold, to red hot on the way to white, so that red may be seen as an intermediate product of a transformation from one tonal absolute to the other.) Gage shows that Goethe's popularity followed from his defending this idea that tonality precedes hue from Newton, who had shown that it does no such thing. It was "Goethe's emphasis on the polar structure of both the formation of colors from light and dark and their reception by the eye (which) made his . . . scheme, rather than Newton's, so attractive to Romantic philosophers such as Schelling, Schopenhauer and Hegel . . . All these thinkers, however, were attracted prima-rily to the logical structure of Goethe's ideas and were hardly concerned with experiment or even experience, for which they depended on the example of painters."[59]

I take this to demonstrate that, in the interests of reason (which is to say, of its supremacy) philosophy will (or would) argue with the empiricisms of either science or art. In its will to subject all qualities to a rule of pure ratio it returns one to Lichtenstein's observations about Plato, but it does so by con-firming that philosophy needed a way to *talk* about color as black and white, it was only as such that it could be permitted into discourse. Whether it was or not

was almost beside the point, irrelevant, or frivolous. Reason always imagined itself in black and white, its human version being drawing, which turned into black-and-white photography, beloved of documentarians but in the contemporary world an option rather than a fundamental, found in advertising, fashion, and art, but no longer on the front page of the newspaper.

This seems to suggest that reason requires that the subject's autonomy be expressed in a prior homogeneity. For Goethe, it required a mimesis grounded in a whole: "'The separation of light and dark from all appearance of color is possible and necessary. The artist will solve the mystery of imitation sooner by first considering light and dark independently of color, and making himself acquainted with it in its whole extent.'"[60] Drawing describes the world by putting down lines that aren't really there and relationships of light and dark that are. It is reasonable in that it announces the limits of its artificiality in an arbitrary sign—the line—and ties itself to the real through the language of the sublime, light and dark being qualities as well as properties, systematized into a ratio. Reason finds the world in what can as opposed to what can't be drawn, i.e., in what can be presented as colorless. Thus the popularity of gray amongst social realists, minimalists, and conceptualists—all reasonable, and serious.

As Gage makes clear, Goethe was also aware that color begins divided, where tonality is united, his idea of polar structure making him in this the ancestor, via Schopenhauer's argument that "the retina itself was stimulated by the complementary poles of red and green, orange and blue and yellow and violet,"[61] of Ewing Hering's opponent-color theory, which would contribute to painting's liberation from drawing. Beginning divided, color's hetero- as opposed to homogeneity is extended and complicated and rendered more than a binary by virtue of further differences brought into play within it by luminosity, tonality, transparency, materiality—well represented in painting, the source of most of Goethe's theory, by the differences evident between brands of the same color, each framing it in different conditions of fluidity and oiliness.

The nineteenth century showed that color could be independent of black but not of white. That is what Chevreul demonstrated in addition to a question about relative brightness. After that, black may be basic but it's not essential. When Matisse says black is a color, that is to say it is no longer prior to color; it's just another option for that which reason defines as frivolous because black can't be shown to precede it. We know that Matisse or his assistant used to wash his paintings down with turpentine every night so that if and when he finished them the next day they would look as if they had been painted all at once in a continuous set of movements—fresh, the surface wet all the way through to the end and never a clotted crust. In a letter in which he talks about Toulouse-Lautrec and color—somewhat surprisingly, since that artist is more often appreciated for his graphic qualities—Matisse may tell us what the look of freshness he was aiming for was meant to suggest. It was meant to make color

operate "in accordance with a natural, unformulated and completely concealed design that will spring directly from [the artist's] feelings; this was what allowed Toulouse-Lautrec, at the end of his life, to exclaim, 'At last, I no longer know how to draw.'"[62]

The natural and the unformulated and the completely concealed are not necessarily as continuous with one another as Matisse seems to think, perhaps. And I have implied that his interest in spontaneity, which is undisputed, was necessarily accompanied by a calculation around the known look of the spontaneous. However, the natural and the unformulated together suggest the sensuous before it is left behind and replaced by a thought about it—or about what to do with it. And a completely concealed design is one that has been made to defer to what it may support but not be.

The frivolous could be, is for the serious, that which was (only) worth looking at if the sensuous was all ("merely") that one was looking for. For reason it could not be enough because reason is always looking for itself. In Matisse, it would have to find itself in what had been "completely concealed." I have no doubt it can be found there, and have already suggested one such instance in regard to *The Red Studio*. Its concealment, though, means that it can only be found in what plays with it (hides it for example) and doesn't begin with it.

When an artist has sought to identify painting with the idea of looking at something implicitly worth looking at, in the sense of the sensuous as not necessarily a preliminary state of its own suppression, as in Matisse's paintings of people who were already attractive (which directly illustrate Kant's suggestion that a beautiful painting is a painting of something beautiful but in a way that conflicts, or so it seems to me, with his idea that "the ends of women" require a "logically conditioned" aesthetic regard[63]—i.e., that women's social obligations preclude specifically them, among all that can be beautiful, from being seen as only if not merely that), we tend to see such a practice as a certain sort of refusal of avant-gardism. Matisse plays with Santayana's definition of beauty as pleasure considered as the property of an object at the two obvious levels traditional to painting, summed up in de Kooning's famous remark about oil paint being invented to represent flesh. His insistence on color and the desirability of forgetting how to draw follows from his interest in pleasurability. It is an insistence on maintaining the instantaneity of the sensuous, whereas it is precisely by resisting beauty in favor of critique, its substitution of meaning for pleasure, and homogeneity for the unformulated and in that heterogeneous, that avant-gardism proposes itself as a high style able to resist its transformation into a beautiful style by remaining severe.

This is the sense in which avant-gardism is grounded in drawing's continuity with reason, has no wish to forget that even for a moment, and sees Matisse as frivolous. Drawing is reasonable and therefore the preferred media of works devoted to seriousness. Think of the argument against painting launched

on behalf of minimalist sculpture in the 1960s and the even more bizarre arguments for banality as a virtue which have accompanied subsequent tendencies.

And to be sure, somewhere in those arguments is resentment mingled with incomprehension. They are arguments that recall Hegel's remark about no man being a hero to his valet, not because the man's not a hero but because the valet's a valet.[64] Incomprehension would follow from having been unable to translate a set of terms into one's own. This being accompanied by rage against nature's unfairness (or rather, its lamentable and unpredictable insertion of fairness within the mostly unfair) and irritability if not rage at beauty's persistence despite significance having become attached entirely to its critique. (In that Hegelianism itself has been turned into a means for attaching significance only to ugliness or banality—understood as critiques of a discredited beauty—art history has become in this sense the expression of a social realism which has forgotten what it was once going to bring to the working class.) A double rage that returns one to Lichtenstein and beauty's long history of repression— matched exactly by a persistence due to one's being unable to think without it— especially to make, or make judgments about, works of art, however abject these may want to be in a context where goodness is inseparable from guilt. Lichtenstein makes clear that if it is to be there, then it will be said to be there to be repressed. In a historicist era, the sublime is likely to take the form of a document. A brochure for a lecture series at the Getty Museum offers one called "Beyond Beauty: Antiquities as Evidence." We shall get beyond it. What we really want to know about is everything else. Where the (male) power was, where the blame lies. Usually it's in the same place. As ever, the sensuous is a preparation for speculation about issues to which beauty is said to be barely relevant— and about which it may indeed have nothing much to say.

Set against that background there is another historical question about beauty, which has to do with where it may now be. If all works are by definition combinations of (references to, if these are not to be found in themselves in intended objects) the beautiful and the sublime, so that one may say that works of visual art always risk becoming exercises in containing the uncontrollable through a rhetoric of teleological purposiveness, the possibility of beauty's suppression has become more acute as the media traditionally associated with so-called fine art have ceased to be the ones through which beauty conceives of itself. The eighteenth century was a world that imagined beauty in terms of sculpture and painting: flesh which had the translucency of marble, cosmetics which enhanced by means of a layering that covered the surface. White lead, the traditional ground of oil painting, was also the basis of facial makeup in Kant's lifetime. Once beauty employed the language of the traditional arts, but now it doesn't. It employs instead the language of photography. Makeup nowadays enhances not by covering but by making the original more like it was than it ever was when left alone. Photography, made in an instant, developed in the dark, in a

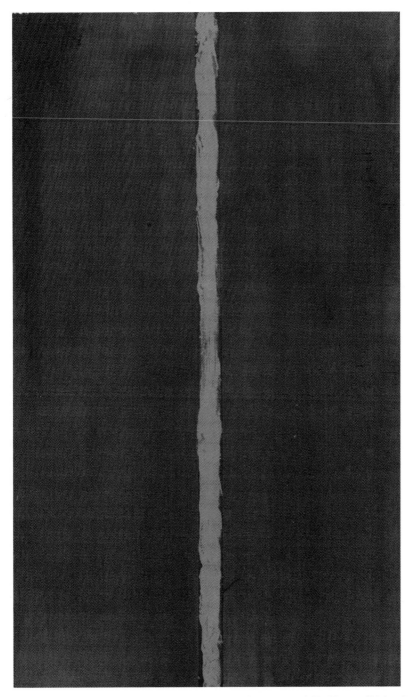

Barnett Newman, Onement I., *1948. Oil on canvas, 27¹/₄ × 16¹/₄" (69.2 × 41.2 cm). The Museum of Modern Art,*
New York. Gift of Annalee Newman. Photograph: ©1999 The Museum of Modern Art, New York.
©1999 Barnett Newman Foundation/Artists Rights Society (ARS), New York.

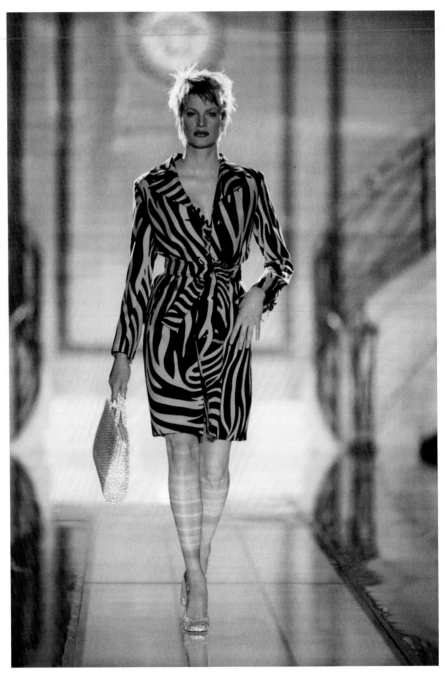

Kristen MacMenamy Models Versace Dress. *Photographer: Laszlo Veres, 1996, Paris, France.*
Courtesy CORBIS/Photo B.D.V.

Maja Lisa Engelhardt, Mark III, *1994. Acrylic on canvas, 80³/₈" × 80³/₈".*
Collection: DCA Gallery, New York/Galleri Weinberger, Copenhagen.

pool of poison, as a simultaneity, is like the beautiful in this property of always being all there at once. Unlike paintings, which are made bit by bit, over time, in the light, but also out of poisonous materials. Beauty has relocated itself. There is a kind of beauty which painting now looks at from the same distance from which it looks at flesh or water—surface which is alive, surface which is also a depth, two aspirations for painting which it cannot actually attain. It finds the same properties in photography and its attendant technologies, i.e., where art has long since found the banal sublime and the grounds for painting's critique and irrelevance.

The condition of the photograph is one of simultaneity, flawlessness, intensification, and one grants that once these occur in painting they no longer function as they might elsewhere, because painting is itself serious by definition, which is to say, glamour inevitably acquires a critical status if found in a work of art. The word "glamour" was originally an early Scots corruption of the word

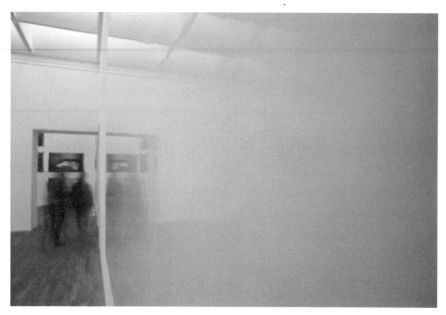

Karin Sander, Wandstück, dreiteilig (Wallpieces, three parts), *1993. Polished wallpaint, 9.8' × 13.8' (300 × 420 cm). ©VG Bild-kunst Bonn. Collection: Kunstmuseum Bonn. Photograph: ©1993 Achim Mohné. Courtesy of the artist.*

"grammar," reflecting the magical power through which it organized the writing which had recently arrived amongst them, so the glamorous is that which is magically articulated.[65] In such a situation Matisse would once again emerge as a model. He, after all, used the colors of that season's fashions as a palette, making painting aspire to the language of the glamorous from the start.

Kant has been accused of telling us that a beautiful work of art is one that is of something beautiful and is beautifully made, the traditional virtues noted above in Matisse, but never telling us what that looks like. If he had it might have gone elsewhere, like the unconscious fleeing the spot where Freud found it, driven by its exposure to take up a more secure residence in consciousness—where it feeds off the discourse that it makes possible. As suggested, the question is not What does it look like at the moment? (you'll know when you see it) but, rather, Where does one (expect to) find it, and why? The limpidity and contrived immediacy of Matisse's thin paint could also recall Nietzsche: "Everything that is good is light, what is divine runs on delicate feet: first principle of my aesthetic."[66]

It is as an image of that which defies gravity, or seems to, that painting has always approached the beautiful—Austin quotes Euripides' Helen describing the phantom representation of herself that went to Troy as "Not me, but a breathing likeness composed of airy Sky"[67]—but in our time it is obliged to do so by appropriating the surface of photography. The surface of painting having long

since lost the grounds which permitted it to be a normative surface, reaching out to all the other surfaces in the world in the knowledge that the human face imitated it, it now seeks to incorporate within itself that other surface out of which the world now makes itself. This is the extent to which it can't be itself exciting. There could, then, be a kind of painting which sought to embrace this condition and thus avail itself of the language of the glamorous (or alternatively of the document) and a kind which found itself through rejecting it in the interests of an idea of purity grounded in nature. (Which last characterization is meant to suggest that where purity was once a function of abstention from mimesis, it now extends to abstaining from the look of the technological as well as the appearance of natural things.)

Consider two contemporary artists. Karin Sander makes works out of polishing walls, an art of intensification, then, of a ground ungrounded by emphasis. Maja Lisa Engelhardt makes paintings which invoke those of Newman's generation, an art made out of discontinuities that are nonetheless apprehended as mutually articulated. Both are antitechnological, handmade productions. One replaces or incorporates the ground by putting nothing there, the other by putting something there. I'd suggest that the one invokes Longinus's opposition of a living face to a dead face, the other the idea of roughness and provisionality as signs of the presence of the body. Both involve refusal—in Sander, intensification as a refusal to engage the ground as a difference, to undertake to improve it in the sense of changing it; in Engelhardt a refusal of historical irreversibility, to accept that one may not do what seems to have been done before—and in this they set the terms in which beauty and the sublime may be seen to exist in a differential relationship which connects them, as categories, to the contemporary context.

The contemporary is a matter of unbroken continuity: above all the video image, hyperclear and without parts, constantly regenerated by an invisible movement, subdivisible at will into boxes none of which can ever be materially different from one another; but also the computer, infinitely present information of which none is spatially manifest (like Bergson's memory). That is why a modernist style like futurism now seems so quaint. It presents an articulated world, a world of joints and limbs, pistons and pulleys, where ours is a world of blank mobility, of the dumb rather than the histrionic, mute power, machines with skins but not limbs. A space filled with blank and smooth surfaces. In art as in cosmetics, the exposure of layering characteristic of the modern is replaced in the postmodern by a principle of intensification, the notion of duration by the idea of the instantaneous. Painting as temporality and accumulation is obliged to look to the photograph, to the technological in other words, as the form which is always simultaneous and in that complete. Sander embraces it while Engelhardt rejects it, but in a sense both address the same context of sublimity: In the one the polished wall points to the irreducibility of the applied surface, a dumb and

blank accumulation continuous with its support as is a photograph with the paper it's on; in the other, to the irreducibility of painting as a series of acts, simultaneity as multiple temporalities, a handmade sublime made out of refraining from the look of the technological and, in that, evoking it.

One may say then that beauty as glamour—beauty conceived as the attractively unproductive—stands in a differential relationship to a techno-sublime, a sublime found not in the presence of the forest but in the presentness simulated by the computer, not in the temporality of nature but in the simultaneity of the electronic. Beauty would in this context be flawless and blank, flawlessness being a prerequisite of the absence of lack, which is the breeding ground of the sublime as critique, and blankness a precondition of attractive indifference—the Byzantine Christ, the king's face, the face of the fashion model. The sublime, as a techno-sublime, would be limitlessness but not rough, and in that characterized by the terms I just associated with the beautiful, flawless and blank, a casing that tells one nothing about how the computer works, simultaneity and invisibility rather than process and visibly moving parts, the electronic as opposed to the mechanical. This would mean that the differential relationship between the sublime and beauty continued to be found in their tendency to share the same terms, and that beauty continued to be surrounded by that which it was not, but would in this achieve, or have restored to it, when making an appearance in works of art, a function critical by default. It would become that which prevented the sublime from becoming a religion made out of negative critique.

Perhaps this is a part of Damisch's observation that, "All things considered, things would have gone even worse for the Greeks if Paris had chosen Hera or Athena and thereby gained the political or military means to obtain victory . . ."[68] Quite apart from the state in which it would have left the Greeks, choosing anyone else would have set loose on the world a force unameliorated by temptation while infatuated with duty and law.

1. Damisch, op. cit., 20.

2. Kant, op. cit., 165.

3. Jacques Derrida, *Specters of Marx: The State of the Debt, the Work of Mourning, & the New International*, trans. Peggy Kamuth, introduction Bernd Magnus and Stephen Gullenberg (London: Routledge, 1994), 56–57 et passim.

4. See Gilbert-Rolfe, "Nietzschean Critique and the Hegelian Commodity, or, The French Have Landed," *Critical Inquiry.* Fall 1999 (Volume 26, No. 1).

5. Derrida, op. cit., 162.

6. Jacques Derrida, *The Truth in Painting*, trans. Geoff Bennington and Ian McLeod (Chicago: University of Chicago Press, 1987), 56.

7. Derrida, op. cit., 75.

8. Paul Guyer, *Kant and the Experience of Freedom* (Cambridge: Cambridge University Press, 1996), 260.

9. Guyer, op. cit., 263.

10. Guyer, op. cit., 258 et passim.

11. Guyer, op. cit., 264.

12. Alex Potts, *Flesh and the Ideal* (New Haven: Yale University Press, 1994), 117.

13. Potts, op. cit., 226.

14. Dave Hickey, "Nothing Like the Son, on Robert Mapplethorpe's *X Portfolio*," *The Invisible Dragon, Four Essays on Beauty* (Los Angeles: Art Issues.Press, 1993), 55–57.

15. Julia Kristeva, *Desire in Language, A Semiotic Approach to Art and Literature*, ed. Leon S. Roudiez, trans. Thomas Gora, Alice Jardine, and Roudiez, L. S. (New York: Columbia University Press, 1980), 142.

16. Guyer, op. cit., 154.

17. Potts, op. cit., 88.

18. Potts, op. cit., 82.

19. Potts, op. cit., 83.

20. One might compare this to the way art historians often see subjectivity as a starting point that is reached through a retreat from objective reality. In Meyer Schapiro's essay on the Armory Show, modern art gets a tremendous boost from Impressionism, which he describes as being grounded in the artist's subjectivity (p. 144), and after thirty years it will be to subjectivity that art returns once again as part of a general shift away from the social and towards the private and the psychological (p. 174). In between, all sorts of things will have happened which, while prompted by Impressionism's involvement with the subjective, led away from it. The implication is that while crucial to the development of new directions, subjectivity is what artists turn to only as a last resort, when the defeat of the Commune makes it difficult to keep doing realism, or when some other kind of realism runs into the ground for some other kind of reason; i.e., it is a stepping stone to something more important that one most often encounters it. See Meyer Schapiro, "Introduction of Modern Art to America: The Armory Show," *Modern Art: 19th & 20th Centuries, (Selected Papers I)* (New York: George Braziller, 1978), 135–178.

21. Kant, op. cit., 73.

22. Jean-Francois Lyotard, "The Sublime and the Avant-Garde," *The Inhuman, Reflections of Time*, trans. Geoff Bennington and Rachel Bowlsby (Stanford: Stanford University Press, 1991), 94.

23. Richard Shiff, "Verbalizing Visual Time: Barnett Newman as Writer-Painter," lecture delivered at the International Association for Word & Image Studies Conference, Carlton University, Ottawa, August 1993.

24. Lyotard, op. cit., 95.

25. Lyotard, op. cit., 93.

26. Ibid.

27. See, for example, Gilles Deleuze, *Différence et repetition* (Paris: Press Universitaires de France, 1968), 164–168.

28. Lyotard, op. cit., 92–93.

29. Richard Shiff, "Breath of Modernism (Metonymic Drift)," *Visible Touch, Modernism and Masculinity*, ed. Terry Smith (Sydney: Power Institute of Fine Arts, 1997), 206–207.

30. Ibid.

31. Lyotard, op. cit., 98

32. Shiff, op. cit., 213.

33. Shiff, ibid.

34. See John Johnston, "Machinic Vision," *Critical Inquiry* (Autumn 1999, XXVI, 1), 28.

35. "Shirley Kaneda interviewed by David Carrier," *Shirley Kaneda* (New York: Richard Feigen Gallery, 1998), 6.

36. Ibid.

37. Ibid.

38. Ibid.

39. Kaneda, op. cit., 13–14.

40. Ibid.

41. Ibid.

42. Ibid.

43. Barnett Newman, "The Sublime Is Now," *Barnett Newman, Selected Writings and Interviews*, ed. John P. O'Niell, notes & commentary Molly McNickle, introduction Richard Shiff (*Tiger's Eye*, 1948; New York: Alfred A. Knopf, 1990), 170–173.

44. Compare also with Guattari: "It's the idea of a transcendent subject that is being questioned here, as well as the opposition between discourse and language (*langue*) or, even more, the dependence of diverse types of semiotic performance in relation to a so-called universal semiological competence. The self-conscious subject should be considered a particular 'option,' a sort of normal madness. It is illusory to suppose that there is only *one* subject—an autonomous subject, centered on one individual. One never has to do with the multiplicity of subjective and semiotic modes of which film, in particular, can show how they are orchestrated, 'machinated,' and infinitely manipulated." Guattari, *Soft Subversion*, (op. cit.), 161.

45. Jean-Francois Lyotard, *Lessons on the Analytic of the Sublime*, trans. Elizabeth Rottenberg (Stanford: Stanford University Press, 1994), 58.

46. Lyotard, op. cit., 59.

47. Gilbert-Rolfe, "Where Do Pictures Come From? Sarah Charlesworth and the Sexual Development of the Sign," op. cit., 193–202.

48. Barbara Claire Freeman, "Feminine Sublime," *Encyclopedia of Aesthetics, IV*, ed. in chief, Michael Kelly (Oxford: Oxford University Press, 1998), 334.

49. The filmmaker John Ford once stopped a shoot and began tearing pages out of the script. When someone asked him what he was doing he said he wasn't going to start shooting again until something "happened in this damned script."

50. Francois Raffoul, *Heidegger and the Subject*, trans. David Pettigrew and Gregory Recco (Atlantic Highlands, N.J.: Humanities Press, 1998), 160.

51. Michael Fried, *Absorption and Theatricality* (Chicago: University of Chicago Press, 1980), 5 et passim.

52. Stephen Bann, "Are They Thinking of the Grape," *The True Vine* (Cambridge: Cambridge University Press, 1989), 43.

53. Gabrielle Jennings has pointed out to me that there's a corollary type of male model, the ones who look feminine: long hair; make-up; high cheekbones; grungy sex appeal. When not anchored in the semiotics of brutality the male reaches towards the (involuntarily parodic) feminine.

 The independence of the female model's image from that which it advertises is, on the other

hand, underscored by the fact that a lot of women who model for a living are very good at business, as is noted in a short riposte by Naomi Campbell to a novel whose author "attacks 'the howling mindlessness' of my profession . . . through his hero . . . a magazine writer with a yen for models and unfortunate habit of boring us silly. Connor drones on about Kurosawa, spouts Stendhal, and then when we fail to appreciate his brilliance, he writes us off as creatures with the IQs of lipstick.

"Puh-leez!! The models I know are sharp as tweezers . . . Thanks to people like Iman and Jerry Hall, who insisted upon being paid what they were worth, we are all taking care of business. I myself own a jeans label and am currently shooting a movie." (the *New York Times Magazine*, Sunday 1 November 1998, 57.) It is interesting that people have reached the point of writing novels that express exasperation at being unable to overcome through verbal display, which is to say, about how the attractive fails to give way to ideas. (And not only because of the principle at issue here, but because those who are attractive, as Campbell makes clear, also have economic lives which, like everyone's, are driven by ideas quite unrelated to beauty—as idea or anything else. At the level of the socio-economic beauty doesn't come into it, it's all action with a quest.)

54. Jacob Burkhardt, *The Renaissance in Italy*, trans. S.G.C. Middlemore (London: George C. Harrap & Co., 1929), 340.

55. Norman Bryson, "Gericault and 'Masculinity'," *Visual Cultures, Images and Interpretations*, eds. Bryson, N., Michael Ann Holly and Keith Moxey (Hanover, N.H.: Wesleyan University Press, 1994), 235.

56. Ibid.

57. Charles A. Riley II, *Color Codes* (Hanover, New Hampshire: Wesleyan University Press, 1995), 319.

58. Gage, op. cit., 12.

59. Gage, op. cit., 202.

60. Ibid.

61. Ibid.

62. Jack Flam, *Matisse on Art* (London: Phaidon Press, 1973), 121.

63. See Stephen David Ross, *The Gift of Beauty* (Albany, N.Y.: SUNY Press, 1996), 144–145.

64. Hegel, *Philosophy of History*, p. 32. Hegel says the first part of the adage is traditional but that he added the line about its being because the valet's a valet, which he says Goethe used ten years later without giving him credit for it. Of the valet he says that "the undying worm that gnaws him is the tormenting consideration that his excellent views and vituperations remain absolutely without result in the world" (Ibid). The contemporary situation is in contrast to one in which they have nothing but results, which are achieved by retaining a rhetoric of disenfranchisement. As has been said elsewhere, the image of the marginalized is to the left what that of the silent majority was to Reagan.

65. Diane Stevenson first brought this to my attention and I am delighted to learn that the word's origin should be in Scotland, a country infrequently associated with glamour in more recent history.

66. See Richard Klein, *Cigarettes Are Sublime* (Durham, N.C.: Duke University Press, 1993), 19, for a discussion of Nietzsche's remark, which makes it clear that for him this first principle required the addition of an (in this instance racially defined, exotic) alterity in order to become sublime:

A woman can be beautiful; a Gypsy woman is sublime . . . Nietzsche writes about Bizet's music as if he were describing Carmen herself: "This music of Bizet seems to me to be perfect. It approaches with delicate allure, supple and polished. It is amiable, it raises no sweat. Everything that is good is light,

what is divine runs on delicate feet; first defined, fatalistic; it remains however that of a race not an individual. It is rich. It is precise." (letter from Turin, May 1888).

67. Austin, op. cit., 146.
68. Damisch, op. cit., 136.

IV.

The Attraction:
Painting and the Photographic Model

A world made only of politics, or of politics as diplomacy pursued by other means, unconfused, in the purity of its quest, by any interest in the attractive but unproductive, is not without its advocates in the world of art criticism and theory. It could not be, since it would be a world without frivolity.

Its current form is the world made possible by Foucault, where there only ever was power of, however multiplicitous, one sort. David Lyon makes a related point in a book about postmodernity which ends with the sentence, "Nietzsche would turn in his grave,"[1] when he says that the paranoid vision of Thomas Pynchon's anti-hero Slothrop "is worthy of Foucault himself."[2] It is a textual word.[3] Friedrich Kittler has observed that Foucault's work ends at the historical moment when the collective public memory stops automatically converting, or naturalizing, everything into black and white. When, that is, history abandons the look of the discursive. Moreover, while (as has been suggested here) writing may itself be seen as a technology, Kittler thinks that Foucault—like Heidegger—preferred to overlook that aspect of the sign and context of discursive meaning:

> Before it falls into libraries, even writing is a communication medium of which the archeologist only forgot the technology. That is why his analyses end immediately before that point in time when other media penetrated the library's stacks. For sound archives or towers of film rolls, discourse analysis becomes inappropriate.
>
> Nevertheless, as long as there was history, it was indeed Foucault's "endless bleating of words." More simply, but not less technically than the fiber optics of the future, writing functioned as the general medium. For that reason the term *medium* did not exist. For whatever else was going on dropped through the filter of letters or ideograms.[4]

It may then be that a general faith in the power of (or in power as) discourse is sufficient to explain the popularity of an argument put forward some years ago to the effect that cheap photography was at first liberating for the lower classes, because it allowed them to construct themselves as subjects through collective self-documentation, but became bad for them when color replaced black and white, at which point the tonal language of historical consciousness, which is to say of the newspaper photograph and the early newsreel, was displaced by the color of the marketplace, seducing the underclass into becoming subjects oriented toward sustained and self-destructive gratification rather than progressively self-fulfilling liberation.

When film was only black and white it had been the same color as

writing, i.e., as truth and power. The objection to color photography was a nostalgic protest directed against immediacy on behalf of retrospection and occasioned by seeing that the colorlessness of print, which Goethe wanted to be the basis of all color, had been blown away by appeals to the senses—to vision rather than revision.

Advanced at the height of 1980s PC terror, this extreme advocacy of the banal sublime was another expression of the argument that Courbet and realism were good but Monet and impressionism bad: Dullness and monochrome are good because they lead to the idea, brightness and color bad because they remain at the level of sensation rather than leading toward good ideas and, thence, to ideas about goodness. It is, as noted, Platonic, identifying color with illusion and therefore falsehood, and perhaps also conventionally Christian in its insistence that truth is not a matter of the surface and can only be revealed when the latter has given way to an idea.

The eighties enthusiasm for rectitude, which was not unrelated to dismay at the horrifying turn toward the Right in the actual as opposed to symbolic political life of a decade polluted throughout by Reagan and Thatcher—followed by versions of themselves, the trivial rather than terrifying Bush and Major, who could not sustain the enterprise because they were not mad—created a fashion for gloomy fatalism within the art world. A rage for demystification accompanied a feeling that a historicist futurity had been snatched away by intervening events, possibly revealing a plot that would otherwise explain itself away as a logical or even natural occurrence, such as might be said of the development or evolution of black-and-white into color photography. It was a moment when the American sublime could be described, in an early essay on the work of an artist who has since become eminent for his deployment of an anthropological image of personal identity, as symmetrically divided into two kinds of religious hell: "At the heart of the American experience of nature is the schizoid vision of the garden or the map: a lost, innocent paradise restored by grace, or a utopia earned by reason and work; the Puritan's rebirth as immediate and unearned, or the point of departure for the Unitarian's progressive struggle towards enlightenment."[5]

The photography preferred by the art world's Foucaultian administration was all colorless during the 1980s—for example, Levine—and was in this, as in all else, continuous with the classical identification of colorlessness with seriousness revived and imposed by the alliance which had deposed Greenberg in the previous decade. The decade's enchantment by demystification would encourage me to say that the surveillance camera, the last black-and-white camera in daily use, took the place in the imagination of intellectuals which the brownie had once had in that of the working class whose interests they felt so keenly.

Walking in a Gaze

But I think that, quite apart from what it might miss about art and life, to dwell on photography's social unreliability misses something about its relationship to the subjectivity it has done so much to form (dreams, for example, having long since been agreed to be cinematic in visual and narrative structure).

It misses everything that has to do with the color photograph, still or in motion, as image, object, and surface, which follows from (a secularized) beauty having relocated or bifurcated itself—into photography, or between the photographic and everything else—in the manner described in the previous chapter. One implication of which could be that beauty remains, historically speaking, as unnatural (unusual, unpredictable, unsusceptible to regulation by logic or reason) as ever, but now has more options and may therefore be even more playful than in the past.

As I have suggested, this has consequences for the relationship between painting and the photographic. It means that painting's demystification by a photography closely identified with the sublimes of pure ratio (photography as an instrumental realization of a technology under control) and documentation (the image, deaestheticized, made entirely the property of historicism's monotheistic doctrine of power as divisible but derived from a single source) is half the story. The other half concerns painting's seduction by photography, which is not a demystification but a change of course, less about attack than attraction. It may have been very naughty of photography to become colored, but it allowed it to become a source of painting's rejuvenation.

In order to grasp the degree of frivolity this might make available, and the price or prize involved in resisting it, it will be best, before returning to painting, to develop this aspect of the photographic through discussion of the fashion image, which has a special relationship to the subject it helps to construct in that it originates not in the world but within the photographically based apparatus of appearance and communication described above by Richard Martin as Versace's concept of the fashion image.

It may be a historical distinction, between the nineteenth century and the present, but I do not think that people any longer use photography as a document. Rather, as some of my opening remarks about life in Orange County and everywhere else were meant to imply, in the twentieth century people above all want to inhabit the photographic rather than use it. Go to a shopping mall and what one sees are people wearing video-colored clothes eating video-colored food in a video-colored environment. A record is too slow and in any case beside the point—whereas a simultaneously generated video image is both superfluous and confirmatory, the surveillance camera as benevolent self-consciousness. People don't use photography to further their understanding of the historical conditions that define them, which is to say, to turn those conditions into reasonable black and white rather than frivolous color. They let it use them so

that they may enter the world of the image without understanding it. Knowing as it were instinctively that no one lives in the world of the real, because that's not where life is, people seek to share in the life of signifying contexts. The contemporary subject seeks to be an image created by video, to live within and through its perfect, seamless surfaces and pulsing electronic flow, a consciousness habituated to the technological possibilities for linkage which already organize the discontinuity of its dreams, i.e., of unconsciousness. Color allows contemporary technology to do this where print and black and white photography could not. I mean by this that, to judge by appearances, technology is *in* the contemporary subject, i.e., it shares space with, or displaces, nature within the body as well as outside it—philosophy having unintentionally cleared a space for it by robbing the body of its interiority.

If the fashion image may be seen as a tripartite structure—the model, the clothes, the photographic—where each part borrows the properties of the other two, and if twentieth-century fashion has been about clothes and cosmetics which intensify rather than conceal, then these are the terms in which a secular beauty, frivolously irreducible to critique, defines fashion as a zone with which power has to identify itself—demonstrating in its need to do so the powerless power of pleasure (seduction) over work (production).

As I said when I introduced my argument, Stephanie Hermsdorf and I sloganized the body of the contemporary model in a discussion of it and its image from which this one derives, as "thin, blond, mobile"[6]—to which I shall here add the blankness that is necessary to the electrical. In developing an idea about beauty's relocation (as glamour and attractiveness) to the photographic— which is always thin and is now electronically mobile—one is concerned with the first and third of those properties. By this route I can proceed from glamour to photography—as sign and object—and thence back to painting's possible relationships with the photographic as that which possesses the magic painting once thought its own.

Taking the fashion image as the conventional form of the glamorous, then, I think it right to start with the model's walk if one is to talk about mobility. It seems worth recalling again that clothing is very hard to design. It has to look good when standing or sitting and also when walking, much more complicated than architecture, let alone sculpture. One wants then to say a few words about the walk as that which frames it, and which must have some relation to walking in the world at large. I should say it has a very direct relationship, as straightforward as that of the clothes and the cosmetics to the condition of the photograph.

All three are involved in constructing an image of mobility, which is otherwise (un)grounded in the mobile, from or through which follows or flows fashion's general relationship to a world of objects which are themselves signs. This begins with the fashion image's association of the contemporary body with

the electronic seamlessness of video where it had once connected it to the mechanical elision of interruption which was film and, before that, to an image at once vital and static, the painted image, the sculpted form. However, one must stress that whenever fashion associates the body with anything it does so only so that the body can triumph over it.

For example, fashion flirts with transgression, and in as much as transgressing is made up of serious acts and affairs—inversion, breaking rules, crisis, violation, things to fear and by which to be tempted—flirting with it turns seriousness into a plaything, a serious object for frivolity's mischievous subject. The confirmation of which is that fashion has long been aware that even symbolic transgression is now available only as the symbolic form of a symbol. Now that all frontiers of length and plunge have been surpassed, shock is never shocking and cannot be. It's either fun because it's in fashion or boring because it's not. Fashion, like art, would have to transgress against the idea of transgression if it were to do anything new with the idea, which, unlike art, it has no need to do.

On the contrary, its goal is always the same: to sum up the whole world in a particular costume presented by way of a particular posture or range of postures, once related to the picture or the statue, now realized as movement. It's no longer how she stands but how she walks.

In a highly informative article in *The European* whose title, "There's More to a Walk Than the Legs," goes directly to the question of movement as necessary supplement, Stephanie Theobald describes how nowadays it is desirable that beauty be accompanied by a reference to imperfection:

> In a changing modeling world that no longer demands bodies like gazelles and necks like swans, imperfection—albeit beautiful imperfection—can take you a long way. [Claudia] Schiffer has long been aware that she is known as *la vache Normande* in bitchy Parisian fashion circles because of her slightly lumpen gait, yet her pounding tread and loud glamour have turned her into one of the world's richest models.[7]

The walk must incorporate, or be framed by, the banal sublime: "Paris's top posture coach, J. Alexander . . . insists that there is no such thing today as a fashionable walk: 'The walk should reflect real life: natural, unbothered, bitter, angry or fresh, young, pretty, confident. I prefer the latter look.'"[8]

Confidence would seem to be something that any of the other qualities recommended by Alexander could also be. It is in itself affirmative intransitiveness, and a preference for it an assertion of its necessity in the construction of the fashion image. Real life is to be reflected in an image of confidence. This would mean that the model's posture would interact, play with, other images of the confident.

Here is how Theobald describes how to do the walk: "Tilt your pelvis forward, pull your shoulders back and imagine you are walking along a chalk line. Put your heel on the line and lead through with the instep to make your hips swing to maximum effect."[9] It's a march, in other words, and I want it to relate to the history of walking as marching. Theobald notes that Alexander is careful to say that if you're not good at it you'll look silly. One must have "the most important asset in the world—charisma—or you will end up looking less like Stella Tennant and more like John Cleese from the Ministry of Funny Walks,"[10] and that of course would return one to the Laocoön problem, and how careful soldiers have to be not to look silly. Playing with marching would be playing with the masculine in an obvious sense, and perhaps a devastatingly final one if attractiveness were to play with it without critiquing it—without sharing its terms, thus depriving it of any ability to say that it owed its final defeat, its transformation into the frivolous—to itself.

George Weidenfeld, the publisher, has described Germany in the twenties as a place where one marched everywhere: in to see one's father or off to school or work. When Hitler came along they just changed some of the tunes and issued uniforms. Militarism having since become unfashionable, the contemporary runway model models a body free to move, as opposed to the voluntary automatism which was once the German—and not only the German—citizen's body. A body free to move is the ideal form of a contemporary bourgeois type, the businessperson as a sociospatial nomad—up and down the income scale, (constantly) prowling for (immediate or long-term) opportunity, spread around the map by the corporate employer, going with the flow, swept along by the market.[11] The model models an ideal form of the subjectivity characteristic of late capitalism. As ideal form—as entirely visual, unspeaking, separated from the world by the runway or the camera—the model's walk celebrates, but, in that, deconstructs, the untidy walking of a culture that's at least overcome, or deferred and displaced, the militarism of its recent past. Walking is irreducible to the historical, because the body isn't, and therefore can be about history and ideology as much as of it.[12]

This walk—as may also be said of contemporary art—although an international style, contains subdivisions. However, because individuals play with and confuse—frivolously deoriginate—typological categories, one may only see these clearly by comparing mannequins in shop windows around the world. The original standards are set by France and Italy: French posture is unitary, columnar, the body arranged according to a central oneness, neck, waist—the figure as a vertical axis; that of Italy binary, a series of mobile relationships between symmetries, shoulders, breasts, hips—the figure as a field of departures from the horizontal. One leads to stability, the other to movement, and these two paradigms provide the terms for all others. It is through reference to them that one notices that while German mannequins don't march they do stride, that English

ones retain, whatever happens to be in fashion, a pre-Raphaelite connotation, roughly speaking the image of a fragile girl who's nonetheless good on a horse, and that American ones tend towards the athletic and therefore toward health— so beloved by Americans that they've made health care a precious object, like art—and which is always dangerous to frivolity because of its conceptual proximity to death. Athletics inherently raise the question of health and therefore decay and therefore death; talking about them promises to bore one to death.

The postwar and subsequent success of American fashion was based on sports clothing. And, it turns out, on the unusual length of American models' legs.[13] This success had been anticipated by American designers like Claire McCardell and Vera Maxwell who "looked to mechanization and the assembly line for a model of dress. Efficiency and utility were desired traits of dress long before war's scarcities made them a government requirement . . ."[14] Sports bring the values of militarism (close-order drill, victory, and defeat) into civil and commercial life, and it is interesting that clothing aimed at efficiency brings with it an idea of the body free to move suitable to all of these. At the social level, McCardell aims at clothes which women can work in—threatening to upset the social order—while Chanel, to whom Martin compares her, aims, in turning a servant's outfit into the famous little black dress, to subvert without disturbance. At the religious level, its basis in sports clothing requires contemporary American fashion to be playful with the culture's most deeply held virtues.

The American sublime once more looms into view as Martin says of McCardell's most important idea, which foresaw in clothing what would fifty years later be the general condition of consumer objects, that: "To be able to think of an essential wardrobe in four components is an intellectual engineering closer to Thoreau's principle of economy of living than to the merchandizing of fashion near or far from Walden Pond."[15] Martin's and McCardell's American sublime may not be the nightmare proposed above by Sherlock, but is founded in a purity and economy of means like that espoused by Greenberg, who, as noted, thought it characteristic of the culture. McCardell anticipated a situation in which the practical would have to be fully integrated with the attractive along American lines. The frivolous would become wholly identified with utility and practicality, and eventually take it over. Now, in a world so long Americanized as to have become post-American (Americans themselves, thanks to cappuccinos and BMWs, no longer having to be wholly there), it is with the simplicity of the American sublime that fashion plays when playing with simplicity, the virtues of grace or labor becoming incidental to the play—incidents in an articulation in which labor is presented as effortless and grace as a given rather than a reward. The contemporary fashion model operates in a world (of images) in which McCardell's interchangeable elements are the norm and where the American sublime is the conventional form of simplicity: "for Versace, a linen dress is as simple as a Barnett Newman painting, which is to say that it is calculated and

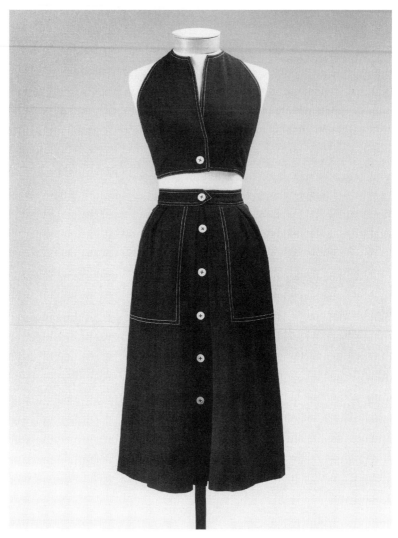

Claire McCardell, Sports Ensemble, *1944. Black linen. Collection: The Metropolitan Museum of Art, New York, Gift of Claire McCardell, 1949. (CI 49.37.30a, b).*

contemplated to every measurement and variation."[16] Fashion is always most playful when being serious, when it invokes images of pure ratio.

As technological image, fashion locates the body within a world of surfaces that resemble, or reassemble, its continuity and immediacy in terms that it borrows for itself. As an image of the social it feminizes the athletic, which had been sublime to Winckelmann and so many others before and since for its severity. To frame beauty, sports clothing had to shed its threatening air of

competitiveness in favor of a confidence which derives from being without competition. In this, the fashion image seems Kantian in that it is an attractive picture of the attractive, its secularism guaranteed by its playful attitude to the problem Kant had with reconciling beauty's lack of ends with woman's necessary ones. She no longer has any, and—McCardell contributing to the terms in which "woman" might guarantee her mobile independence, by introducing a costume which could with small adjustments work at work or be playful while at play—costume, in that, becomes the locus of a differential between the serious and the frivolous unlike that of capitalism's heroic phase, when great pains were taken to keep the two apart.

Secularism would have to be agnostic lest it become another religion—as atheism requires God and antifascism fascism—from which it follows that the secular blurs distinctions sacred to others, taking irresponsibly from either side. The contemporary woman's suit, a triumph of American fashion, represents a subject ready to work or play at will and therefore able to play with the distinction, the need to defeat the sport's connotation which lies nonetheless at the origin of the enterprise stemming from the seriousness, expressed as humorless ideology, of athletics and the commercial Calvinism fundamental to American fundamentalism. (Significantly, the male model models either a suit you can wear to work or clothing in which to play, typically in a rugged and competitive way. In symbolic reference to both ecological responsibility and a heroic, if racist, past, safari outfits were at one point a major item of male leisure wear, for example.)

Especially when moving, the body in the women's suit plays with the dearest values of sports and the market: "Lucy Clayton College, one of Europe's most prestigious deportment schools, now holds 'assertiveness training sessions' instead of walking classes as it did in the fifties. Kate Smart, head of image training, describes today's walk for ladies as having 'slightly masculine overtones.'"[17]

The reader's imagination will no doubt be more agile than mine, but I can conceive of little that is less masculine or more feminine than a fashion model. These "overtones" would then be framed or deployed from a distance. The context in which they occur is one of soft fabrics, fluid motion, and, in the fashion video, typically of continuity as interruption—provided both by cutting and by strobe lights—which focuses on the body's articulation in relation to the garment(s) that move interdependently with it, in concert or with a slight delay as the case may be. The body as a volume is inseparable from the walk, while as a surface it identifies itself with photography, which in the fashion image doesn't document things so much as it proposes them as conditions of the photographic. The model lives in the photographic, where, at her legs rather than her hands, the absurdity of the masculine is paraded without comment, agnostically rather than satirically, as a frame or coat hanger for everything it isn't.

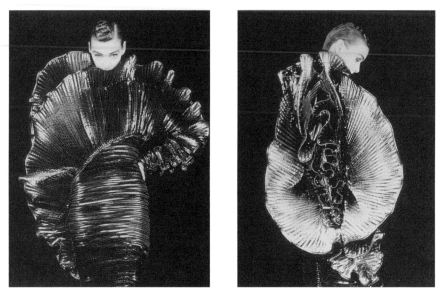

©*Krizia, Advertising Campaign, Fall/Winter 1987–1988. Photograph by Giouammi Gastel.*

Understanding Media

The Kantianism of the fashion image as event lies, in some respects, in the properties the model shares with the material conditions of the image. Fragility combined with seamlessness characterize the photographic surface, making it the visual form closest to writing when it seeks to imitate speech—immediate, seamless, beyond fragility in its incorporeality, and also, like photography, implicitly representational. Both photography and writing live on the page— usually it's a case of tear the page up, throw it away, there are many more where that came from—hence the despair brought on by the intrusion of color. Their power derives in part from one's sense that a page that bears a message or a sign is flimsiness itself combined with greater immediacy than anything but music, which is mobility without any substance save possibly breath. Another part derives from their reproducibility, and their connection to the idea of deorigination common to print media (where one starts not with an original but with a number of copies, which may be reprinted) and to industrial or technological objects, making printing the model of capitalist production, and writing, of the subject it produces—which both so patently are. All the more so, or, I am suggesting here, at least noticeably differently, since printing ceased to be a matter of an impression and writing became something which began at the keyboard.

No art form could survive such competition without acknowledging it in some way. Survival would be dependent on such an acknowledgment, would

have to take the form of either convergence or denial. The question has a certain urgency, in that if beauty is now (when, in fact, was it not?) inextricably entwined with glamour (a magic language of order without meaning, i.e., a grammar), and if the place where one finds beauty as glamour is in certain photographs, then only that painting which seeks to make the idea of painting itself converge with the condition of the photograph could articulate the language of glamour, i.e., be beautiful. (It is in these terms that glamour seems important to beauty because it is in being glamorous that the latter guarantees its own freedom from morality, or at least from moralizing.)

Painting that doesn't seek such a convergence is, in its commitment to denial, consigned eternally to the sublime as a poetics of the negative: not beautiful, eruptive, rough, sincerely nonaesthetical, lumpy, scabrous, always threatening to lapse into the merely human in its attempt to get beyond just that, i.e., to preserve pathos (meaning) in the course of invoking terror (meaninglessness).

The beautiful, on the other hand, in being dumb and blank—dumb in that it does not propose, offers the grounds for no argument, and I shall shortly come to the broad significance of the blankness with which it nowadays associates itself—is indifferent to the pathetic and the terrifying, leaving them in the eyes of the beholder, who recognizing beauty's refusal to be interested, may indeed feel terrified and pathetic: powerless in the face of an attractiveness which is also an indifference (the beautiful an object which mutely raises the question of what the right way to look at it might be as it, equally wordlessly, eludes such demands for a teleological purpose).

Painting could only be dumb and blank in this way to the extent that it did not propose a critical relationship for itself toward photography—convergence could not be critique. Accompanying this, perhaps underlying it, is another problem that photography poses for painting, their capacity for convergence is qualified by their being opposites: Photographs are fragile, made of paper, where paintings are bulky and made of wood and cloth; the photographic surface is taken all at once, developed and printed all at once, always a continuous surface, where painting's surface is built piece by piece and layer by layer.

If beauty now inhabits the photographic, painting can only address it in terms of equivalence, then, for two reasons: Because mutual criticality comes automatically with the forms' mutual exclusiveness, and because beauty has nothing to do with being critical. Gerhard Richter may be a good example of the conventional relationship between painting and photography, where the relationship is automatically critical and beauty is (I think just as automatically) excluded (in favor of critique), and his example is instructive for those of us who might want to go in quite another direction.

Richter has played with the photograph in terms, which reexamine the look of the photographic by subjecting it to the methodology of painting. In doing so he's produced at least three effects. The first is the effect created by the

landscape paintings, in which a photograph is the basis of the work. In these, photography mechanically produces landscapes as boundless as Friedrich's. These are the works in which Richter came as close as he ever would to the question of beauty; they are blanker and less obviously motivated by a critical theme than his other works—and as it happens they're also more thinly painted.

The second effect is the opposite of the first, and is found in the (very powerful) Baader-Meinhof paintings. These, based on newspaper photographs, slow down the photographic surface by making a painting of it. Where the thinness of the landscape paintings paralleled the continuity of the photographic, in the Baader-Meinhof paintings the methodology of painting thickens the surface up, makes it register the mark and the smear. As it does so, it makes the language of painting consume photography, restating it as a memory, by means of which photography's instantaneity is placed next to the immediacy of the painted mark.

Both of these effects of Richter's are the products or the producers of critical relationships. In the first, photography critiques painting by continuing to be the stronger signified, contextualizing all that is done to it by painting in a way which defines the latter as a surplus. In the second, painting critiques photography, functioning not as a redundant (excessive) signifier, but as one signifying in a way that the photographic signifier can't. Not at all a simple reversal of the first effect, Richter's second effect is a condition of rivalry or comparison, which is why I say he places photography and painting side by side in the Baader-Meinhof paintings.

Neither of these groups of works have much to do with photography as the locus of the beautiful. Their criticality precludes it as, one might say, does their emphasis on production (methodology), in the sense that they make a drama of the (implicitly critical) relationship between the handmade and the material.

A third group, however, addresses the photographic implicitly rather than explicitly, in a way that is not critical and in which one sees the photographic as an agent of seduction rather than as a principle of production. These are Richter's abstract paintings, which seem to exist to be photographed. On their own his abstract paintings seem to have an awkward relationship either to the rest of his work or to other abstract or nonrepresentational paintings. The attempt to lodge gesturalism in the same historicist logic of production techniques as everything else seems unconvincing precisely in the sense that one cannot be convinced by the work without having first acceded to the argument which produced it, and to that extent too these works seem like equivalents for paintings rather than actual paintings.

But once converted into full-page color photographs in *Artforum* or *Parkett*, concentrated into the intimate space of the page, the flatness of which gives reason to the uneven surface it illustrates, one sees the point. The works, as photographs in magazines, provide one with an idea of the status of the

nonphotographic image in the world of the photograph (which is, now, the world), as well, of course, with an idea of the role of the photographic image in the dissemination of the nonphotographic (if it can be said to be that, i.e., if there is such a thing at all). The nonrepresentational paintings, which contain no overt references to photography, exist to be taken over or led astray by it. They cannot do without it, are helpless before it, have a relationship to it which is dependent rather than deconstructive: They tell us nothing about photography.

To this extent Richter's nonrepresentational paintings at least locate the photographic as a power rather than as the object of a power (a critique). They are demonstrations, also, of the muteness of the photographic, its characteristic evenness and brightness.

Which is to say that what is demonstrated is something about photography's (or the photographic look's) possession of an idea about, or access to an experience of, light ("everything that is good") that is denied to paint, marble, and bronze, and which has come to be that which provides the beautiful with a grammar. Photography offers a surface homogenized, rendered continuous, by being made out of light. Paint is pigment trapped in a polymer made out of oil and varnish—one looks at the color through a lens made out of oxidized oil. Marble glows from within, seeming to supplement the light from outside with its own. Bronze seems to absorb light, to suck it in and give some of it back. But in photography, light starts with the surface and is the surface.

The task for painting, presented with such a challenge, would be to reconstitute it uncritically—magically rather than critically—which would mean separating it from its function and origin in representation without representing it. Which is to say such painting would be the presentation of photography's surface of light as a possibility for painting, rather than painting as—as it is in Richter's nonrepresentational paintings—painting as a representation of that surface which yearns to be reunited with it.

It is not that Richter's paintings are representations of nonrepresentational painting, that question, which is raised by that of their place in his total oeuvre, is more than answered—i.e., is more than satisfactorily problematized— by the works themselves. It is that they await reproduction, are not fully realized without it.

But there could be another relationship to the photograph. One which traded on painting's superiority in two respects: Painting can be blanker than a photograph—because nothing was there to now be absent—and it can be dumber, a mark made of and which makes non-sense, whereas photography must be at least the registration (a marking) of absence, absence represented (actual absence replaced by the representation of—another—absence) as opposed to preserved. The production of absence is not the same as the production of blankness, but only its representation. For the same reason, photography can never be entirely dumb, cannot but be engaged in teleology or in the parallel

Gerhard Richter, Baader-Meinhof: Cell, *1988. Oil on canvas, 200 × 140 cm. Courtesy of the artist.*

Gerhard Richter, Barn, *1984. Oil on canvas, 95 × 100 cm. Courtesy of the artist.*

Gerhard Richter, Abstract Painting, *1984. Oil on canvas, 190 × 500 cm. Courtesy of the artist.*

engagement of withholding from it. Here its identity as a mechanical apparatus works against it. It cannot avoid imposing a straightforward logic, known to us all, on the world, and, in that, it can't avoid communicating, it has no capacity to withhold (or even to signify withholding). The fashion photograph may be the purest form of the photograph, in that there is in it nothing but representation but also nothing to represent, in the sense that representation implies a need for interpretation. The fashion model herself aspires to the condition of the photograph, light, flawless, able to play with awkwardness because she herself is ostensibly fluidity itself, and the fashion photograph takes place as often as not in no space, with a monochrome backdrop—ideally, perhaps, the color of a photographic gray card, that which sets the camera's exposure in the first place,[18] or it can be black, light's zero, which the model occupies and illuminates. But even the fashion photograph is explicitly laden with ideas (from sexuality as a matter of symmetry and mobility to—how could we resist?—how these function as signifiers of class and exist as capitalist reappropriations of the above mentioned properties, etc., etc.), and it is in their service that it places its own light-produced and light-filled service.

For example, I have written elsewhere about David Reed's paintings, which since the 1980s have been made of color reminiscent of photography and in particular of the color of film and television, and of movements—flows— which give way to other movements, rather than of forms which give way to forms.[19] Unlike Richter's, his painting doesn't begin with an image—of either a figure or a technical process—which it then studies, but instead steals the look of photography (and I should note that Reed is a great admirer of Richter's work) in order to paint not hermeneutics but light. Where Richter is a realist Reed is an impressionist, but not of natural light. Richter's Habermasian interrogation of the means of production begins with pictures of things or marks, whereas Reed's paintings are not analytical but begin with the light contained by painting and the question of how to extend and find within it an idea of mobility that can link it to the contemporary. When Reed had a retrospective in the museum in La Jolla (his hometown) which Venturi has adorned with stubby little columns, Robert Pincus wrote in his review of the show that the lateral extension of much of Reed's work implied "Western vistas—real ones and cinematic ones."[20] The simultaneous presence of these two has already been noted in Newman, but

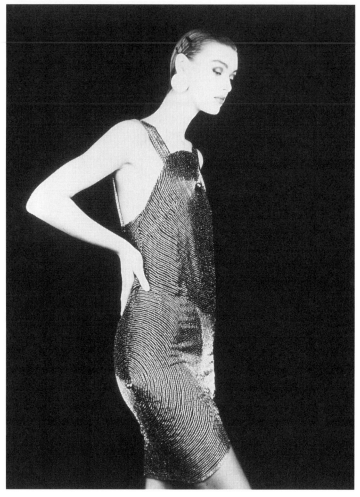

©Krizia, Advertising Campaign, Fall/Winter 1987–1988. Photograph by Giouammi Gastel.

where Newman found depth in a ground revealed in the stripe, a void which divides the surface while continuing beneath what it divides—and for which it is the ground—Reed's lateral movement fills the surface up close. The space is more like video, with its restricted depth of field and comparative lack of definition, than cinema's. I note also that Reed has two ways of working: In one the ground is replaced; in the other it is maintained as a source of light which color moves within as much as upon. In Reed's installations of his paintings, images from films, and films themselves, are juxtaposed to the works, but they're always video images of films or films on video.

In impressionism, light as matter took the place of that which could be recognized through drawing. Or as Mieke Bal says, in an essay about Reed's

David Reed, #275, 1989. Oil and alkyd on linen, 26" × 102". Collection: Linda & Ronald F. Daitz, New York.
Photograph: ©Dennis Cowley. Courtesy of the artist.

work that never mentions impressionism: "[R]eed's painting *represents* not figures, as figurative painting does, but the theory of light-writing that it enacts; it thematizes what, in light-writing, *matters*. There are no shapes with edges, no outlines; the light now is the shape, creates it, and constitutes its climactic point."[21] The immediacy of light obliges its representation to have light itself within it, which in painting means to identify the medium's ability to suggest movement with light's imperceptible speed.

One perceives light as still because it travels so fast its speed is invisible, making visibility possible, but the surfaces of paintings always suggest or communicate an idea of movement—the process which produced them is discernable as a series of movements which reach toward others. While, in that, never entirely still, a painting's surface invokes a stillness outside itself by stirring up the repository of the idea of stability which supports it, the stretcher, historically finite, ontologically stable, straightforward and preindustrial in structure and appearance. Built on a solid support from which it is detached by its own opticality, painting's surface exists between that solidity and the continuity it cannot attain, light's unbroken immateriality. As matter, as Bal describes it, it is energy and as such continuous with the rest of the visible world. As unbroken immateriality it is a continuum on whose invisible priority the visibility of all other materials depends. The one is the other side of the other. As matter, Reed uses it to connect painting to the life force of the technological sublime—electric speed, light, and color—a formlessness never located in a form, and therefore not needing to be freed from one. As unbroken continuity it remains unrealizable and invisible in the same sense that language refuses to reveal its own terms in the course of making all others possible.

As matter known only as unbroken immateriality, light was once an idea which gave rise to a plethora of other ideas, but since, Newton has also had a place in technological reality (i.e., in the real as technology). This is the sense in which painting's and photography's relationship to one another is one of seduction rather than production. What is it that always stands outside whatever it and its situation might, at any time, be? It's image: that which refers to it by not being part of it, or by being a discontinuous part. (Derrida: Once it's a part, then

there's a new outside.) In Richter, the photographic image is one of documentary truth—it is the visibly true—because of its being an instrument of mechanical reproduction. In Reed, it is the image of an immediacy which is at the same time a movement, a truth not of historical time but of the body, not of production but extension and continuation of a completeness which contains reversibility as well as the irreversible. In the work of both, painting is seduced by an immediacy it can only know as an image, as writing can only strive to represent the immediate presence of speech. It can be an image of the serious, or one the serious can't contain in the sense that it can't come to it with an analytic task for it to perform. One does not watch itself watching here, bound up in a morality of representation. Instead subjectivity adjusts to its fully photographic condition, of movement as immaterial embodiment of flow rather than form, and of light's borderless extension as opposed to irreducible interiority. Photography as a matter of light is an irresistible temptation to a surface that aspires to an immateriality promised but always contradicted by its being a crust. Matisse used to wash the canvas down, Reed constantly grinds it down with an electric grinder, both trying to get it to be as immaterial as possible.

But if the photographic stands outside of painting by proposing a continuity beyond painting's wildest dreams, painting can represent or otherwise deliver a dumbness and blankness to which photography in turn can only aspire. One sees in Reed's works—and, in different but compatible terms, Chang's and Kaneda's—that painting can get something out of the photographic only by ignoring its role as document and representative social process in favor of the photographic idea of surface meant to disappear into its own clarity, to be an image of instantaneity undeferred by recall.

The surface which seduces painting was always associated with immediacy and belongs now to an electronic rather than a mechanical idea of speed— as the masculine plods or struts in contrast to the fluidity of the feminine, so does the mechanical heave and clank in contrast to the effortless hum and pulse of the electrical. The quaintness, for us, of the Russian and Italian futurists lies in the fact that they saw movement as divisible. The blurred legs of Balla's dog, the staggered motion of Malevich's knife grinder, point to Bergson as they also point to film's division into frames. When Viktor Birliuk insists that a man in motion has more than two legs, he may insist that he's talking about perception as such, in which case he's surely wrong, but to us it sounds like cinema. Cinema belonged to the mechanical age, a hand-cranked projector or film camera is and was quite possible, a mechanical as opposed to electrical camcorder or video console is of course inconceivable.

Paintings are objects made so that seeing them will be a seeing of their making, their hermeneutic and critical status in this unavoidable and guaranteed, but only as memories found in the immediacy of surface affect, their realization consisting of the dissolution of their own priority. As scenes of accumulation and

revision, paintings are exceeded by the continuity and immediacy they produce or which emerges within them, precedes them as aspiration, and in the contemporary world surrounds them.

The impressionists lived in a world of colored objects, already disappearing into signs of commerce and psychology, but of black-and-white photographs. The world's surface had not yet become continuous with its image's. But now, in its production of blankness that is not absence, and by being really dumb—declining the semantic level—painting can bring discontinuity and deferral to the idea and image of spatiality and movement which surrounds it through a question of similarity and dissimilarity that it can consider in terms of its own great resource: the surface that has no depth. That is to say that in the electronic simultaneity of the contemporary photographic image, painting finds not its antinomy but a technological double or parallel. Painting's surface already contains the photographic idea of a surface made out of light, and it is as such that it plays with the idea of the limit, which in painting is not the hypothetical but invisible limit of a mechanism but the visible one of a material seeking to dissolve its own materiality in its referent, and as such a solution to be materially active in some other way—as event rather than crust, movement now rather than symptomatic trace. Always a matter of parts, the specificity of the stretched (or unstretched) canvas obliges it to become involved in the question of how bodies end so that others may begin (be outside them). This involvement would culminate in the provisional realization, as indetermination, of formlessness, the collapse of the thing into what lights it, or of light as a being or a kind of mobility without substance—meaning before semantic realization, surface without depth (or depth without surface, not the impenetrable but the vertiginous)—considered as a matter of construction or at least accumulation and adjustment. The sort of thing one can't photograph but which the photograph proposes, and which is not a thing but a quality. The photograph proposes an immediacy predicated on a continuity it cannot represent but only use, in the production of an image independent of its surface while continuous with, to the point of being contained within, it, when considered as an imprint ungrounding its grounds. The sign of and precondition for which continuity, in the contemporary world, is blankness.

1. David Lyon, *Postmodernity: Second Edition* (Minneapolis: University of Minnesota Press, 1999), 110.

2. Ibid., p. 74.

3. "Duchamp's Fountain, that touchstone of modern aesthetics, is nothing, except a latrine, if not a text." James Kirwan, *Beauty,* (Manchester: Manchester University Press, 1999), 108.

4. Friedrich A. Kittler, *Literature Media: Information Systems*, ed. and introduction John Johnston (Amsterdam: G+B Arts International, 1997), 35–36.

5. Maureen P. Sherlock, "Arcadian Elegy: The Art of Robert Gober," *Arts Magazine* (September 1989), 48.

6. See above, I n. 31.

7. Stephanie Theobald, "There's more to a walk than the legs," *The European* (3-9 July 1997), 11.

8. Ibid.

9. Ibid.

10. Ibid.

11. See also Gilbert-Rolfe, "Born to Be Mild," op. cit., 344–347.

12. See also Gilbert-Rolfe, "Introduction," *Immanence and Contradiction: Recent Essays on the Artistic Device* (New York: Out of London Press, 1985), 15.

 As to the body's being of, as opposed to irreducible to, its context, perhaps one should remember what Benjamin has to say about hearing the sound of Proust's asthmatic breathing beneath his prose, which allows for those who would want to insist that asthma is—as indeed it is—exacerbated by the living conditions necessary to capitalism, and therefore historical as much as natural: "This asthma became part of his art—if indeed it did not create it." See Benjamin, "The Image of Proust," op. cit., 214.

13. Richard Martin, in describing how it disseminated an image of American modesty in regard to beachware in 1950, nonetheless quotes, *"Life* enjoy[ing] the opportunity to embarrass Paris for its pretension and high style, telling that . . . 'Some of the styles, designed for long-legged American girls, came as quite a shock to Parisiennes who saw them worn by short-legged French models and were ready to reject them out of hand . . .' " Richard Martin, "Style from Paris, Reality from America, Fashion in Life Magazine 1947–1963," *Journal of American Culture,* (19:4 Winter 1996), 53.

14. Richard Martin, "Fashion exists perilously between freedom and oppression," *2wice*, II, 2 (XXXXX 19??), 101.

15. Martin, op. cit., 103.

16. Richard Martin, *Gianni Versace* (New York: Metropolitan Museum of Art, 1998), 53.

17. Theobald, op. cit., 11.

18. If the fashion image, when in black and white, plays with the colorlessness of print by presenting it as shades of gray which may not be identified with seriousness, color photography—whether moving or still—is dependent on the image of a woman: "With the introduction of color film technology… there arose the need to balance color films to a standard in both motion pictures and photography. A system was devised where a woman posed with sample color swatches and a gray scale. In still photography this woman is called 'Shirley'. The original model is rumored to have been named Shirley, but her actual identity is now shrouded in mystery and relegated to the status of hearsay lore among lab technicians and industry insiders. Today the slang term 'Shirley' is still used to refer to this printer balancing negative, though many different models are used."

 From the press release for "Shirley," by Sharon Lockhart and Daniel Marlos (an exhibition of a film with an accompanying cibachrome production still "which reference the process of color balancing"), Blum & Poe Gallery, Santa Monica, April 2-24, 1999.

19. Gilbert-Rolfe, "Painting Movement," op. cit., 235–237.

20. Robert L. Pincus, "The Art of Seduction" *The Union Tribune* (22 October 1998), B6.

21. Mieke Bal, "David Reed's #275," *David Reed Paintings: Motion Pictures* (La Jolla, Calif.: Museum of Contemporary Art, San Diego, 1998), 42.

V.

Blankness As a Signifier

Leaving aside a question to which I'll return, that of the blank stare, it seems blankness first appeared as the ground for a signification that it facilitated but which antedated it. According to Meyer Schapiro the smooth white ground common to most pictorialisms was quite a late development.[1] Blankness, then, was a response to the pictographic rather than a precondition for it. Cave painters did without or felt no need for an uninterrupted field, but one later became necessary—the ground acquired the properties of a clear sky—in order that the image could operate unimpeded by any other presence.

Schapiro makes the point that at first this field is filled with rows of figures, and then turns into a rectilinear space with figures in it, which last he tantalizingly analogizes to the walled city. So in his model, blankness first comes into view as a space in which the pictograph narrative no longer has to compete with a ground cluttered with detail and accident, and then becomes associated with what one might call a pictorialism of the finite space, where the smooth, white ground is coupled with a limit, with a dimension and, thus, a proportion, and, in consequence, with an overt connection between composition and orientation. The space of the image now has a figural relationship to its viewer, blankness has invisibly changed into a *kind* of space, a metaphor of some sort (an account of the development of the space of the signifier which makes it be a passage from the sublime to the beautiful, beginning as unbounded and rough and becoming bounded and smooth).

If blankness signifies from the start the place of signification, and if, similarly, the blank rectangle is already figural before it is filled with figures or otherwise composed—during which process blankness disappears altogether in the course of the full realization of the potential of the rectangle's proportions—then Schapiro's model also suggests that blankness emerges as the condition of an absolute temporality before becoming one of an absolute spatiality. As the surface on which rows of pictograms are arranged, it is first encountered as analogous to silence (the background to stories) and only later becomes associated with depth. And here I take note of the familiar conundrum that space itself could often be (or even usually is) seen as a figure of immediacy, but inasmuch as depth implies movement and therefore time, it must always be giving way to what it is not, to things, to interval, to structure, to deferral. It is in the blank face of the technological that one finds immediacy as a hyperaccelerated duration, the almost-instantaneity of the electronic, duration invisible to the naked eye—and in that I am defining blankness as a surface both continuous and uninterrupted, I note that Tom Mitchell has observed that continuity and uninterruptedness might for some invoke the image of a sphere, which to me suggests that the blank and smooth surface of pottery may have been the first achieved or manufactured blankness and, as such, an early product of something that moved fast.

Be that as it may, if blankness originated as a necessary absence, a condition of erasure, clearing, which makes possible a level of clarification—the maximum mobility of the sign—unimaginable (as it were, literally) without it, humanism and the traditions to which it gave rise seem to have maintained it in that condition, allowing it to be no more than a precondition for the emergence of the pure and unimpeded idea, which is to say, a necessary absence (a contemporary version of which would be an approach to formlessness that only wanted to see it in terms of the unformed). This would be a further sense in which blankness has been theorized only in terms of that to which it gives way, so that blankness is defined as space without incident, its temporal equivalent time without change (inflection or interruption), i.e., time without incident.

This is to define blankness as that which, lacking incidentals, becomes, in works of art and other visual signs, itself incidental but, in that, still fundamental to what is incidental to it. Absolute silence, absolute depth, become conditions for all that doesn't so much replace them as occur in their place. John Shearman has discussed the Renaissance as a time and place where "the invention of the work of art may sometimes be predicated upon the full engagement of the spectator in front of it," but this would be an engagement having little use for blankness insofar as it depends upon the spectator's "willingness to read it realistically in behavioral or narrative terms"—at least during those sometimes, which in Shearman's account seem to encompass a large number of the period's most important works.[2] The behavioral and the realistic involve the composition of incidentals—filling in all the blanks.

This would seem to me to raise another kind of question were one to inquire as to the social role of blankness within a tradition that sees it only as the ground for the sign and, as such, a sign of absence or potentiality. Insofar as the social is a matter of displayed signs of power, blankness has a spotty history although one could talk of it as a sign of asceticism or austerity, as in Spanish noblemen's dress or the abandoning of ornament in bourgeois as opposed to aristocratic dress in revolutionary France. Blankness as imposed absence where its imposition denotes piety, that absence of anything good to look at which is also the sign of seriousness in too much contemporary art. If that be blankness then it is blankness as the absence of the material as pleasurable stimulus, pleasure in misery, and, as such, it is structurally analogous to silence and, if you like, to depth.

There may be another question about blankness and the social, which I cannot develop here, but which would return one to Schapiro's analogy of the blank rectilinear field bounded by its margins or frame and the walled city with its cleared ground hived off from nature. Writing about Heidegger in the course of developing an argument about time and the political in Derrida, Richard Beardsworth says, "If the basic trait of the human is to be thrown out of familiar paths . . . these paths meet in the *polis*."[3] As a convergence of ungrounded

Philip Johnson, Model of the Grace Cathedral, Dallas. *Photograph: ©Giorgio Plamisano, New York.*

(inauthentic, leading-astray) paths, the polis seems comparable to the image of blankness as a new place, a detached zone of origination for the inherently ungrounded—suspended in absence, which is to say the absence of any other sign—where the inherently ungrounded could be writing, deoriginated by the white ground which allows thought to start or start again in its own space. This may indicate another use for blankness, as that without which one cannot have the sociocultural considered as an affair of inscriptions and fresh starts, history as clearings and beginnings.

The End of Absence

Here, however, I shall restrict myself to suggesting that the contemporary is witness to the end of blankness as absence, whether one be talking about production and reception of visual works—of art or not—or the context in which this takes place, which is the world as visual work.

Specifically I'm interested in what blankness looks like now as opposed to a hundred years ago. I think its appearance has changed and so has what it appears to be. As a signifier it's changed its connotation. Where it once marked the absence of the sign by being a sign for absence, it is now the sign of an invisible and ubiquitous technological presence.

Where blankness used to be excluded from the world, it is now everywhere and in everything. The difference between the late nineteenth and the late twentieth centuries is the difference between wallpaper and the blank wall, and,

Stanford White, Cultural Services of the French Embassy, *New York, 1906. McKim, Mead, and White. Photograph by Christian Haub.*

the parallel development in clothing and a lot of visual art, to which reference has already been made, between an idea of layering and one of intensification. What once stood for withholding or obliteration, potential or loss, now appears as the condition of presentation and as a sign for clarity. Contemporary blankness is the successor to, or at any rate comes after, modernism's use of transparency, and I think the way it works now has something to do with the late twentieth century's taking transparency, and with it immediacy, for granted, where the nineteenth was still concerned with the accumulation of details which could have implications from which one could, in time, draw conclusions.

The passage from the Victorians to modernism and beyond is one which leads from a *horror vacui* to a displayed blankness, and which is also the passage from the mechanical to the electronic, from the steam engine and the mechanical calculator to the jet aircraft and the computer, from visible to

invisible energy and activity. We have gone from that which takes place in a recognizable duration to that which takes an instant. The blankness we have now is indebted to the moment of transparency that preceded it and signifies differently nowadays than it did once because of its, and our, relationship to the instantaneity of the electronic. That transparency was also close to the idea of the instantaneous, whereas detail is a matter of duration, and this is the sense in which the kind of modernism grounded in an absolute substitution of transparency for detail and plenitude may be seen as a transitional period between what it despised and what takes it for granted. Before modernism, accumulation and detail, after it, blankness: Stanford White on the one hand, Philip Johnson's Dallas Cathedral on the other.

Blankness may be associated with the flawless, the completely adequate and complete, which is to say with beauty, as well as with the unformed, through which characteristic it may also become the location of the sublime. Either association posits a close relationship with inscrutability, a condition itself often associated with both the beautiful and the sublime, although the argument I've made here would require that where the sublime may be seen to be necessarily inscrutable, for the beautiful it's just one possible option. It would also follow from what has been said here so far that if inscrutability has remained a constant feature of the sublime, in other respects the latter has changed, the terrible infinity or obligatory inscrutability of the sublime now being a property of technology rather than nature. The contemporary techno-sublime does not seek to overcome the body by simulating the natural, however, as Burke saw a repeated loud noise as "capable of the sublime" in that it brings the listener "just to the verge of pain."[4] It seeks instead to obviate the body. Or to redefine it as a face attached to a pulse.

Cézanne saw the blank—empty and white, blank and *blanc*—canvas, as already deep, waiting only to be carved out. This is blankness as potentiality waiting to be ordered as opposed to emptiness waiting to be filled, so it's no longer the object of a *horror vacui*. In this respect Cézanne might be seen as halfway toward a contemporary idea of blankness as a condition in which something is already happening—halfway because the depth he saw in the blank canvas was still a depth, tied to human perception and to the idea of the human as requiring volume.

The whiteness of the canvas signifies preparation, brown linen activated by white paint. Similarly, without electricity the screen is just the dead face of an inert object. Turned on it is already active but can't be a depth because instantaneity precludes depth to the extent that depth requires duration for its realization. Carving takes time because it takes place in space, as it were. A surface, on the other hand, always points in two directions at once, is by definition an interstitial condition, and is in that sense both instantaneous and not spatial. These are the terms, I think, in which one may think of blankness as an active

signifier, and as signifying kinds of activity, in the contemporary context, and in which the late twentieth century has available to it the possibility of blankness as an activity, something happening now, as opposed to a condition which can only point to a beginning or an end. Electronic blankness occurs as event rather than eschatology, as a quality making possible any progression of properties.

As an event running through any narrative it may frame, the appearance and function of blankness in objects and signs like computers and the image of the body offered by fashion suggests a comparison and convergence between, as one might put it, being and the sign, which might be useful here. Anthropomorphize blankness and it goes to the idea of the impassive; analogize it to language and it becomes a beginning and an end.

As the property of a face it complicates communication, symbolically precluding communication by communicating incommunicativeness. The term "blank expression" sums up the problem: It implies communication through noncommunication, the recognition of incomprehension.

If one does not anthropomorphize it, and thinks of a blank sheet of paper instead of a face, blankness becomes that which writing can't write—one can't write a blank any more than one can literally draw one; blankness would preclude drawing. (Invisible ink being a deferral of what will have to emerge as a visible line, one more legible trace.) Blank sheet or blank face both present themselves as already full of meaning expressed as impassivity or the absence of a mark. The face signifies by refusing to signify. Mallarmé looks at a sheet of paper all day, fails to write a poem on it, sends the empty—if it may still be called that—sheet to his publisher *as* a poem.

As far as the sublime is concerned, one may say that the Victorian scene presented a mechanical complexity which meant to be awesome but now perhaps seems comforting, particularly when decayed, in comparison with the passive-aggressive blankness of the contemporary. In contrast to that, being able to see how things work is reassuring however overwhelming they may be, and it seems touching to us that the Victorians should think that they could symbolically control the industrial by covering its products with pictures and architectural details depicting plants. The effect created by the nineteenth century's decorating the mechanical with references to the preindustrial, the gothic and the classical in particular and the organic—the natural—in general is in practice ironic: Schiller's gothic as the facade of that which eliminates nature altogether, or Ruskin's nostalgia for the Gothic as amelioration of that to which it was opposed. It was a visible world as ours is not.

Victorian decoration always accompanied a mechanism whose operation could be seen, both it and what it ameliorated were present to vision, where for us the absence of decoration embellishes the absence of visible articulation. The steam engine's smoke was always egregiously and triumphantly visible, especially from far away, as in any image of a train puffing its way through England's

verdant vales and fields or across the prairies of the American West. The jet airliner on the other hand seems to me quite different. From afar one can't see any visible signs of locomotion. High in the sky it seems to move soundlessly and enigmatically, driven by an exhaust imperceptible at that distance. Only when one sees the aircraft from closer up, as it taxis slowly and enormously past a terminal window—the heavy, soundproof, glass sustaining its association with distant sound—does one notice that objects behind its jet stream become wavy images of themselves, dissolved in a translucent stream of poison, which is usually invisible. In the nineteenth century, pollution was maximally visible: soot everywhere. In the twentieth it is, in contrast, minimally apparent, the subtler but equally deadly fumes of the internal combustion engine: Manchester covered with soot, Los Angeles suspended in a delicate biliously green haze.

Modernism abolished ornamentation and instead made the outside disappear into a presentation of the inside. This is especially clear in architecture, where glass was used to abolish the facade and lay bare the interior. On occasion, this could lead to the architectural program requiring a kind of supplementary space in which the building could actually perform its function, as in Mies van der Rohe's National Gallery in Berlin, where the disappearance of the facade into transparency requires most of the gallery space be located below ground, where there can actually be unpunctuated walls and where paintings may shelter from an excess of natural light. Often, however, modernism could never get further than the outside. The exterior of the Tupolov 104, the first passenger jet built by the former Soviet Union, was as sleek and modern as any other jet aircraft of the late 1950s, but its interior resembled a railway car designed, at the very least, just before the First World War, with plush, floral-patterned seats above which hung nets for one's luggage—possibly leading to materialist skepticism during turbulence. Clearly, Soviet engineers looked to the nineteenth century for comfort and reassurance because they realized that the modern was never comfortable and not all that reassuring.

In one respect, contemporary objects like computers and televisions are more like the TU 104 than they're like the buildings of van der Rohe, for they too have exteriors which give no clue to what goes on inside. The same could be said of Frank Gehry's guest-worker housing project in Frankfurt, where I'd also raise the question of differences which occur in architecture when the facade may be blank without being massive; in Gehry's case, massiveness is subverted by the facade reappearing as color, the blank (opaque) alternative to transparency.

This is another sense in which transparency, to a considerable extent the goal of the modern, whether it be achieved through defamiliarization or by way of an essentialism such as van der Rohe's, is the opposite of what surrounds us now, where the idea of transparency has been replaced by an idea of interaction. And one notes that many of Gehry's buildings might, in one or another respect, distantly recall that architecture which came at the beginning of modernism.

What comes after recalls the beginnings of what it succeeds. In, for example, the Guggenheim Bilbao or the Disney Concert Hall in Los Angeles, he has realized a highly articulated ectoplasmic architecture which calls for comparison with the work and ideas of Gottfried Semper, the nineteenth-century architect who wanted to find architecture's essence in the wall—as divider, or surface, rather than structure or support.

This returns one to wallpaper as opposed to Sheetrock, the wall covered with paper as opposed to the wall intensified as much as concealed by paint. And I'd note, in passing, that Europeans and especially the British still resist the blank wall, and that while this may be a function of their resistance to the twentieth century in favor of the heroic nineteenth, I'd also suggest that its ready acceptance in America had as much to do with a residual loyalty to seventeenth-century fetishizations of plainness as to any taste for the modern. Where Europe seems always to be adjusting and reconnecting to capitalism and the technology it produces and is produced by, American Calvinism has always been connected to and continuous with it: Europe remembers the idea of a society; America only ever was a market with people preaching in it. In the one the absence of wallpaper represents a freedom from decoration, in the other the contemporary expression of a traditional value.

The Victorians covered up blankness as far as possible, allowing modernism to use transparency as an uncovering as well as that which does not need to be ornamented—as beginning and end, earth and world as one, totality as the condition of the essential. But in contemporary objects blankness has come to be associated with the (perhaps Bergsonian) simultaneity through and with which the electronic proposes to replace the diachronic articulation of the mechanical—in image as in deed. In this, blankness has moved from an earlier association with the idea of process as potentiality which can be visually articulated or manifested—withholding and, therefore, promising; absent and, therefore, capable of becoming present—to become instead the signifier of an idea of process as present but unrepresentable, invisible because unimaginable in spatial terms (i.e., as visual, and particularly as visibly a matter of inside and outside and the concealed and revealed).

Recalling the celebrated or infamous instruction allegedly given to Greta Garbo, "I want you to be a tabula rasa," one would note that nowadays he'd only have to say "Just look cool sweetie darling," or something like that. What Rouben Mamoulian may have said to Garbo in the course of setting up the final shot of *Queen Christina* represents the old-fashioned assumption about blankness. Blankness as a space of projection, where anything can happen or even be made to happen. In the contemporary context blankness is eloquent rather than the absence of a message, the condition of a subject whose fashionably blank expression, formerly known as a lack of expression, is neither communicative nor incommunicative but rather brings the two as close together as they can get.

To invoke what one might hesitantly call "contemporary subjectivity" is to describe not what actual contemporary subjects are but what the contemporary subject proposed by the context would be, and I'm suggesting that it would be one which aspired to the condition of the electrical rather than the mechanical. I have suggested as much in regard to the paintings of Chang, Kaneda, and Reed, and to the fashion image. We're familiar with the human identifying itself with the scientific models fashionable at the time, particularly with its having spent the seventeenth to the nineteenth centuries transforming itself from a combination of a clock and a telescope to something more like a combination of a steam engine and a calculator. If one wishes to discuss the late twentieth century, one might do better to consider the face rather than what is said to lie behind it, precisely because, paradoxically, the model that one would now require would not and could not be a visual one, and could not be because of its origin in an idea of instantaneity—movement without perceivable time and therefore without space: the face as an interface, transmission and reception together on a plane of convergence.

Garbo's face may have been a tabula rasa, just as a sheet of paper may be seen to be empty, but not so the contemporary model's face and not so the computer screen when it's turned on. In both cases, one is in the presence of a blankness that is a mobility, active rather than awaiting action. Perhaps one could say that insofar as faces are mobile by definition and pages not, technology, having come to be characterized by instantaneity, and having substituted the electronic page for the one made out of rag or wood pulp and only capable of being inscribed from outside itself, through the application of an entirely different material, has managed to attribute the properties of the one to the other.

What is signified is nonvisual in the sense that it's not tactile. In the sense that Merleau-Ponty describes the Cartesian concept of vision as being modeled on a sense of touch, the electronic surface of the video screen presents a non-Cartesian action which is not conceivable as action between forms.[5] This condition, to which the facial arrangement of contemporary fashion models aspires, is neither the absence of expression nor a particular expression, but the possibility of expression in the sense of a presentation of the conditions of expression. This is one sense in which blankness is more easily described as an excess than an absence in the contemporary situation. What it exceeds is the visual conceived as a matter of forms.

There are no such things as blank forms, while there clearly is such a thing as a blank surface. A smooth surface can be blank but a smooth form is still a shape, with a figural relationship to an at least implicit field and all that that implies. Blankness itself eludes the tactile; Descartes's blind subject is always touching something or failing to find anything to touch. This is the visual as outsides which must have insides, and which finds its contemporary expression in

the putatively anti-Cartesian Lacanianism of the stain and the blind spot, a Hegelian symptomology of the limits of the tactile and the visual. And it's also the sense in which the face can only be blank because it's an array of mobilities on a surface, the front part of the head as opposed to the head itself. The face as the place where the body interfaces with everything its face faces.

I have mentioned Bergson, and once again have in mind the Bergson-ianism identified or invented by Deleuze, of a continuity between outsides predicated on the idea of the surface, the plane and the point, as opposed to the form, the shape and its interior. These would be the terms in which the active blankness I've sought to invoke here might be seen as a necessary response to what technology has, equally necessarily, produced: the substitution of becoming-electronic for becoming-animal, conceivably as a logical consequence of modern-ism's transparent humanism. In *Against Nature,* des Esseintes describes a blond who becomes a racehorse which turns out to be a railway locomotive.[6] The Victorians, perhaps because of being alert to the animality which lay behind or below the rational mechanism which their technology persuaded them was their consciousness, were able to see machines and the machinic as animal bodies and movements. No one can see the contemporary context as such, but it does seem possible to see it as made out of faces rather than bodies, of surfaces containing instantaneous mobility rather than bodies articulated through times. Video's capacity to "morph" one image into another, beloved by children and American politicians, makes the point over and over again that the face belongs to technol-ogy, but that is still the face as a form. A surface is a face but not necessarily a form, and it is its freedom from form that gives it its instantaneity.

After Gunpowder

But I want to approach my conclusions about blankness—which lead to some final remarks about the post-human techno-sublime which lives in it, and with which beauty frivolously plays, the post-human being a productivist and plain androgyny with therefore slightly masculine overtones—by way of what Hegel says about gunpowder, another technological agent of dissolution. (As with Hegel so with Deleuze, I am inclined to say: When insides cease to be impreg-nable, people cease to believe in them and soon stop building them altogether.)

Hegel says of gunpowder that: "Humanity needed it, and it made its appearance forthwith." Moreover: "It was one of the chief instruments in freeing the world of physical force, and placing the various orders of society on a level. With the distinction between the weapons they used, vanished also that between lords and serfs. And before gunpowder fortified places were no longer impreg-nable, so that strongholds and castles now lose their importance."[7]

In, as it were, not quite the same spirit, perhaps this may be rephrased as follows: Capitalism needed, for its objects and the subjects who would mold

themselves around them, an exterior at once receptive and expressive, and technology produced one forthwith. It was one of the chief instruments in that substitution of passive aggression for physical force which is the triumph of the market over politics. With the distinction between speeds of access abolished, it also caused the distinction between metropolitan and provincial to disappear. With the computer, places, fortified or not, lose their importance in relation to a larger placelessness where information is to be found and some discourse takes place.

Placelessness is the condition of the face. It can be anywhere and is always a completeness made up of movement. The condition of placelessness is that of the ultimate mobility which is capitalism's central theme and which is realized in the ludicrously entitled "age of information," where even if you're really there you are simultaneously accessible to and from everywhere else. Heidegger's nightmare: distance no longer defining the neighborliness between farmers that was so important to him. Now they have mobile phones, powered by the hydroelectricity from the dam across the Rhine, which he had wanted to keep under some sort of control. Blankness is the sign of placelessness and of that which joins all places seamlessly and of the instantaneity which it approximates in practice and which is fundamental to its teleology. The term "cyberspace" seems fatuous because it is precisely space that has been eliminated, cyber or any other. By the same token, one cannot attribute a lack of expression to what is in fact an expression; blankness complicated is by definition not blankness as absence or lack. Nor can I resist, having invoked Heidegger let alone Hegel, quoting Derrida: "To bear witness would be to bear witness to what we *are* insofar as we *inherit*, and . . . we inherit the very thing that allows us to bear witness to it."[8]

Contemporary blankness is heir to both the Victorians' *horror vacui* and the transparency that sought to deconstruct it, and it is as such that it mutely testifies to the dependence of both on an idea of the interior and therefore of human space and time to which it itself may not be returned. Our relationship to the video screen is one of pure discourse taking place on a ground that virtually no one can visualize in the sense that one may visualize the workings of a steam engine or a printing press, and quite like the way language can't be made to express its own grounds, which I have described as the surface's disappearance into its own clarity.

Blankness changed its identity when it stopped identifying its significance with either the result of human labor or that which marks its absence. The smooth stone surface (produced emptiness) or the area of the canvas which has been left unpainted (emptiness made to produce space, as in Cézanne or Matisse), or uncertainty (which is to say, active absence, as in Rauschenberg but not Ryman), are both uses of emptiness which link it to the labor that produced it and in that to erasure or potentiality. Contemporary blankness

doesn't necessarily work like that although it may well continue to invoke such readings in the course of redirecting them. Which is to say it inherits and bears witness to them. Consider the contemporary role of smoothness, blankness full of decision, in automobile design, another place in which blankness is tied not to contemplation but to speed. With regard to both speed in the streamlined object and clarity in the world of video, one recognizes blankness as a property of the surface, which has to be flawless and, therefore, cannot be said to present blankness as symptomatic of any kind of lack.

This is why I'd say that the contemporary is an inversion of the traditional relationship between blankness and transparency and impassivity. Norman Bryson, talking about David's uninflected brushwork, describes it as a transparent signifier vulnerable to discursive control on account of the absence of gesture.[9] This is the uninflected as the official style, and Bryson's point is well taken. But I wonder if the reverse isn't true in the age of the photograph and the photographically instantaneous. The selfless lack of gesture of which Bryson speaks may after all be that because one recognizes in it the effacement of a self and the absence of the gesture that would articulate it. But these were never there in the photograph. In such a context perhaps one could suggest that it is the uninflected which always resists direction, while the inflected can always be qualified by connotation, and therein rendered subordinate to, or an effect of, what it is said to connote. This might suggest that the absence of visible mediation is a challenge to a hermeneutics of bodily recognition, that that in which the human is least apparent—because it was never there—is by definition that which is finally out of the human's control: inscrutability as the absence of putative empathy, the conversion of the trace from nature to technology.

Perhaps one might say that the transparent signifier is vulnerable to discursive control until you stare at it for a long time, when, having begun to concentrate on its impassivity, one can think about its indifference to what controls it. It may be controlled by a specific discourse, but that's only because it may be controlled by any other discourse too, which could imply that in that it provides a ground for that to which it is said to be subordinate the relationship is in fact not one of subordination and the subordinated, and is predicated on the opposite of transparency.

As I understand it, the idea of the interface, like Deleuze's Bergsonianism, precludes the transparent because it has no need of the layer. The surface does not give way to what supports it, it is if anything extraskeletal and needs no support from within or behind. This is one reason why the visual, as a matter of the spatial, has to disappear along with the body as an articulation in time. It's a commonplace that the visual arts are at some level never visual, since they're about the visual—an idea of the visual, the experience of the visual—they can't entirely be what they're about. So in the visual arts we expect to see the non-visual components of the visual, clearly laid out and, as it were, in our face. My

observations here have been about the extent to which a similar possibility has spilled over into a ubiquitous aspect of daily life. Insofar as I've put forward an argument: It's a mask that doesn't mask, but also does for the very reason that it doesn't, argument. That is, it's an argument that the absence of a mask is also a mask, which brings me to blankness as singularity.

The ornate grandiosity of the Victorian railway terminus was meant to astonish, and therein lay its sublimity. Burke described astonishment as related to that terror whose object is the sublime, and describes it as the highest sensation on a sliding scale which runs from there down through awe, reverence, and respect.[10] It is not, he says, a positive pleasure. I leave aside the appalling way in which Burke's desperate masculinism obliges him to insist by implication that one can't be astonished by the beautiful, to suggest that the sublime proposed by contemporary technology may be terrifying but it is couched in terms as far away from astonishment, awe, reverence, and respect, as it can get. It is instead a sublimity lodged in an idea of the same as a condition of the singular. It's a user-friendly sublime—bringing together, as capitalism's passive-aggressivity does so well, the banal and the benevolent. But it is nonetheless a sublime, marked as such by its otherness. Just as the face can't not signify, so that there will by now be a developing tradition of blank expressions, so too the computer as an object can't not have an attitude to design properties, to the world of the tactile and the visual. As objects, electronic devices benefit from having little pretechnological history. As has been said, what they do was by and large just not done before they did it. The television may have replaced the radio but the radio didn't replace something else.

Electronic communication entered the house as something that could be put on the shelf, then transformed itself into an independent piece of furniture, the television. This first disguised itself as a kind of sideboard, with fake wood and sliding doors—such as one still finds in American hotels, which labor under the delusion that being reminded of the 1950s makes everybody comfortable— but has since progressively transformed itself into a rounded black thing, molded rather than constructed, unlike anything else in the domestic interior except the telephone. Plastic objects gesture toward one another across rooms filled with references to the once handmade, offering access in both directions, genealogically divorced from the interior, whose irreversible penetration by and continuity with what was once an outside they represent. My mother recently had to buy a new television and was first alarmed that she couldn't get one with doors and subsequently put out that, being rounded and postrectilinear, she couldn't even put a few flowers on top of it. Such objects are, by design as well as volition, at once at hand and irretrievably apart. One has only to add that the latest sales triumph in the electronics world has to do with putting computers and fax machines in rounded black casings instead of the gray, more geometric ones, which have been the norm and which clearly refer to things like metal file

cabinets. A symbolic equation of the office with the home, work with what gives relief from it, performed within the language of that which cuts across both, obviates both, proposes a world in which there's no necessary distinction between them. Performed, as Barthes was quick to see, by objects which are extruded and molded rather than constructed, things with skins, embodiments which need make no reference to the organic for they have already internalized it as a principle, at least of appearance.

For the visual arts, the technological in its current form presents the same problem, if in other terms, offered by the body as a zone of intensification as opposed to revelation. The task is to make the technological visible; the trouble is that it already is. Manet saw it coming. The world could make more meaning as a flat image than a fat thing. Not only flat, but approximated. The national standard for color video in the States is known by the initials NTSC. No one knows what they stand for, but they can be remembered by the phrase "never the same color." These are the colors which all clothes, cars, toys, and foodstuffs nowadays strive to imitate.

One could certainly divide the visual arts, over the past twenty-five years, into those where people work with blankness and those where people cover it up. One a response to the demands of the sublime, another to the narratives technology makes possible. The last fifteen years have largely been dominated by art of the latter sort, social realism represented as pop piety or conventionalized transgression. One could see it coming when, in the late 1970s, artists and critics of the more literal and sentimental sort started to vociferously denounce what they called and still call "blank abstraction." And despite its detractors' malicious intent, it was indeed abstraction's blankness that was at issue. Minimalism, the last popular abstract style, was all about blankness, but in a rather neo-classical sort of way, blankness attached to grayness, colorlessness as sobriety and the serious, the art object as a product above all of drawing, which is to say, of the idea. In this sense it too was as nostalgic for form as all the retro piety which has replaced it. It may have been the last moment in which blankness stood for absence, for form giving way to the pure idea.

What could once be called abstraction had first, in Mondrian and Malevich and then again in Newman and Pollock, to free itself from the form it was said to abstract in order to become nonrepresentational. That done, it has for some time now clearly been struggling with the transmutation of the sublime from the space of unbounded nature to that of an uncontrollable technology. In the course of this struggle it has lost—as it lost its exclusive relationship to beauty—the implacable and blank as resources peculiar to the work of art (these are now commonplace), nor can it claim to own the idea of a world of surfaces, for such is the technological world which has taken over the world as such.

This is the dilemma first spelled out in Lyotard's essays on Barnett Newman and the sublime, where I first found the problem of the instantaneous

posed as technology's challenge to painting. I have suggested here that the problem of *Is it happening?* posed by Lyotard, would seem to me to lead to another—whether or not Lyotard's was answered—which would be the problem of singularity. I mean by this that art could only converge with blankness as I've discussed it here by being a handmade object which neither rested on naturalist nostalgia nor imitated that which—as the last necessarily handmade object in the world—it alone could not be: continuous, instantaneous, wholly uninflected by the body.

Paradoxical though it may be, the problem for painting, for example, an art of images, becomes how to live as a thing in a world that has ceased to be a world of things and become itself a world of images. The passage from Victorian *horror vacui* to the present is that passage, the passage from potentiality to instantaneity. If in the former, blankness was not a sign but, rather, the place for the sign, in the latter it has become signally characteristic of the surface of all the signs which exclude it with recognizability and narrative, i.e., which seek to subsume it within form and formality, shape and protocol, urge and economy. Lying outside of art it would have to be art's subject. Producing and produced out of discontinuity, art would be the only thing not continuous with it. Placeless art, neither nature nor technology, lost in space which can't be instantaneous— because, as repetitive pulsation, and, as it were, temporalized space, it is as much a constant deferral of the instant as its realization—everything else an ornament we've seen before.

1. See Meyer Schapiro, "On Some Problems in the Semiotics of Visual Art: Field and Vehicle in Image-Signs," *Theory and Philosophy of Art: Style, Artist, and Society* (*Selected Papers IV*) (New York: Braziller, 1994), 1–7.

2. John Shearman, *Only Connect . . . Art and the Spectator in the Italian Renaissance* (Princeton: Princeton University Press, 1992), 27.

3. Richard Beardsworth, *Derrida and the Political* (London: Routledge, 1994), 115–116.

4. Edmund Burke, *A Philosophical Enquiry into the Origin of Our Ideas of the Sublime and the Beautiful*, ed. & introduction Adam Phillips (1757; Oxford: Oxford University Press, 1990), 127.

5. Maurice Merleau-Ponty, "Eye and Mind," *The Primacy of Perception and Other Essays on Phenomenological Psychology, The Philosophy of Art, History and Politics*, trans. Carleton Dallery et. al., ed. and introduction James M. Edie (Evanston, Ill.: Northwestern University Press, 1964), 170.

6. See J. K. Huysmans, *Against Nature*, trans. Robert Baldick (Harmondsworth, U.K.: Penguin Books, 1959), 37.

7. G.W.F. Hegel, op.cit., 402.

8. Derrida, *Specters*, op. cit., 54.

9. Bryson, *Word and Image*, op cit., p. 238.

10. Burke, op cit., p. 123.

VI.

The Visible Post-Human in the Technological Sublime

The post-human could by now be said to have a status at once historical and subjunctive, as that which is manifest in what capitalism produces while proposing a condition in which humans are potentially irrelevant. Baudrillard says somewhere that, if it could, capitalism would make do with white rats.

Whether or not redundant as means of production, however, humans remain a factor, for the time being, as consumers. Baudrillard's vision is fatalistic, paralleling but hardly confirming Fukayama's smug optimism in the perpetuation it describes, and compelling in that one can easily see the present as a state of affairs in which, having first morselated labor through the assembly line, then invented a robot for each stage, capitalism is now propelled by a robotic logic in which the participation of actual people is restricted to serving machines, consuming what they produce, and gambling on the stock exchange. The last twenty years have seen the arrival of a condition in which the only way to guarantee a proliferation of abstract value which can keep pace with the production and consumption of things is to make sure that all the money in the world is invested in the stock market, where, at the time of writing, the price of shares in electronic communications is high despite their failing, so far, to have passed beyond the subjunctive. They are valuable because everyone feels they are fated to make money, for they are the heart of techno-capitalism, the material and symbolic expression of the sublime of pure ratio and futurity, which guarantees its persistence. The post-human is then a condition where human knowledge is necessary but human beings (i.e., being as human) are redundant. The unverifiability of the post-human would lie in that achieving it would be to be lodged in the condition of having been, active only as inscription, hypothetically the trace of an origin. Present but unverifiable, it maintains a relationship to the human in which it is both an alternative to consciousness as it knows itself and that which has already entered and changed consciousness. It is a future that has also already arrived. As usual, Baudrillard's fatal vision is amply supported by the newspapers. The title of a front page story in the *New York Times* of Sunday, 21 June 1998, "It Isn't Human, but the Voice on the Line Is Ready to Help," goes beyond parodically reiterating the theme of capitalism's predatory solicitude to tell us that: "Later this year, many callers wanting flight information from United Airlines will speak not to a person but to a computer that acts like one . . . 'Speech recognition has passed a threshold,' said Raymond Kurtzman, a leading researcher in the field of artificial intelligence. In the next few years, he predicted, 'The bulk of business transactions will take place between a person and an automated personality.'"[1]

Perhaps one may find an antecedent for this in the gradual intrusion of

secular science into a subjectivity which thought of itself as God's object, one day waking up to realize that it had thought itself, or been thought by thought, into quite another condition. The techno-sublime and all that comes with it looks back to the idea of the autonomous sublime, which should perhaps now be seen as the idea of free will secularized and thus free to run amok (i.e., actually free, deteleologized), which is to say as a product of the Enlightenment considered in Hegelian terms where one historical stage gives way to another which is dialectally continuous with it. An "automated personality" is an oxymoron, like "life in Kansas" or "American health care," or that of an intelligence artificial in its lack of intuition. But, like these, an active oxymoron whose presence amongst us determines that idea or image of personality itself is now indebted to the image and idea of the automated. To the extent that thoughts are made out of words and habits of speech, to whom one talks comes to affect the way one talks.

Scientific Capitalism

Lyotard, deriving his argument from science rather than society—insofar as one may make that distinction in this context—proposes a kind of victory-over-the-sun version of the post-human, which he calls inhuman but which seems quite consistent with his idea of the postmodern. In this version, science works toward a brain which, floating around in a space capsule, could survive the collapse of the earth into the sun and think about it as and after it happened—remain critical and remain to be critical of it, as it were. A passive-aggressive victory over the sun, in which the latter was denied the ability to totally obliterate that which originated in or with the human, but only through the latter's having achieved a functional independence (autonomy) of its origins—as the sublime declares, in Schiller, its independence of the sense which brought it into play. It is, says Lyotard, a question of "how to make thought without a body possible . . ." but "theoretically the solution is very simple: manufacture . . . hardware capable of nourishing our software or its equivalent, but one maintained and supported only by sources of energy available in the cosmos generally."[2]

A life force independent of nature, then, which would remember it and continue thinking, which originated there but in other terms. In Lyotard's theory of the postmodern, the work of art is born of a desire to find a starting point outside the modern, which as an instituted modernity can't possibly be truly modern any longer—its postmodern inspiration in that respect itself an inspiration deduced from modernism—but becomes a part of modernist art history once made. Similarly, electricity, and the artificial intelligence it can support anywhere in the cosmos, proposes a future which is now part of the subject's present as futurity.

Subjectivity has always imagined itself as something else (but always as an object of creation) and now supposes itself to be like, but not the same as, a

computer. It used to be like, but not the same as, the Creator. The post-human as an autonomy, separate from the human, begins as that which follows from the human but can't be contained by it—with, that is to say, the inadequacy of the human. In common with the postmodern, of which it may be producer and product, the post-human proceeds from the need to conceive of an object not predetermined by an extant historicism which is itself circularly humanist: the modern as a history of, or the construction through the historical of, or the historical constitution of, the exclusively human subject.

I have suggested here that that exclusivity is now itself based on a heteronomy that was not there before. Or as Kittler puts it: "Kant's 'I think,' which in Goethe's time had to accompany every reading or aesthetic judgment, was within the true so long as no machine took over pattern recognition for him. A contemporary theory of consciousness which . . . has consciousness simultaneously transmit, store and calculate like a true behemoth without specifying the media or technologies involved is merely an euphemism."[3]

At the same time, technological objects become post-human in principle once they have achieved a certain distance from their original identity as extensions of the body and in that invent other bodies which become models for the (model) human body. The model of the body is always an image found in the properties of things. The inside of the car proposes not only a different mentality but a different body than that proposed by the preserved steam railway seen through its window. Things inside the car are like the body, smooth, continuous, curved, soft. What was the body and mentality that could see itself as extended by wood and steel?

These are the terms in which technology, capitalism, and the sublime are for us related. Or the same thing. Technology is produced by capitalism in order to consolidate and extend capitalism's interests, which include the latter's constant transformation, because capitalism's persistence depends on its being the surprised beneficiary of technological innovation at the same time that it's its source, so that the product is also the producer as thinking is thought's producer and product. I have suggested that the sublime becomes identified with the idea and image of technology, appears within it and adopts its appearance, at the point where the origin of technology is found in earlier technological functions rather than in anything ever done or thought by a human—which is to say, where the technological is seen to have become the origin of, that which makes possible a kind of thought and a kind of body which wasn't there before.

The difference between modern dreams and precinematic dreams, apart from the analysis subsequently brought to bear upon them and, therefore, one of their causes, is, as noted, that in modern dreams one takes one's passage from one location to another for granted, but in older dreams, one is transported magically or, same thing, is surprised to find oneself there. Cinema abolishes surprise in the dream as a question of spatial disposition. That's quite a difference. Technology

has subsumed the idea of the sublime because it, whether to a greater extent or an equal extent than nature, is terrifying in the limitless unknowability of its potential, while being entirely a product of knowledge—i.e., it combines limitlessness with pure ratio—and is thus at once unbounded by the human, and, as knowledge, a trace of the human now out of the latter's control. To the extent that it has its own logic it's independent; to the extent that it's parasitic on human logic it's uncontrollable because it does more than it's meant to (transforms rather than serves): The techno-capitalist object is one which is always experienced as indispensable—to experience (no one remembers what remembering was like before things could be recorded, so that memory could always be second-guessed by the record).

Techno-capitalism's unboundedness has in no small degree to do with the simultaneity it imposes on the world and against which Heidegger railed. It is unboundedness as extension through intensification, less the conquest of spaces than the production of new ones. Capitalism conquers by making itself indispensable, war being a condition that prepares geographical areas for the free market. Fascism was a false start which caused capitalism a lot of trouble, communism even more of a problem as it turned out, the postcolonial countries still a difficulty for it because they won't get out of the nineteenth-century nationalism whose victim and product they are. That said, there are few actual or cultural spaces left to be folded into capitalism, seduced into productivity or otherwise made useful if only by default (which means at no cost, pure surplus: As with Deleuze's beloved nomads all being now under contract to McDonald's to supply beef for the Chinese market, so too has it come to pass that Heidegger's English-language publisher is Rupert Murdoch, whom he would surely have regarded as one of the Neros and Caligulas of his time). From a market perspective everything is simultaneously engaged in the (predictably unpredictable) extension through maintenance of capitalism.

That is the banal sublime, which now lives not only in Orange County but also in Ulan Bator. Within and from the techno-sublime of which that is one aspect there is a general question about technology's promise or realization of simultaneity which to me confirms Heidegger's prognoses, and to which I now return. It confirms them while also indicating some of the reasons we don't care. One of them is that we like it. Another is that we can't imagine the world any other way. But a further one would be the suggestion that Heidegger's insights are all predicated on imagining a world without technology in the face of the technological, which is to say, long after it had departed. The question has to do with how absolute simultaneity would preclude resonance, which is to say, contemplation—leaving only recognition and calculation—and in that deny a separation between things or signs, between different bits of the message. This returns me to memory and its technological double, and Heidegger.

Being Disturbed, or Deferred

Heidegger describes the single sentence known as the Anaximander Fragment, which was written during the first half of the sixth century B.C.E., as "the oldest fragment of Western thinking,"[4] and discusses the difficulties of translating it given that translation's major adversary, historicism, "has today not only not been overcome, but is only now entering the stage of its expansion and entrenchment. The technical organization of communications throughout the world by radio and by a press already limping after it is the genuine form of historicism's domination."[5]

Historicism is the problem because it is both product and producer of what prevents one from hearing the Greek as the Greeks did: "[T]o translate the Anaximander Fragment . . . requires that we translate what is said in Greek into our German tongue. To that end our thinking must first, before translating, be translated to what is said in Greek."[6] Perhaps unsurprisingly, however, "Thoughtful translation to what comes to speech in this fragment is a leap over an abyss . . . [which] does not consist merely of the chronological or historical distance of two-and-a-half millennia . . . [but] is wider and deeper . . . [and] hard to leap, mainly because we stand right on its edge."[7] In fact, we're "so near the abyss that we do not have an adequate runway for such a broad jump; we easily fall short—if indeed the lack of a sufficiently solid base allows any jump at all."[8]

Heidegger wants to think his way back to a moment before, as he puts it, "Being" could have been interpreted as "idea," which is to say, before the formulation of conceptual language, after which "it is unavoidable."[9] Conceptual language, anticipated by Socrates and realized by Plato, will bifurcate, giving rise to thinking which is about applying thought rather than thinking about thought—i.e., thinking about doing which is disconnected from thinking about being—and the next thing you know people who are even better at that than the Greeks will have taken over, and with them their self-alienating practicality. Roman words will displace the Greek words, "actuality" displacing "being" and "thing" "essence," and in effect the conditions required for that "collapse of thinking into the sciences and into faith [which] is the baneful destiny of Being"—and from which Heidegger seeks to rescue it—will be in place.

In what is something of an understatement, Heidegger says that to do this would require one to dispense with presuppositions. One must not see it retrospectively, i.e., as pre-Platonic (which is Nietzsche's mistake) or pre-Socratic, but also one must not see it anthropologically, as pertaining to a "philosophy of nature—in such a way that inappropriate moralisms and legalisms are enmeshed in it; or that highly specialized ideas relevant to particular regions of nature, ethics, or law play a role in it . . ." or, "finally," as a remnant of a "primitive" outlook that "examines the world uncritically, interprets it anthropo-morphically, and therefore resorts to poetic expressions."[10] Inasmuch as that is what the Anaximander Fragment seems to be, Heidegger's demand that presup-

positions be cast off goes beyond questions of method or ideology. The fragment is very short and (in Nietzsche's "pre-Platonic") translation, and the two others which Heidegger puts forward (his own and a "pre-Socratic" one,) read like a bit of naturalist philosophy filled with moralisms and legalisms: "Whence things have their origin, there they must also pass away according to necessity; for they must pay penalty and be judged for their injustice, according to the ordinance of time."[11] A necessary rise and fall linked to a theory of justice itself derived from natural duration. To think it as the original thinker thought it would be to transport oneself (philosophically) outside of philosophy to, and once there to think with, what philosophy replaced with that conceptual thinking which, in turn, gave rise to a tyranny of self-propagating usefulness. While arguing against retrospection, Heidegger doesn't appear to see any contradiction in taking the fragment to be prophetic, and in that a challenge and a goal to contemporary philosophy, which will undo or destroy or deconstruct itself on the shoals of a sentence which anticipates its current dilemma (and is therefore a sentence in both senses of the word) while being innocent of that dilemma's (use of, or as a use of) language. "Nature," or "thinking," or "justice," and, above all, "time" are to be heard as they were before their original meanings had been obscured by their translation into concepts which were then further degraded by the Romans and successive technocrats.

The difference, for Heidegger, between the Greek of the Anaximander Fragment and modern language is that the subject conjured up by modern philosophy (i.e., as opposed to the authentic one he sees embodied in a—pre-chainsaw—woodcutter) is "incapable of seeing itself as existence, opening to the world, and possibility-to-be"[12] because Kant, following Descartes, attested to "his own dependence on ancient-medieval ontology" by "interpreting the human being with the aid of the traditional horizon of *production* . . . [whereas] [t]o be finite means not to *produce*."[13] It had become so by progressively forgetting words' original volition.

But what accrues to language is elsewhere felt as change which is not loss, and is in that sense independent of concepts and the volition they provide. To think of a far simpler problem than that posed by Heidegger, the problem of hearing Shakespeare, from whom—Christian but not modern— we are not separated by a gulf as wide as that between ourselves and the author of the Anaximander Fragment, but whose English would seem implausibly rustic to us. Part of the problem would be that the problem of reading Shakespeare—who probably had to suppress his Warwickshire accent in order to get on in London[14]—is that on the one hand one wants to read him as the greatest English poet, on the other hand not to. The original audience didn't hear Shakespeare, or read the Anaximander Fragment, as great or originary, while for us to hear or read them is, partly, to realize why we do.

This realization includes the sense in which, in Shakespeare's case at

least, to think back to the original context is not a key to an error so much as the addition of original intention or connotation to what something has now become. A reader who in her head heard Shakespeare in the accent of the English south Midlands in the sixteenth century would to some extent lose rather than gain, in that she would not be hearing that which causes Shakespeare's works to survive their enunciation in modern English.

For example, most people—unless, like Shakespeare, they come from the English Midlands or even further north—do not read or hear, as he would have and they still do, "Rome" as rhyming with "room" when Caesar says there'd be plenty of room in Rome if Cassius weren't around. For centuries now, the southern English accent that Shakespeare may have sought to acquire, in which Rome rhymes with "home," rather than the one which gave him the rhyme he must have heard in his head—still thinking with the regional inflection he may have tried to abandon when speaking—has been the one in which his plays are performed. This is perhaps to say that (any) language is, in practice, anthropological, even historical and accidental in signifying if not significant ways—as with the evolution of pronunciation and the falling away and acquisition of new rhymes and homonyms—and as much an economy of replacement as of loss. By changing the sound of Shakespeare without necessarily intending to do any such thing, generations of actors have prevented him from becoming lodged in the past, and instead allowed him to continue to speak. Its continuity with the past is to be found in its transformation, whereas to hear it as it was once heard would imply an equivalence from which all historical reverberation had been erased in favor of a simultaneity.

In English (unlike German), the word "idea" is exactly the same as in Greek, save for the alphabetical difference—and therefore perhaps experienced less as a Greek word than as one that once was Greek. The reader, or listener—for him the same thing—for whom Heidegger calls would in principle have to experience the Greek as not strange, i.e., putting aside presuppositions would amount to putting aside what had displaced it, so that to return to the original Greek would be to realize history's wrong turn in such a way as to be no longer driven by it. A listener, then, to whom ancient Greek could, in some Borgesian way, have become as familiar as her or his native, or "original," language—whose own literature and philosophy would itself be in part the result of thousands of years of misunderstanding what was now to be read clearly—and therein to exist in some kind of relationship of equality with it. Or even to replace it. Neither seems conceivable in human terms. For the fragment to be read as Heidegger wants to read it, it could not be read as if it were being read retrospectively. It would be a reading beyond the human inasmuch as to purge language of its accretions and wrong turns is itself to reduce it to propositions, whether pre-conceptual or not, while eliminating those reverberations to which Heidegger is generally so sensitive, just as for Shakespeare to be heard as he may have been

during his lifetime would be to suspend one's sense of Shakespearean performance as enactment and reenactment, i.e., as a present which is a (deduced and otherwise constructed) echo of a past. Certainly some words and propositions have changed since the sixteenth century, if not as much as since 650 B.C.E. "Subject" is one of them.

Humanly impossible because it suggests a reader who would become wholly a function of the text—i.e., of philosophy without human accident and incident—this seems, however, technologically plausible, and this is a sense in which, while his is the opposite of a search for the historical condition of Being, that search, whose presuppositions his seeks to throw off, suggests a parallel between Heidegger's thought and that which he hated, electronic technology, which similarly dispenses with reverberation. Reverberation in Heidegger is a kind of cybernetic clutter caused by a history that went astray because people misunderstood the original, pre-Socratic, meaning of the word *techne*. But only the technology which that misunderstanding made possible realizes, hypothetically, his vision of direct access. There could be an artificial, post-human, intelligence which read and heard the Greek as just another language and, simultaneously, as the original language. That is the degree to which the contemporary is his nightmare: Hermeneutics does not propose the human as the human, but, as Derrida's work in the 1970s showed, writing as the human. The contemporary is Heidegger's nightmare inasmuch as it is he who, seeing it as the opposite of what he wanted, revealed the extent to which it was the latter's perfect mirror.

For example, I have suggested that the post-human is to be found where one used to find the human, in the look of things. What once reflected patience and craftsmanship is now at once unbelievably precise and at the same time inscrutable. What is ultimately unfathomable about them is their lack of mystery, a condition of the sense in which contemporary things neither conceal nor reveal themselves, reminiscent of or exactly like the kind of concealment through display available to humans only when they're naked, since no one gives anything away until dressed, which act reveals that he or she is a person who would wear that, and what's more, wear it in that way. In both the blank surface and the naked body, what replaces mystery is inscrutability as a given. Hardly anyone knows how computers or even fax machines work; people only know how to use them. Those who do know are more concerned with what computer technology can potentially do—i.e., with what they don't know about it yet—than with what it does.

In referring to how things look, I have also suggested that, even before one asks what they do, let alone how they work, the way such machines live in the world as objects tells one something. As an idea which converts maintenance, the preservation of the same, into irreversibility—the introduction of the new— solid-state construction and the semiautonomous component are the perfect

image of and solution to what J. M. Bernstein describes as "Capitalism's constructive movement, its development of the forces of production for the sake of indefinite expansion, and its consequent drive for universality. . ."[15]

Capitalism is now an affair of supplementation through the part: There's something that's not working, rip out the whole panel and replace it; a speaker is dead, get another speaker; there is a new kind of printer to go with the old brain, and/or, vice versa, a very broad kind of solution to the maintenance and expansion question which has its analogue in the slash-and-burn principle on which markets are founded. New markets to replace old ones is capitalism's strategic quest, innovation within existing ones its tactics. Contemporary corporations make money just through mobility, chasing cheap labor and low taxes, bankrupting labor pools while entrapping new ones in a miserable futurity, the abandoned themselves now primed for reentrapment on cheaper terms.

Where an earlier capitalism was able to preserve the preindustrial theme of maintenance of the unchanging through acts of repairing, late capitalism has made the theme of replacing so pervasive that now to repair *is* to replace. Any idea of unbroken continuity, in the way that the *Argo* had been entirely rebuilt before returning to port but was still the same boat, is called into question by nothing lasting long enough to be entirely replaced piece by piece, because it must always soon be replaced by an entirely new version of itself—as if Jason had returned in a newer kind of boat, capable—these are objects which do things—of more than it is, or, better, subsuming what it is and does into something (some function) which it could not have anticipated.

What is more, the contemporary machine, for example a computer or CD player, is not one thing but an assemblage—workstation or video system, a place or a process rather than a thing—always being superceded in this or that respect, for which deficiencies it can compensate through the replacement of this or that part until the moment of the station or system's final suppression, which is imminent from the start.

I have said that perhaps the arrival of the technological post-human as something people noticed could be dated from the moment when it became impossible to see machines as beasts but where they had, rather, turned into another kind of being. The principle of articulation no longer visible, the personification available to des Esseintes has slipped away. The locomotive belched steam and smoke from within and was driven by visible gears and rods, an iron horse which des Esseintes first describes as a woman, i.e., as an industrial version of Winckelmann's sublime, brute force framed by the feminine. (The common conflation of women with horses is likewise interesting from the perspective of the beauty and sublime question inasmuch as it is predicated on there being qualitative conditions for comparison having to do with slenderness, grace, fluidity of movement, while traversing these similarities one finds the distinction between cart horse and racehorse noted by Little Hans.) But the jet

aircraft seems to defy personification—or animalification—despite British Airways naming its aircraft, and, to move closer to the cybernetic topic at hand, no one ever named writing implements: simple Heideggerian tools too low on the totem pole to be named as ships and horses are, and steam locomotives were, named, and which therefore began as instruments of mediation never described as beings, gradually turning into something else not readily analogizable to any living thing—unless it be to a part of one, what was once a finger is now a brain—without ceasing to be banal and instrumental, the victory of the cybernetic the victory of that which was never personified. Until, that is, now, when, having never been an animal, it has become the locus of a being with which humans interface.

If human memory implies simultaneity as a condition within time, then writing, like sewing, can be seen to contain not only the promise of the mechanical from the start—because of its dependence on the idea of the standard unit—but also the simultaneous as the mechanical's utopian double and ideal, to be reached or approximated through the instantaneous. This began to be realized through writing's nineteenth-century relocation to the typewriter, which, beginning mechanical and ending electronic, promised the machine which would do its own writing: the computer, no longer conceivable as an extension of anyone's hand because it brings so much to the task on its own account. One has gone from an object which is a simple thing, to a mechanical and therefore more complicated thing, to a thing which isn't quite an object, or just a mechanism, because it calculates and retrieves, acts instantaneously but at one remove, not only as an extension of the writer's action but also in response to it—as to the question of removal, one would also note that the writer writes on a computer program itself written for her to write on before she writes.

In thinking of writing in this way, as having moved from the end of the arm to somewhere to which it is deferred and then represented, one may also recall that to the extent that the West's history was one of the sword and the pen, it was the history of people who were sitting down at the time: a man on horse and a man at a desk. Thus were the West's institutions divided between images of aggression and passive aggression, the mounted aristocratic thug and the seated clerical swine. Both the stirrup and literacy were imports to the West from the rest, the stirrup arriving much later than literacy—those who developed logic out of the latter having apparently been uninterested in conceiving an efficient way to stay on a horse's back while killing someone. However, while its logic was incapable of getting the West from standing in a chariot to sitting on a horse, ever since Europe finally grasped the thought, people who stand up for a living haven't counted for much—the category includes laborers and foot soldiers. In certain circumstances, the king was the only person who did sit down, which is why thrones have to be raised above floor level—he can sit while still being above those who are standing, like God or a man on a horse.

Thanks to the combination of immediacy and deferral that is the techno-sublime, in the twentieth century the equestrian and the scribe have come closer together: the pilot in her cockpit with her computer, the professor in her office with hers. Deleuze described the contemporary class system as one in which the cybernetically connected, administering class, constitute capitalism's superego, and the unconnected its id, and it is parenthetically true that it was at the dawning of the era of the typewriter that the sword accepted its definitive administration by the pen with von Moltke's and Grant's invention of the modern general staff in response to the acceleration (and intensification) of warfare made possible, or desirable, by the railway and electric telegraph. It is also the case that the triumph of the computer is also the triumph of the sedentary as stationary, no more bracing walks around the stacks when one may bring it up on the Internet. The body collapses into the sedentary whence it must then be retrieved. As noted with regard to Orange County, the twentieth century is perhaps quintessentially sedentary: People drive to work where they sit at their desks, at their screens that is to say; then they exercise madly to ameliorate the effects while listening to their Walkmen, like Romans vomiting while poets play lyres and sing.

In these terms, Lyotard's brain in a space capsule is the dream of the sedentary professor. Everything retrievable, if only as data—which is to say, only as everything Heidegger didn't want. Everything and anything is accessible to it but nothing is physically present in it—which was always true of the written, and why Heidegger's nightmare is truly his in that it is one of technology as a monster slumbering within hermeneutics. Instead of the physically present there is ungrounded intelligence, electronically supported, encouraging or allowing the sedentary to be a transition to the obviation of the physical world that it always was for writers.

Virilio has talked about the museum's expansion through the computer, a response to the problem of having to get more and more into the museum without having the space to do so in which simultaneity replaces the spatiotemporal, the museum as memory becomes Bergsonian rather than Hegelian. When Schinkel designed the Altes Museum in Berlin, and changed the idea of the museum from treasure trove to story of cultural and national evolution, he could present history as a sequence, spatialized, because you have to enter by the front door. Virilio's museum presents history as simultaneity rather than sequence, which is to say, history technologized, data without necessary culmination, within time but without end. Point of view becomes entirely a matter of how it is to be used: It doesn't necessarily have to end in Prussia because it doesn't necessarily have to end; it is history without and beyond culmination—in effect history dehistoricized.

Whether or not post-human, this is certainly post-human*ist*, because of its not being clear how such a presentation could be said to derive from a necessarily human perspective. Gorbachev once made the telling remark that

"History needs people," but in being capable of reacting to the person sitting at its screen—in being a means of access as well as of inscription—the computer points to the redundancy of its operator by mutely offering its promise of a technology which would be self-sufficient, needing a minimum of supervision and maintenance and knowing the finest expression of the minimum to be zero. This finally technologized world, which could run by itself because it could think for itself, would be one in which the original Greek could (only) be heard in a kind of simultaneous—as it were nonoriginary—relationship with other languages, its retrieval having to start from the same zero as that of any other. The price would have been the elimination of being in favor of, and by, writing—with sound written into the world of the written along with every known and imaginable surface.

A world without objects—since there would be no need for them. Objects would—again an idea made possible by Heidegger but anathema to him—only function as signs for what the object once represented. In place of the chalice as a sign of its own making there's just a sign, a parody of the idea of essence—and present in everyday life now as the condition held symbolically at bay by the idea of commodity fetishism. A world without earth in the Heideggerian sense, then, with, therefore, no ground to be cleared, it began with a clearing. In the clearing but introducing no corporeality into it, ghosts taking up no room, is the spook of a givenness in which everything is deoriginated, unreturnable either to nature or its administration by the human—i.e., through personification.[16]

The post-human, as a possibility implicit in technology, parodies Heidegger, because it imagines an intellect that knows only equivalences and a world that only signifies. What is more he seems, as if while dreaming, to have described how it works while getting ready to denounce it.

Consider the following lines from the Anaximander Fragment:

> The presencing of what is present, with respect to its ergon character, thought in the light of presence, can be experienced as that which occurs essentially in production. This is the presencing of what is present: the Being of beings is energeia.[17]

If one substitutes the presencing of what is not being, and the non-Being of signs, for the "presencing of the present" and the "Being of beings," the concepts of ergon and energeia seem to describe what one sees on computer or video screens quite well. Particularly since Heidegger speaks in the next paragraph of the "concealed richness of the same."

A few paragraphs later Heidegger begins to get himself worked up about the idea of a world government made possible by technology:

Man has already begun to overwhelm the entire earth and its atmosphere, to arrogate to himself in forms of energy the concealed powers of nature, and to submit future history to the planning and ordering of a world government. This same defiant man is utterly at a loss to say what *is*; to say *what* this *is*—that a thing *is*.[18]

Putting this together with Heidegger's objection to seeing the world as a system,[19] the point to be made here would be that while it has become clear that there's not going to be a world government because the idea of the social has been replaced by that of the market—a substitution inherent in capitalism and made possible by electronic technology—the rest has all happened. In this regard, Martin's chum Adolf was endearingly old-fashioned in his belief that he could harness techno-capitalism to the interests of the state—one result of which misunderstanding was that after the war Germany had to pay a lot of money to the Ford motor car company for trucks built without permission during it. A world defined entirely in economic terms is already ungrounded, its ungroundedness underscored by its technological nature, both product and producer of it, which comes to replace nature itself with a world of the same (i.e., of pure ratio and data) where, as Bernstein puts it, "all that is solid must melt in the air"[20] (one notes that it passes through liquidity to meet the gaseous).

With the obviation of the object, which follows from the obviation of the human (its subject), the question would have to become one not of what the object is and hence of its origin, but of its disappearance. That would be crucial because it would mark the transition from the human to the post-human, the place where the former become active as data which could be retrieved, legible in electronic terms. The inhuman, where Lyotard finds the sublime, is still concerned with the human, with terror, the void, with what accompanies the human, with what engulfs or is the field of extension for the human, with the idea of the not-human. The post-human is what comes afterward. It has no need of terror; a void is its home, its natural habitat, as it were.

I have suggested that this possibility, indifferent to the idea of lack, may be found in the blank surfaces and pulsing screens ubiquitous in the contemporary world. Having made some comparisons between the nineteenth and twentieth centuries, I now offer a final one, which is prompted by Elaine Scarry's description of Thackeray's novels as working through an unease caused by a surface serenity and an underlying despair,[21] which has to do with why the post-human would subsume both the human and the inhuman.

Despair being presumptive, the nineteenth century worked hard on a serene surface. It is interesting in this respect that the Victorians painted passenger locomotives colors that required them to be constantly cleaned—the fire and boiler themselves being thoroughly hidden. It was an era in which, as has been said, a bank never looked like a bank if it could afford to look like a building

from ancient Rome. Nowadays banks display the safe in the window so that the police can see it in the middle of the night, but that development too—as has been noted—belongs to an earlier era than ours, the one that succeeded the Victorian use of surface to conceal, and consisted of seventy-five years or so of defamiliarization, of buildings made of glass, of, one might say, no serenity but only the aesthetics of despair, of revealing, of negation and subversion in all its forms and variants, and which finds its late expression in the Charles de Gaulle Airport, where one is made to pass through tubes like a hamster and is never inside but is rather situated always between two outsides, where one came in and where the plane is, so that the interior is only ever a continuation of the exterior by other means.

As noted, this does not describe objects that were recently made, beginning, in my case, with my car, or the telephone, or the computer, or the fax machine, or for that matter the coffee machine, a living memorial to steam, which it produces but which does not drive it. All these are encased in continuous plastic skins—the car with a skin made out of metal mixed with plastic which was then covered with plastic paint. They contain different insides, although all contain at least one computerized element. If they are not quite serene, the extent to which they're not is the extent to which they're banal, a banality which is a function of their being designed to disappear without revealing anything.

Serenity would encourage contemplation—as the beautiful is traditionally seen to be most useful as that which provides a calm and graceful atmosphere in which to contemplate terror—while the banal wishes only to slip into its function as a function. The car is meant to disappear once you're in it, by which time you're supposed to be gripped by some sort of Mr. Toad fantasy which will cause you to consume a lot and vote Republican. The telephone disappears as soon as you pick it up, at which point you're engaged in a conversation with someone who's not where you are. The computer communicates through its screen, the term "interfacing" fitting one's relationship to it exactly, as noted. The fax machine ingests and expels, again communicating laconically through its screen, a slit in an otherwise impassive shell. The coffee machine is an exception because of the historical nostalgia that comes with it, but even it works only when it's closed. Of these objects the car and the computer, the two which one has to sit down to operate, are the two most highly developed fantasy machines.

The post-human in things in general, then, is that which proposes an entity with which only the human could interact as an other, and which—neither a decorated thing nor personifiable mechanism, although we may long for it to be so—is at once a being and nonorganic. The relationship between the outside and the inside of such entities is one between a blank surface and an interior which is not mechanical but is rather an affair of the electrical and the simultaneous and the near-simultaneous, more like a brain than an articulated body, and in a

general way Bergsonian in its capacity to make connection through what is already present to a memory. It would in that be the place of two sorts of multiplicity. One, that of pure ratio, is what Deleuze calls the "multiplicity of exteriority, of simultaneity, of juxtaposition, of order, of quantitative differentiation, of *difference in degree* . . . "[22] This, he says, is "a numerical multiplicity, *discontinuous and actual*" and distinct from the other, which is "an internal multiplicity of succession, of fusion, of organization, of heterogeneity, of qualitative discrimination, or of *difference in kind; it is a virtual and continuous* multiplicity that cannot be reduced to numbers."[23] Entirely made of numbers, the technological may also produce a heterogeneity irreducible to them: the two conditions of the sublime, pure ratio and the infinite extension of quantity within simultaneity, limitless extension of qualities incalculable in its heterogeneity.

The sense in which the post-human (living in a post-history made of simultaneity which might, though, be subverted from within by the concomitant demand for a history of the simultaneous) appears to be at once a being and nonorganic—an electric brain feeding on nutrients generally available in the cosmos—would be that in which the techno-sublime could be seen to have subsumed both the human and the inhuman, the latter a negation of the former, and where the human found the possibility of the post-human to begin with, because, as Lyotard makes plain, the inhuman is the human exceeded.

Shirley Tse, a sculptor who works with plastic, has said that when she saw video images of Buckingham Palace in the wake of Diana Spencer's death she saw a sea not of flowers but of plastic wrapping. Heidegger, though unlikely to have been a fan of the Princess, would probably have been sick. Tse also sent me a dispatch from Reuter's of January 15, 1998, in which one learns that chemical engineers have "managed to coax plastic molecules into assembling themselves into structures that are not only beautiful, but useful . . . grow[ing] into crystalline forms that coat glass and could someday lead to faster communications."[24] The scientist in charge of the project, Samson Jenehke, explains that: "Much of nature is a product of hierarchical self-assembly, and humans are the example par excellence . . . Making materials that are on their own smart, intelligent and able to orchestrate their own growth marks the chemistry and polymer science of the future."[25]

In a world in which technology wraps nature, while at the same time elsewhere ceasing to be a prosthesis and instead originating its own bodies—which appear as surfaces that grow on glass, ancient vehicle of transparency, in an experiment aimed at replacing "semiconductors, crystals that can control millions of electronic signals... [with] a system that would allow this to happen with light [which] would be much faster and more efficient,"[26] Lyotard's brain can start as a brain that was never human, but was instead born inhuman, from other than human materials.

If Heidegger has been proved right in his claim that technology could

not be explained as prosthesis or instrument, but rather only in terms of the (pernicious) idea contained or displayed by the instrumentality and aspiration to the prosthetic, then it is perhaps also arguable that art, *techne* itself, is similarly ungovernable but in a (non-)sense he would, or did, not allow or recognize. In this, Heidegger seems betrayed by the independence of the very *poesis* in which he places such faith: art is not only or possibly essentially an instrument either, even of the counterinstrumental, but rather occupies both what is bounded by "the horizon of productivity" and its alternative frivolously and therefore transgressively, responsible to neither its instrumental function nor hermeneutics.

Like technology, as I have described it here, painting was always other than human not only in offering a surface made of poison which made present what was absent, but in proposing to make the absent present through a special kind of presence which was its own. Nonrepresentational painting is painting in which the latter subsumed the former early in the twentieth century. Deprived (by photography) of its original reason for being, no longer obliged to re-present but therefore forced to be present as more than a sign and site of signing, painting redeployed its capacity to present absence, positing the space of painting not as a receptacle but as a force—intransitive in not deriving its identity from outside—as it turned to an engagement with its own identity as a kind of beingness. It is as such that it, as I have noted here in respect to different aspects of the work of Chang, Reed, and others, offers a place in which to think about movement in the absence of form, the visualization of formlessness being one of nonrepresentation's implicitly primary themes, and which links it to the idea of the sublime.

A place in which to consider the idea of surface without depth, which is to say of spatiality—without which there can be no movement—which is not volumetric, since the formless need know no volume, and static even as it can only be considered, which is to say perceived or interpreted, in terms of relative movements, or speeds, and which does this within the context of the same, the unified surface, a homogenous materiality—the surface is in a solid state—but which is also a surface that is heterogeneous, in that it is also capable of combining not only every surface but also, heteronomously, every signification which could be found or lodged in, mounted or painted or inscribed on, or separated from any surface. In this, nonrepresentational painting offers a surface without depth, and, as nonrepresentation, a signifier long since alienated from any signified which could be said to be straightforwardly human. It's at least inhuman: not figure and field, inside and outside, solid and void, surface and depth; but formlessness, movement, indeterminacy, surface without depth.

Historically, nonrepresentational painting stands at the same kind of remove from the history of painting as representation as that of the computer from a history of technology in which machines extend the human rather than proposing its obviation. Both nonrepresentation and the technology of the

computer subsume their origins by deferring and displacing them, positing themselves as other kinds of things or processes than those that made them possible. It is as such that I have meant, in this book, to put forward the idea that the one may provide a context in which to look at the other. The comparison would only be useful as long as one were not seen as a picture of the other. It would, rather, be a question of what sort of thinking did representation make possible about that which it obviously is not, the technological, given that the thinking of the handmade is now a thinking in which the latter simultaneously creates two conditions: of nature replaced by technology and of nature in an unstable equivalence with it, their mutual irreducibility blurred by the parallelism of their terms.

I have mentioned Scarry on Thackeray in regard to the nineteenth century and its serene surface, and turn to Pynchon for a literary equivalent of the contemporary's. Pynchon suspends the separation of surface and depth so as to equate the serenity of the surface and the despair of the depth and put them in the same place. This is reflected in his practice of making the most awful villains sympathetic, a suspension of the humanist-inhuman opposition which is more intense in Pynchon—goes further as proposition or provocation—than can the usual practice of giving bad guys good lines, because in his work what is called into question are the limits of both depth and surface as concepts, their abstraction allowing them to be typically encountered as interchangeable. This in its turn leads to the recognition, facilitated by Pynchon's considerable use of the technological, that one is in the presence of a model of thinking which is post-classical in its equation of mentality with technology—i.e., of the possibility of thought which took its form from that which was made possible by the human but has now returned as a supplement irreducible to its origin.

From a mentality which derives its image in part from post-human thinking, it's a short step to a body which looks beyond the human for its model, finding it as always in the technology through which it looks at itself, framed, in the fashion photograph, by a corporeal expression of itself at once frivolous and ideal. As I have said, photography is perhaps itself the first technological instance of simultaneous retrieval, taken almost in an instant, developed all at once (again, perhaps Bergsonian rather than Hegelian), and fashion photography the place where the idea of the body attached to a principle which is born of the photographic is most in evidence.

Just as philosophy is always attaching the mind to some analog—at one minute it's the Holy Roman Empire, then a cross between a telescope and a clock, and nowadays a computer—so too fashion finds a surface for the body in the world in which it finds itself. In the medieval period ectoplasmic, clothes reminiscent of suits of armor, by Thackeray's it's become a drama of layering, presentation through concealment as deferral, implication through distortion. In the 1930s, it was a matter of mechanical articulation and streamlining, culminat-

ing in the outfit made of parts which could be exchanged and adjusted to confuse work with play and daytime with night, and with it a greater continuity between inside and outside than ever before.

I have suggested that nowadays the question is not streamlining, which is assumed and a priori, but intensification. The body as flawless but relatively unadorned. The contemporary body produces (and seduces) itself through the terms of the photographic, seamless and present all at once, which are themselves mimetically continuous with those originally its own. Clothes, similarly, don't conceal, and therefore don't reveal, but intensify. Cosmetics don't cover but, in the language of the trade, enhance. The play of inside and outside having given way to the hegemony of the surface, the body assumes not the appearance and condition of the fortress with tantalizing openings, nor to that of layers which play with an image of display as concealment (i.e., as displacement) but rather to a condition of continuity. Where painting, by having nothing to do with technology, might be seen to say something about the possibilities of the post-human techno-sublime, for thought, so too the fashion photograph, subsuming both body and technological in an image of frivolity—i.e., by pretending to know nothing about anything serious—might suggest itself as the realization of the visible post-human in the human at its most and least human, the last a function of its indifference to the idea of seriousness in the face of the obligation to be an image which it inherits from Helen. That it has that obligation to confront the serious with frivolity is, I think, why it is impossible to suppose that it is the sublime rather than the beautiful that is capable of transgression.

That is the sense in which I have suggested here that both painting and the fashion image play with the post-human sublime which is made both possible and visible by technology, and whose terms are: blank and static activity, intelligence without gestural expression, encoding without inflection or irregularity, pure measurement, and pure power. It is found in machines which resist personification but nonetheless interact with the human, and its terms are the surface without depth, continuity as flawless and infinite extension, which are those of the techno-sublime and the beauty which exists in a differential relationship to and within it and its blank energy. And in a way, and parodically, it is the technologically sublime post-human that makes Heidegger's listener possible. A listener returned through a possibility of equivalence that comes from a loss of origin, to a vantage point that can suspend its own beginnings. Not Heidegger's reader at all, then, but a mirror image of that reader. Represented, at a humorous but quite literal level, by the professor in the academic cockpit accessing absolutely everything. Heidegger ends the Anaximander Fragment with a line about having to poetize on the riddle of Being: "It brings the dawn of thought into the neighborhood of what is for thinking."[27] Thinking about the post-human leads one to the thought that the neighborhood's changed but it is always dawn, a perpetual futurity. A dawn during which the woman who runs the Xerox room at

the high school where my wife teaches said to her that she had given all the machines names but they knew us, of course, by our numbers.

1. John Markoff, "It Isn't Human, but the Voice On The Line is Ready to Help." *The New York Times*, Sunday, 21 June 1998, 1.

2. Lyotard, "Can Thought go on without a Body?" *The Inhuman*, op. cit., 13–14.

3. Kittler, op cit., 132.

4. Martin Heidegger, the Animaxander Fragment, in *Early Greek Thinking*, intro D. F. Krell, trans. D. G. Krell and F. A. Capuzzi (San Francisco: Harpers, 1984), 13.

5. Heidegger, op. cit., 17.

6. Heidegger, op. cit., 19.

7. Ibid.

8. Ibid.

9. Heidegger, op. cit., 29.

10. Heidegger, op. cit., 22.

11. Heidegger, op. cit., 13.

12. Raffoul, op. cit., 111.

13. Raffoul, op. cit., 114.

14. John Mullen (University College, London) "Lost Voices," *www.newsunlimited* (London: Guardian Newspapers Ltd., Friday, 18 June 1999): "Linguist John Honey thinks that the Bard 'grew up speaking the Stratford-upon-Avon variant of the Warwickshire accent'—but he would have had to ditch it to get on in the world."

15. J. M. Bernstein, *The Fate of Art: Aesthetic Alienation from Kant to Derrida and Adorno* (University Park, Penn.: Pennsylvania State University Press, 1992), 266.

16. One could relate this also to Derrida's description of ideology as requiring "*a physical* body . . . a technical body or an institutional body . . . a visible-invisible body, sensuous-non-sensuous, and always under the tough institutional or cultural protection of some artifact: the helmet of the ideologem or the fetish under armor." Derrida, *Specters*, op. cit., 127.

17. Heidegger, op. cit., 56.

18. Heidegger, op cit., 57.

19. See above, II, ms, 12.

20. Bernstein, op. cit., 266.

21. Elaine Scarry, *Resisting Representation* (New York: Oxford University Press, 1994), 130.

22. Gilles Deleuze, *Bergsonism*, trans. Hugh Tomlinson & Barbara Habberjam (New York: Zone Books, 1988), 38.

23. Ibid.

24. Reuter's, Washington, 15 January 1998.

25. Ibid

26. Ibid.

27. Heidegger, op cit., 58.

VII.

A Last Word About Beauty

As she leaves the narrative of *The Mighty Morphin Power Rangers,* the woman in the leatherette bikini says goodbye to the group and then turns into an owl, which underlines her association with wisdom. But when I saw it I recalled that the white fascist party in South Africa had adopted the owl as its symbol during the first multiracial elections there, and things hadn't turned out very well because in the African language spoken by most of the population the word for an owl translates as "the killer that comes in the night." I could not but think that this would introduce an element of unintended ambiguity into the narrative for part of the film's worldwide audience. Which, if suggesting that an image of an owl is likely to be more ambiguous than one of a woman in a bikini, also implies that wisdom is more locally restricted in its choice of symbolic connotations than attractiveness. Or, alternatively, that the local people were on to something about the analytic.

I have suggested here that the video screen can support any image as long as it can fill it with a light which is not ambiguous but rather entirely known, as technology, to the point where it is now able to disappear into itself as a naturalized condition of appearance—from which art will want to retrieve it— comparable to that which described writing's relationship to thinking while it could forget it was a technology. Contemporary technology doesn't need to forget; it never pretended to be human. At the same time, I've described the video screen as the face of the post-human and said that there too there is an intransitivity—which I have otherwise identified with beauty—or something close to it, in that where one used to say that one couldn't get machines to work, of computers one says that they won't let one do something. One has a different relationship to them than with the world they've replaced, and as such with the surface through which the video screen does that replacing, and I have sought, here, to raise the question of what would be involved in engaging beauty and the surfaces on which it currently alights without allowing it to turn into some dreary image of wisdom, flapping away into the historical and hermeneutical gloom and away from the light one wants to describe.

I have suggested that the dominant discourse in contemporary art world life is one firmly committed to the gloomy as a virtue. The artists I have discussed here are all in the art world, certainly, but the central concerns of the dominant discourse are best represented by works like Cindy Sherman's or Nan Goldin's, which give one a comforting dose of deformation or despair going in, and in that begin and end as critical objects, never emerging from the gloom even to return to it. Bernstein, to whose *Fate of Art* my sense of the techno-sublime owes a number of debts, nonetheless draws precisely the conclusions alongside of which I've tried here to wonder aloud about another approach. Bernstein wants all that came after Adorno to return to him, and in brilliantly

reconciling Derrida and others with the Frankfurt Institute spells out succinctly Adorno's position as one which is paradigmatic for an idea of art which in my opinion is too comfortable with the reasons it gives for its repression or displacement of the beautiful. Bernstein explains that for Adorno "modernism is best understood as a diachronic movement from beauty and taste to the sublime. 'Works that transcend their aesthetic shape under the pressure of truth content occupy the place that aesthetics used to reserve for the sublime.'"[1]

One could not wish for a blunter statement than that of the will to submit pleasure to the demands of duty. It seems to me to recall Winckelmann, and the manly virtues of the eighteenth century, in its valorization of an aggressive truth that exerts pressure and seeks to occupy what was previously the reserve of an earlier version of itself.

It misses something out. As I think does Ross, even though he pursues quite a different path than Bernstein or Adorno, never allowing beauty to be mired in a critique where it has lost from the start: "The gift of beauty is the abundance of things, is given from the good, framed as cherishment."[2] However, in discussing beauty as both a derivative of and a problem for the good, Ross seems to have no place for an attractiveness which would be indifferent to its origins or obligations, or even one able to stick around: "In art, the gift of beauty is restricted, enters restricted economies of work, framed by history and judgment, framed in place. The gift of the good is sacrificed into work, in art, still bearing the mark of the good, witness to the abundance of the good, remembering wondrous beauties and catastrophic disasters."[3] Once again beauty has become something to be remembered, which is to say, as something which is not happening. Because it's not allowed. If it were to happen one wouldn't be able to contemplate the implications of only being able to remember it. This is the sense—which has everything and nothing to do with the form and conclusions of Ross's argument—in which the postmodern preference for the abject, as in Sherman or Goldin, is Victorian. It wants to make mourning a prior condition, and end, of pleasure.

Frivolity cannot be contained or transcended by mourning, and it is for that reason that it can't be contained by theories of power; it simply has no place in the discussion. It must therefore be a terrible temptation, and I think that's the sense in which this book has been driven by two of Oscar Wilde's aphorisms: "I can resist anything but temptation," and "Only superficial people don't judge by appearances." Too much in contemporary art defines itself by what it struggles to resist, particularly since a formulaic resistance is now what would need to be subverted were there to be life left in the idea of subversion. In a similar vein I have suggested that there is something to be gained from asking what surfaces look like and materially are, as opposed to where they may be situated within an argument about what they represent as traces of a history which has already been written.

A last word on beauty is a contradiction in terms, but this will be the last one here. I have said that beauty would have to be feminine because it exhibits the characteristics of neither the androgynous nor the masculinity in which the latter shares: It is not transitive, neither represents nor possesses actual power, but is instead frequently identified by or located within fragility and the delicate—and, in my opinion importantly, the frivolous. That, presumably, is why it scares people, what permits beauty to spook the serious, which must hurry to get beyond it if it is to maintain its hegemony. One can only conquer fear if one can be reassured that there's something of which to be afraid, and in declining to offer either resistance to, or acquiescence in, the tasks assigned to it by critical thinking, beauty fails to offer such reassurance. In general the intellectual community joins with the world at large in rejecting any limit on the language of force, ignoring beauty's powerless power.

But it is hard to see how one could speculate on what the limits of enlightenment through scrutiny might be without talking about both. Deleuze said of Nietzsche that he offered a way out of the duality offered by Marx and Freud, a starting point for another discourse (which would not be a discourse), which would not be founded in dialectic—to which one could add here, or deformation. Whatever the fate of discourse might be, the implications for art of what I've said here are that it has the choice of either seeking to possess the vitality of the fashion video or submitting itself to the dead hand of critique. Since it is art it cannot not be attached to critique in some way, and would therefore have to seek a way of getting outside of the opposition that might at first suggest, since to see the frivolous as anticritical would be to reduce it to a discursive category.

However, frivolity being something for which, as a produced object and given its critical nature, the work of art would have to strive, its end—the purpose with which it played, or in which it found itself or was found—could be to expand one's sense of what the sensuous borrows from the electronic. Hegel says that art is "more or less borrowed from the sensuous and addressed to man's sense,"[4] and one wants to see to what the sensuous is nowadays attaching itself, and in that adding on to itself, and, for what kind of sense it seems in conse-quence now to call. The artwork cannot but be an intended object, but it could be one which opens itself to the world rather than taking recourse and shelter in what preemptively frames that world by insisting on its own priority. In its faith in a discourse of fear and/or distrust—were it fondness and/or distrust things would at least be more productive, pleasure is improved by being transgressive, hence beauty's infinite capacity to absorb whatever transgresses against it—the current administration of contemporary art tends to miss the point of much of what surrounds it, and typically to do so through a desire to suspend arousal in the interests of redemption.

That is the sense in which I should insist that Adornoism has for the

David Reed, #350, 1996. Oil and alkyd on linen, 54" × 118". Collection: Sammlung Goetz, Munich.
As installed in the Mirror Room, Neue Galerie am Landesmuseum Joanneum, Graz, Austria.
Photographer: ©Johann Koenigg. Courtesy: Galerie Rolf Ricke, Cologne.

most part itself turned into a jargon of authenticity humorously parallel with the Heideggerian one against which he railed, and also why so much that is in art galleries is less interesting than what's on the street. On the other hand, beauty secularized, glamorous rather than good—indifferent rather than opposed to it— could mean that in order to be a contemporary idea, the sublime might have to attach itself to, or find itself within or through, a deconstruction of looking which confronts rather than evades the idea of the fascinating. Such a confrontation would respond to the counterproductivity of fascination—the subject driven by its object, or lost in it or the drive to be lost—with a counterproduction that takes place at thought's limits rather than securely within them. This sublime would perhaps have to be made of an excess not of "onement," but of series of versions of "onements," realized not in the name of the power of the act, but of that which need not act in order to have an effect, seducing—effortlessly forcing force from its chosen path—the negative terms of the sublime toward that "sublime point at which the abject collapses in a burst of beauty that overwhelms us—and 'that cancels our existence' (Celine)."[5]

Would this be an art at once limitless and symmetrical, an art of disjuncture nonetheless constitutive of an entity? An art more like a body than a

landscape, more like a face than an idea, more like a being than an act? It seems it would have to be, and not only because "[I]f things endure, or if there is duration in things, the question of space will need to be reassessed on a new foundation. For space will no longer simply be a form of exteriority, a sort of screen that denatures duration . . ."[6]

Barnett Newman invented the contemporary sublime and titled his notes on it "The Sublime Is Now,"[7] announcing a concern with immediacy whose significance Lyotard saw more clearly than most while finding a model for it in the tundra. Fragility is one of the properties which links the flower to the tundra—the beautiful to the sublime—and is characteristic of both. Oil companies are destroying the permafrost that covers it right now. Yet if the tundra's flora are known for their delicacy, it is one of the toughest places on earth in which to survive, and that is the only place in which they are to be found.

1. Bernstein, *Fate of Art,* 235.

2. Ross, *Gift of Beauty,* 288.

3. Ibid.

4. G. W. F. Hegel, *On Art, Religion, Philosophy: Introductory Lectures to the Realm of Absolute Spirit,* ed. and intro J. Glenn Gray (New York: Harper and Row, 1970), 51.

5. Julia Kristeva, *Powers of Horro:, An Essay on Abjection,* trans. Leon S. Roudiez (New York: Columbia University Press, 1982), 210.

6. Deleuze, *Bergsonism,* 49.

7. Newman, "Sublime Is Now."

Index

Sculpture in the Age of Doubt
by Thomas McEvilley (paper with flaps, 6 × 9, 448 pages, $24.95)

Uncontrollable Beauty: Toward a New Aesthetics
edited by Bill Beckley with David Shapiro (hardcover, 6 × 9, 448 pages, $24.95)

The End of the Art World
by Robert C. Morgan (paper with flaps, 6 × 9, 256 pages, $18.95)

Redeeming Art: Critical Reveries
by Donald Kuspit (paper with flaps, 6 × 9, 352 pages, $24.95)

The Dialectic of Decadence *by Donald Kuspit, Introduction by Bill Beckley*
(softcover, 6 × 9, 128 pages, $18.95)

Artists Communities: A Directory of Residencies in the United States
That Offer Time and Space for Creativity, Second Edition
by the Alliance of Artists Communities (softcover, 6³/₄ × 10, 256 pages, $18.95)

Design Literacy (continued)
by Steven Heller (softcover, 6³/₄ × 10, 296 pages, $19.95)

Design Literacy: Understanding Graphic Design
by Steven Heller and Karen Pomeroy (softcover, 6³/₄ × 10, 288 pages, $19.95)

Looking Closer 3: Classic Writings on Graphic Design
edited by Michael Bierut, Jessica Helfand, Steven Heller, and Rick Poynor
(softcover, 6³/₄ × 10, 304 pages, $18.95)

Looking Closer 2: Critical Writings on Graphic Design
edited by Michael Bierut, William Drenttel, Steven Heller, and DK Holland
(softcover, 6³/₄ × 10, 288 pages, $18.95)

Looking Closer: Critical Writings on Graphic Design
edited by Michael Bierut, William Drenttel, Steven Heller, and DK Holland
(softcover, 6³/₄ × 10, 256 pages, $18.95)

Please write to request our free catalog. To order by credit card, call 1-800-491-2808 or send a check or money order to Allworth Press, 10 East 23rd Street, Suite 210, New York, NY 10010. Include $5 for shipping and handling for the first book ordered and $1 for each additional book. Ten dollars plus $1 for each additional book if ordering from Canada. New York State residents must add sales tax.

To see our complete catalog on the World Wide Web, or to order online, you can find us at *www.allworth.com.*